BEYOND BOUNDARIES

NEW YORK'S NEW ART NEW YORK'S NEW ART NEW YORK'S NEW ART NEW YORK'S NEW ART NEW YORK'S NEW ART NE

NEW YORK'S NEW ART NEW YORK'S NEW ART NEW YORK'S NEW ART NEW YORK'S NEW ART NEW YORK'S NEW AR

BEYOND BOUNDARIES

New York's New Art

by Jerry Saltz

essays by Roberta Smith and Peter Halley

ALFRED VAN DER MARCK EDITIONS NEW YORK

Editorial director: Robert Walter
Managing editor: Leonard Neufeld
Designer: Jos. Trautwein / Bentwood Studio
Typographer: David E. Seham Associates

Painting on front of dust jacket by Ross Bleckner: Untitled, 1985. Oil on canvas. 48 × 40".
Private collection. Courtesy Mary Boone Gallery.

Alfred van der Marck Editions
1133 Broadway, Suite 1301
New York, N.Y. 10010

Library of Congress Cataloging-in-Publication Data:

Beyond boundaries.

1. Art, American—New York (N.Y.). 2. Art,
Modern—20th century—New York (N.Y.) 3. Avant-garde
(Aesthetics)—New York (N.Y.)—History—20th century.
4. East Village (New York, N.Y.)—Popular culture.
5. New York (N.Y.)—Popular culture. I. Saltz, Jerry,
1951– . II. Smith, Roberta. III. Halley, Peter.
N6535.N5B49 1986 709'.747'1 86-45287
ISBN 0-912383-31-3

Color separations, printing, and binding by Poligrafiche Bolis, Bergamo, Italy.

First printing: October 1986

ACKNOWLEDGMENTS

First, for Laura Carpenter. If not for Laura, nothing.
To Eric Fischl and April Gornik. Both to me a gift.
To Alfred van der Marck and Bob Walter for their faith and vision.
To Lenny Neufeld for his steady hand and gentle heart.
To Lorie Novak who cared about this project as much as I did.
Thank you to Roberta Smith. The hours of conversation will be remembered.
Finally, to Robert Loescher, who lit a fire so long ago.

This book would not have been possible but for the kindness and the patience of the following people and galleries. Diane Cleaver, Abby Chevalley, Maja Damianovich, Diana Formisano, Gary Garrels, Marisa Hansell, Anne Philbin, Massimo Audiello Gallery, Josh Baer Gallery, Baskerville + Watson Gallery, Mary Boone Gallery, Cable Gallery, Cash/Newhouse Gallery, Paula Cooper Gallery, Barbara Gladstone Gallery, Jay Gorney Gallery, Pat Hearn Gallery, Marvin Heiferman Gallery, Jeffrey Hoffeld Gallery, International with Monument Gallery, Michael Klein Gallery, Lorence•Monk Gallery, Luhring Augustine & Hodes Gallery, Gracie Mansion Gallery, Curt Marcus Gallery, Metro Pictures Gallery, Nature Morte Gallery, Tibor de Nagy Gallery, Daniel Newburg Gallery, Annina Nosei Gallery, Postmasters Gallery, Piezo Electric Gallery, Sonnabend Gallery, Wolff Gallery.

Grateful acknowledgment is made to the following for permission to reprint material copyrighted or controlled by them:

Bill Arning for an extract on Meyer Vaisman from a press release for White Columns.
Art in America for an extract on David Storey, © April 1986 by Stephen Westfall in *Art in America,* and for an extract on Gretchen Bender, © April 1984 by Jonathan Crary in *Art in America.*
Tricia Collins & Richard Milazzo for an extract on Kevin Larmon in "Natural Genre," an exhibition catalog for the Fine Arts Gallery, Florida State University, Tallahassee, 1984.
East Village Eye for an extract on Laurie Simmons, from an interview by Beth Biegler, January 1986.
Flash Art International for an extract on Philip Taaffe. from an article "From Criticism to Complicity," Summer 1986.
Gary Garrels for extracts on Jeff Koons and Robert Gober in a catalog for the New Sculpture show at The Renaissance Society at the University of Chicago.
Barbara Gladstone Gallery and Wilfried Dickhoff for an extract on George Condo.
Jay Gorney for an extract on Peter Nadin from a press release by Jay Gorney Modern Art.
Gary Indiana for an extract on Jon Kessler in "The Daze of Our Lives: Notes for an Essay on Jon Kessler."
Mark Innerst for an extract on himself from the catalog for the 1985 Exxon National Exhibition, Guggenheim Museum, New York.
Alfred A. Knopf for an extract for Christopher Wool, from *Dispatches,* by Michael Herr, © 1977 by Michael Herr.
International with Monument Gallery for an extract on Peter Nagy, January 1986.
Louise Lawler for an extract on herself from a press release for *Interesting* exhibition at Nature Morte Gallery.

CONTENTS

FOREWORD

I have chosen the art in this book with the conviction that a major shift is occurring in the New York art world, that a critical juncture has been reached. My selection was loosely guided by the notion that there is indeed a "new art" here, one with certain observable characteristics. This art tends to be abstract but almost never nonobjective. Much of it favors cultural or social subject matter over self-exploration or self-expression. It favors the diagrammatic and the theoretical over the mysterious and the fantastic, over the bizarre and the grotesque, the unconscious and the uncanny. It does not arise from a constant, almost maniacal urge toward self-contemplation. It places special emphasis on the object and almost invariably is smaller in scale, but not in scope, than much other recent art. This art is forming even now, and only very recently has it come to the forefront. But it is already exerting a great influence on our thinking. This is an art with significant repercussions and consequently, an art with a future.

Perhaps history, like people, passes through certain psychological stages of development. Now, in these later years of the twentieth century, art history is emerging from a prolonged "Oedipal" phase, a period in which each succeeding movement felt compelled to react against, even "slay," the preceding movement. Now, after the reaction of Neo-Expressionism against Conceptual Art and Minimalism (which had been a reaction against Pop Art, and so on), we find ourselves at a cross road. This new art is not dominated by any one movement attempting to gain a stranglehold on our attention. Instead of trying to vanquish, it seeks to (re)combine figuration with abstraction, content with formalism, looking with thinking, all in a non- or even anti-Oedipal fashion, without trying to negate any preceding or contemporary art movement. Indeed, other contemporary art includes many artists who continue to produce exciting and significant work. It is, however, essential to stress that this art does not express a pluralist outlook. The works in this book hold passionately to their positions. They express belief in one thing over another; they never offer mere information masquerading as content.

This book is a survey of this new art being made in New York City. The work of the fifty-six artists shown herein constitutes a comprehensive overview of this art, at a time when the art world is poised between one time and another.

Roberta Smith, who has been involved with and writing importantly about much of this work from the start, was a natural choice for me to ask to write the introductory essay. Peter Halley's intensely conceived "Essence and Model" analyzes this new art as expressive of contemporary cultural trends and sensibilities. The statements by the artists themselves reveal the multiple voices with which they speak. I hope the readers of this work get as much out of the looking and listening as I have.

—Jerry Saltz, August 1986

RESEARCH AND DEVELOPMENT, ANALYSIS AND TRANSFORMATION

by Roberta Smith

This essay is being written during the summer of 1986, two-thirds of the way through one of the fastest-moving decades for art in general and after a watershed season for New York art in particular. One experienced observer, Robert Pincus-Witten, called it "the scene that turned on a dime." Even *The New York Times* noticed. In a January 1986 article, Michael Brenson announced that Neo-Expressionism, whose evolution the *Times* had followed so closely, had run its course. In May 1986, in a second *Times* article, Douglas C. McGill pinpointed a new, rapidly emerging geometric art that he saw being developed primarily by a few artists and artist-dealers in the East Village.

Despite the best of intentions, the *Times* articles tended to simplify a very complex situation. So-called Neo-Expressionists will continue to develop their art, just as many of them—Malcolm Morley, Leon Golub, the late Philip Guston, the several well-known Germans and Italians—managed to create significant works before the term was coined. What's over is not so much Neo-Expressionism as its primacy—its not always pleasant grip on the collective (and collecting) consciousness—as well as New York's uncritical infatuation with art from abroad. With a predictability that is at once disconcerting and invigorating, the art world's short-spanned attention has again shifted, this time from Neo-Expressionism to other art activities that have in fact been under way for some time. Yet, when activities long in the forefront recede and others come into focus, the sense of being at a turning point is undeniable. And for the art world, this is the situation at the moment.

Because Neo-Expressionism received so much attention from the general media and seemed, stylistically and temperamentally, to encourage a certain conflation of art and artist, of personality and product, there is perhaps a greater than usual sense of relief. There is the feeling that a fever has passed, that the restrictions and especially the licenses of one regime no longer dominate. One hopes there won't be a next regime, but—even as I write—the dictates of a severe Neo-Minimalism may be taking hold. (Beware the revenge of the third-rate monochromatists.)

It may be, however, that much more is over than just Neo-Expressionism's primacy, that a kind of era has passed. In retrospect, the years 1970 to 1985 may be viewed as a period bounded by the multiheaded hydra of Conceptual Art at one end and by Neo-Expressionism at the other. International in scope, supported and denounced with equal vehemence, mutually exclusive and yet oddly similar, these two movements were the stylistic and chronological poles between which all else moved. They outline a major shake-up, framing a drama in which art's potential and its respon-sibilities were aggressively examined, debated, and expanded in a continual give and take between experimentation and tradition, subject and object, the dematerialization and rematerialization of the art object. Few artists of note have emerged since 1970 without either participating in or being influenced by Conceptual Art. We will probably continue to feel and examine its impact for years to come. And although the majority of artists active during this period hardly qualify as Neo-Expressionist, most moved in some way toward a "new expressiveness" in the atmosphere that Neo-Expressionism created.

This period may actually have had two phases, or have been centered on a drama that was played out twice. It seems accurate to say that the initial 1970s conflict between Conceptualism and the amorphous, composite trend of Pluralism was later, in the first half of the 1980s, simply reenacted between the phenomenon known as "Pictures" art (whose name derives from an article by the critic Douglas Crimp) and Neo-Expressionism. This time the battle raged on an international stage, in a shortened, more exciting version, and for higher stakes, both critically and financially.

Beginning in the late 1970s and early 1980s, Conceptualism seemed to threaten the art object with extinction. For many young artists of "advanced" ambitions, the art object was too closely bound to a series of dubious practices and old sites—the studio, the museum, the art market—and a whole system of values, monetary and otherwise, that in effect shackled the viewer's imagination. The sheer physical attenuation of many conceptual efforts helped refocus art on the issue of subject matter—as a radical, rather than a conservative, pursuit—and implicated art more thoroughly in the realms of the social, the political, the psychological, and so forth. Conceptualism's various texts and captions proposed that art, quite literally, was something to read meaning into and out of, that it was overtly, rather than covertly, legible and communicative. Thus it placed a new responsibility of participation on the viewer. Frequently, texts and captions accompanied photographs, while other activities that fit beneath Conceptualism's broad umbrella—from performance and installation art to earthworks—were often experienced primarily, if not exclusively, through documentary photographs. Consequently Conceptualism, almost inadvertently, opened a crucial fissure in the hegemony of painting and sculpture: it made the photograph an incontrovertible force in contemporary art, paving the way both for appropriation—the use of preexisting images—and for that most important of infiltrations, that of high culture by mass culture.

By the late 1970s, the challenge thrown down by Con-

ceptualism had been picked up and considerably strengthened by the Pictures artists, the purest perpetrators of the often ultrafine art of appropriation. Richard Prince trained his camera exclusively on preexisting photographs, usually from advertising; Cindy Sherman trained her camera on herself, creating eerily suggestive "film stills" for movies that never existed; Sherrie Levine rephotographed famous "fine art" photographs by Edward Weston, Walker Evans, and Alexander Rodchenko. With the work of these artists, the image reestablished its primacy, absorbing the captions and texts of Conceptualism. Sometimes, however, their images were so close to their sources as to be indistinguishable from them, and a highly aestheticized, hermetic seamlessness—as opaque as the blankest, blandest formalism of Color Field painting—would result. And although these artists returned to portable art objects of a sort, a certain attenuation continued; they showed little interest in the visibility of process, the art object's physical structure as a purveyor of meaning—and pleasure.

At the same time a robust opposition hove into view, as the various Pluralist image- and object-oriented activities that proliferated on both sides of the Atlantic during the 1970s gained coherence. They coalesced into the highly marketable international phenomenon of Neo-Expressionism, a style that reveled in material, in angst, in the psychosexual, and where the pleasure principle was also quite at home. In a sense the sensational subject matter often set loose by Conceptualism had merely lodged—to dramatic visual and media effect—in the narrative machinations of Neo-Expressionism. There had certainly been an expressionist strain in some Conceptual performance art. From Joseph Beuys's interactions with dead hares and live coyotes to Vito Acconci's self-exposures and Chris Burden's flirtations with danger, one encountered flagrant gesture, figurative reference, and a degree of heat that had long seemed taboo for advanced, mainstream painting and sculpture. Neo-Expressionism broke that taboo, reconnecting painting and sculpture to its imagistic, storytelling capacities. And while Pictures artists opened art to media imagery culled from TV, the movies, advertising, and so on, the Neo-Expressionists liberated art-historical motifs for further use and attracted a large and interested art-viewing public. Most of all, Neo-Expressionism reiterated, in at times dazzling but usually quite conservative terms, the visual power of the handmade art object.

The best of Neo-Expressionism, seen in the layered images of Sigmar Polke, David Salle, and Julian Schnabel, offered its own painterly, materialist-based appropriation. But most Neo-Expressionism all too frequently suggested that art was on an unmitigated male-adolescent rampage.

Loosely painted figures flailing away in loosely painted surfaces were ubiquitous. By the early 1980s, it seemed unlikely that these figures or their creators could flail on ad infinitum—just as it had seemed doubtful, in the anti-object free-for-all of the early 1970s, that painting and sculpture would quietly wither away.

In a sense Conceptualism and Neo-Expressionism may have revealed two—perhaps *the* two—equally untenable endpoints for art. Conceptualism, all too ready to dispense with the art object and the whole nonverbal, sensuous side of aesthetic experience, often seemed to offer up art that appeared to be blatant exhibitionism or didactic instruction, for medicinal purposes only—and all in the name of progress and its dictates. Neo-Expressionism, throwing itself into the revitalization of the art object and embracing the past with equal vehemence, seemed to say that art could proceed with little or no attention to the notion of progress. Catalytic as both movements were, at their worst they can be seen as complementary forms of irresponsibility. Flawed and extreme, they formed an unexpected continuum. It is hardly a coincidence that several of this period's most effective artists—Beuys, Gilbert & George, and Jannis Kounellis, for example—managed to be at least tangentially associated with both phenomena. It may be that the two movements deserved each other and in a strange way completed each other: that Neo-Expressionism was an inevitable reaction, if not an overreaction, to Conceptualism and provided a kind of closure.

Where exactly that closure leaves things now is subject to multiple interpretations, but the general vicinity is not hard to describe. This is no longer a time of polar (or semipolar) oppositions. Following the thesis-antithesis oppositions of Conceptualism versus Pluralism, then Pictures art versus Neo-Expressionism, and, overall, Conceptualism versus Neo-Expressionism, art—especially American art—is, not surprisingly, in a period of synthesis, of consolidation and enrichment. The territories opened during the past fifteen years are being scrutinized in detail. Some areas are being abandoned as uncultivatable, while others—among them, exploration of the dissolving boundary between abstraction and representation, as well as the fragmented, psychologically complex disunity endemic to the best Neo-Expressionism—seem particularly fertile. Under negotiation is a new, more completely balanced art, cognizant of both the material denial and the intellectual clarity of Pictures art, of both the overindulgence and the physical confidence of Neo-Expressionism. In addition, there seems to be a pervasive realization that pleasure is its own form of knowledge, that few things communicate like an engaging visuality. The pleasures of the text are not incompatible with those

of the object.

The key to these developments lies in the wild-card nature of appropriation, the central issue to take sides on in the late 1970s and early 1980s. What images were appropriate to appropriate? Media images only? Images from science books or cartoons? Images (or styles) from other art? And further, was the camera the only tool? What about using your hands? And which media were these images to be appropriated into? Only photo-based work? Painting? Sculpture? And finally, how did materials, not to mention whole objects, fit into the scheme of things? Thankfully, these questions have eluded single right-or-wrong answers; thus the scheme of things has become extensive and varied.

What seems to have sped art toward its current state of synthesis and depolarization is the fact that appropriation, like the photograph itself, has assumed a life of its own, far exceeding the limits of its initial, more theoretical stage. It has turned out to be extremely uncontrollable and healthily "normal" in the art sense, rather than narrow and esoteric. It would not stay put, being too big and too full of possibilities for any one area of art practice to contain it. A tool for deconstruction, appropriation has itself been subjected to a kind of deconstruction and diversification as its strategies have spread from artist to artist and from medium to medium. Its program has been deprogrammed, and as its "seams" have begun to show more consistently, it has become even livelier. Appropriation's progress from seamlessness to seamfulness is widely apparent, visible among some of the original Pictures artists (several of whom are in this book), among younger artists they have influenced, and among a whole range of artists exploring other venues. Even the purest of the pure have become "seamier." In Cindy Sherman's most recent work, for example, the overtly put-together quality of her characters, special effects, and mise-en-scènes has made her images more communicative, on all levels.

As the branching out of appropriation continues, artists of various inclinations in different media are realizing that working with the camera, or any other tool of mechanical reproduction (or simply with the suggestion that an image is reproduced), in no way precludes an intricate involvement with materials. For certain artists, notably Sigmar Polke and David Salle, there was never any doubt that camera and hand could go together. But this knowledge has broadened in the past several years, especially as various artists have moved beyond the largely figurative media-derived images toward more intrinsically abstract motifs.

In all instances, it seems that the various media are being infiltrated from without while being assiduously expanded from within, and it is this sense of multiple pressures, along with the assurance that each medium can accommodate them, that gives this moment its heady, open feeling. Photography, for one, has turned out to be as adaptive as the strategy of appropriation it helped make possible; it is also quite as elastic, resilient, and absorptive as any other medium. The photo-based work in this book is on an equal footing with painting and sculpture, and in its growth has both changed, and been changed by, them. Its progress is especially paradigmatic of the multiple pressures currently stimulating all media. The set-up photographs of James Casebere, Laurie Simmons, and Ericka Beckman assimilate and mimic aspects of installation art, painting, and sculpture. The seams are particularly visible in Casebere's deserted, cobbled-together stage-set images and in Simmons's spatially disjointed yet color-coordinated modern interiors and exteriors. Beckman similarly builds her images for the camera. Louise Lawler is known for photographing other people's arrangements of other people's art (a kind of installation art twice, or thrice, removed), as a way of commenting on the collusion of art with interior decor. But her images in this book are more directly "installed," providing an approximation of the aesthetic experience (examining an object of delight from all angles) as well as an appropriate (and widely appropriated) critical response: Interesting. In Barbara Kruger's jolting combinations of language and image, in Sarah Charlesworth's stylized fusions of saturated color with artificialized natural images, and in Simmons's carefully matched dolls and settings, we see an array of formalism's obsessions—the picture plane, flat monochrome color, push-pull, figure-ground—adapted to more complex, message-laden purposes. Clegg & Guttmann's and Barbara Ess's photographs incorporate conventions of older art: the former by imitating the seventeenth-century "power portraits" of the Dutch burghers while, in other works, updating (and downgrading) the still lifes they tended to collect; the latter by using a crude lensless camera to evoke the moody vagueness of turn-of-the-century Pictorialist photography while choosing subjects of an unveiled grittiness. Alan Belcher and Nancy Dwyer combine materialized photographs and graphics with sculptural structures of a decidedly Minimalist sort, reminding us of the reciprocity between art and advertising. And the photograph, or reproduced image, is a presence, sometimes blunt, sometimes ghostlike, in many of the paintings in this book, in countless guises and permutations.

In different and myriad ways, many of the artists in this book are involved with breaking down an image—or an object, or technique, or convention (or all of the above,

plus some)—into its component parts, laying these elements out, and then reassembling them so they remain legible within the finished work. I suppose this description constitutes a layman's, or a literalist's, definition of deconstruction. It also constitutes a new relationship of parts to wholes. "A painting is supposed to hang together," complained Minimalist Donald Judd in *Art in America* a couple of autumns ago, referring to David Salle's piecemeal way of making a painting. A lot of artists, not indifferent to Salle's achievement, seem to be answering, "Yes, but not necessarily in the same old way." There's a new way, and not just for painting, either, which more accurately reflects the thought process, by being disjunctive, multivalent, accumulative, and at times seemingly random. Overall, the goal in much of the work in this book is to communicate a particular kind of consciousness through a particular visual-physical articulation, an articulation that starts in analysis and leads to transformation. Here, technique or process is neither invisible (as in much Pictures art), nor merely a vehicle for subject matter (as in much Neo-Expressionism, especially the European variety). More and more, we are reminded that the connection of hand to eye and brain is neither obsolete nor sacrosanct. Technique and process are, rather, deliberate and thoroughly developed aspects of meaning itself. The various artists in this book have found ways to convey a sense of "touch" as diverse as they are convincing.

The best work in this book has an *assembled* quality, a put-togetherness that hangs together, but maybe just barely. Something old, something new, something borrowed, something blue, or fluorescent pink, or bronze. Everywhere use is made of preexisting images or objects—parts of things, diagrams of things, replicas of things, things in themselves—all obdurately present, and all reminiscent. These images and objects have been subjected to multiple uses, reuses, and misuses, melded into assembled states and statements that have nothing to do with assemblage. They've come from somewhere and are headed somewhere else, right before our eyes.

The transformation may be accomplished merely in the act of presentation, as when Haim Steinbach juxtaposes carefully selected, color-cued merchandise on Minimalist-inspired shelves, or when Jeff Koons floats basketballs in tanks of water, skewing the function of their inflatability, as well as our notion of sport, trophy, and commodity. Working in the opposite direction, from art toward commodity, Allan McCollum transforms the unique work of art into an anonymous object—achieving reduced essences of painting and sculpture that are at once mass produced and tenderly made. Sherrie Levine, who began her career by

photographing other artists' photographs and art reproductions and then began making watercolor copies of modern masterworks, is now making paintings; like McCollum's, they're both generic and peculiarly personal. In a performance that for the most part maintains the fine line between anonymity and private individuality, between derivativeness and originality, Levine both evokes and transforms the perennial stripes and grids of modernism by presenting them in specific colors and materials, fashioned by her own hand.

Carroll Dunham, Terry Winters, and Ross Bleckner contrast painting culture with the larger visual culture by broaching an encyclopedic range of pictorial possibilities, sometimes on a single surface, and by continually pitting the natural against the artificial, received images against personal gesture, and obdurate material flatness against amazing feats of spatial illusion. Dunham's paintings are explosive accumulations of borrowed abstract styles (some merely extracted from the wood grains he paints on) that range from the subjective automatism of Surrealism and Abstract Expressionism to the special (often sexual) effects of animated cartoons. Winters fabricates a kind of pseudo-subjectivity of personal forms that are in fact derived from scientific diagrams, transforming these structures via a painting process that stresses paint equally as "natural" (somewhat scatological) matter and as a vehicle for intricate "civilized" expression. One never knows what Ross Bleckner will do next: he plays out his encyclopedic tendencies in constantly changing painting series that are variously "abstract" or "representational," "modern" or "nostalgic." Yet he invariably evokes a black-and-white silver-lighted netherworld which substantiates the notion that painting is essentially fictive, optical, and commemorative.

There are related encyclopedic assessments and juxtapositions of contradictory elements under way in R. M. Fischer's mélanges of industrial and domestic metal parts, in Kenji Fujita's conglomerations of old and new, plain and painted wood, in Jon Kessler's plastic fantastics, and in Joel Otterson's thin columns of objects and cement. In each case these artists achieve a semblance of formal resolution that is continually subverted from within as a work's various parts and their prior uses make their presences felt. Elsewhere, a meticulous form of splicing prevails, challenging the viewer to dissect a series of contingent parts or seemingly congruent layers. Each area in one of Jonathan Lasker's abstract paintings is a discrete, anomalous entity—painted its own way in its own color or pattern—locked awkwardly into a tentative "whole" like part of a Chinese puzzle, but ready to pop out at any moment. Suzanne Joelson layers together straightforward representational images

and abstract shapes, teasing us to read one through the other and figure out the connection. In a series of sardonic yet deeply sincere homages, Philip Taaffe appropriates the motifs of geometric abstractions from bygone eras (Barnett Newman's, Paul Feeley's, Myron Stout's—sometimes part, sometimes whole) and then updates and intensifies them through a painstaking process of printmaking and painting. Robert Gober's mute sink sculptures are distorted rather than found objects whose sensitively inflected white surfaces (reminiscent of Robert Ryman's beautiful all-white paintings) coat the utilitarian with a layer of aesthetic subtlety. Ashley Bickerton, also plying the zone between painting and sculpture, imbues painting's essential aspects (image, front, sides, corners, brackets), plus a few extras, with the hard-edge exuberance and high-tech craft of a custom-built hotrod. Meyer Vaisman, whose stacked canvases are printed with a blown-up canvas-weave image and finished off with laminate (for easy cleaning?), reassembles painting into a hybrid object at once alien and oddly domestic, as if it were part of last year's design for better living.

Much of the best work in this book tilts toward a kind—perhaps a new kind—of abstraction: a highly impure formalism, often hyperactive or multiple in media, in which the old modernist self-referentiality is perpetuated and energized by being turned inside out, so that some aspect of the world is reflected, too. In a sense, perhaps, it is not new, although its widespread acceptance may be. As Elizabeth Murray once said, acknowledging her own debt to the liberating effects of Neo-Expressionism, "People forgot how to work with all the material Johns gave us. Schnabel brought that back." What's being resurrected might also be described as the Minimalist concern for self-evident structure, but in a much more elaborated and intrinsically corrupted form. Above all, the worldliness and extreme consciousness that Conceptual Art visited upon us are in the process of being combined with a physical articulation that is at once sensuous and precise. And finally, it was perhaps inevitable that the "reading skills" implemented by Conceptual Art would eventually be applied to the unfinished business of modernist abstraction. In these various retrievals, we may be picking up where things left off in the midsixties, before the "specific objects" about which Judd used to write (covering work from Claes Oldenburg and Lucas Samaras to Frank Stella and John Chamberlain) got narrowed down into Minimalism, and Pop's image got knocked out of the picture.

Should all this culminate in a chauvinistic cheer that American art is back on track again? Not exactly. It's just that a frame of mind sometimes characterized as "American" is again becoming more prominent in contemporary art. You might say that the notion of art's progress—however much greeted with skepticism—is closer to the surface again and that the explosive nature of appropriation has not ended the possibility of originality or the obligation to pursue it, but rather extended both. American artists may have a deeper attachment to abstraction and a greater hope for progress, as well as a deeper workaday faith in the material basis of such progress. But they hardly monopolize these attitudes. After all, one of the most American artists working anywhere during the 1970s was Sigmar Polke. There are comparable developments emerging from Europe that suggest that what's going on in New York right now is not an isolated occurrence, despite a certain American tone, and that the renewed and newly balanced concentration on medium and message, wherever it is pursued, offers boundless possibilities.

Beyond Boundaries, then, could be said to operate in the gap between regimes, in a brief period of clarity wherein a range of different activities is visible. Editor Jerry Saltz's selections and his organization of them assume that sectioning off the art scene into particular media, ideologically "correct" positions, or lookalike trends is not as interesting as attempting to elucidate some of the common aspects underlying the best work—art that is, inevitably, more disparate than makes many people comfortable. Obviously, I heartily second that assumption. By presenting a partial census of some of the best and most promising art in New York in the mid-1980s, we hope to demonstrate something important about both the recent past and the immediate future.

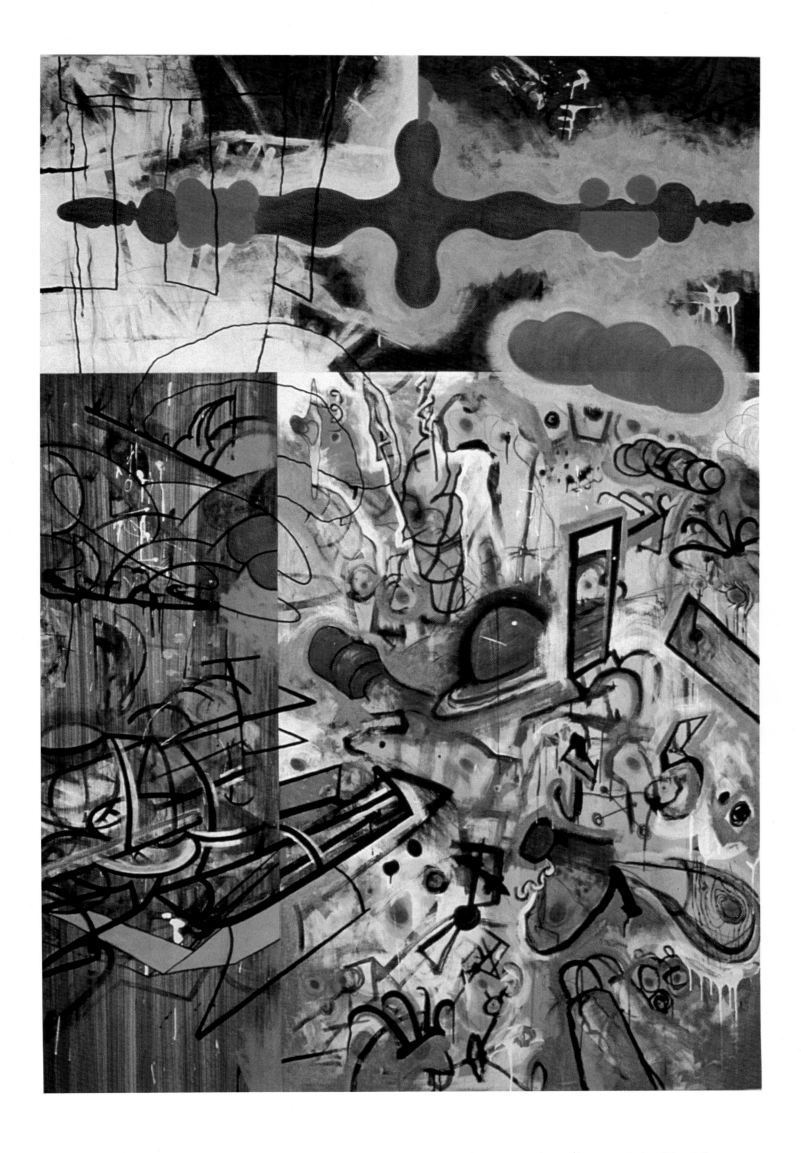

The High Frontier, 1984–85. Casein, dry pigment, flashe, casein emulsion, plastic wood, carbon, charcoal pencil on walnut, zebrano, and pine. 78 × 54".
Collection First Bank of Minneapolis. Courtesy Baskerville + Watson Gallery.

D from Seventeen Drawings, 1985. Mixed media on maple veneer. 18⅛ × 15⅜″. Collection Agnes Gund, New York.
Courtesy Baskerville + Watson Gallery.

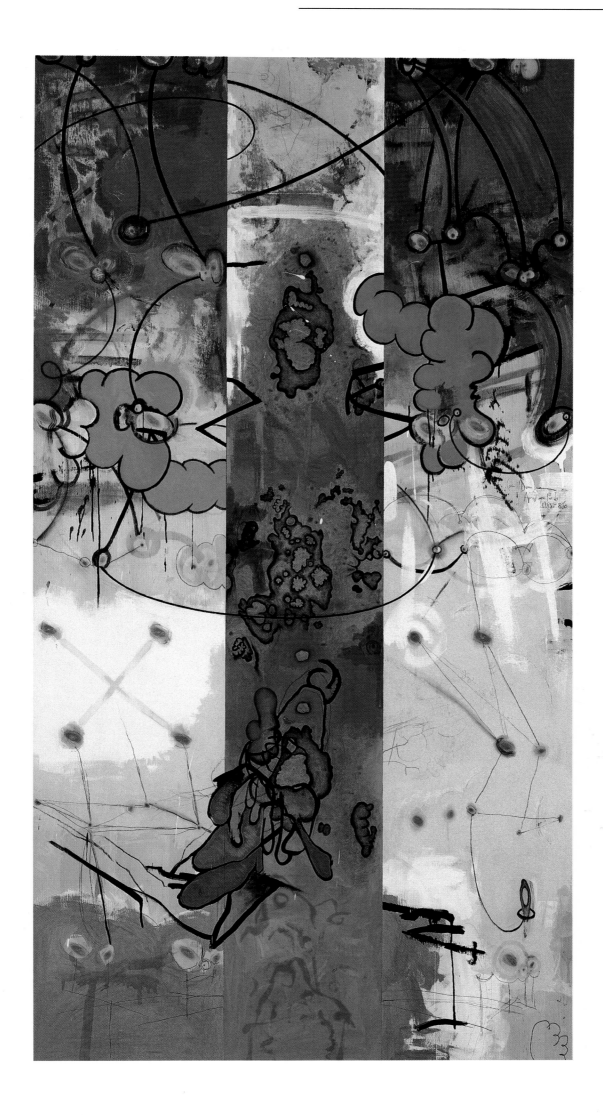

Pine Gap, 1985–86. Mixed media on wood veneer. 77 x 41″. Collection Whitney Museum of American Art, purchase with funds from Robert and Adrian Mnuchin. Courtesy Baskerville + Watson Gallery.

JEFF KOONS

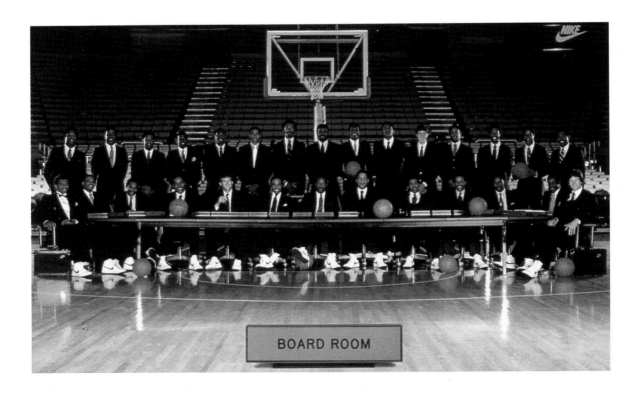

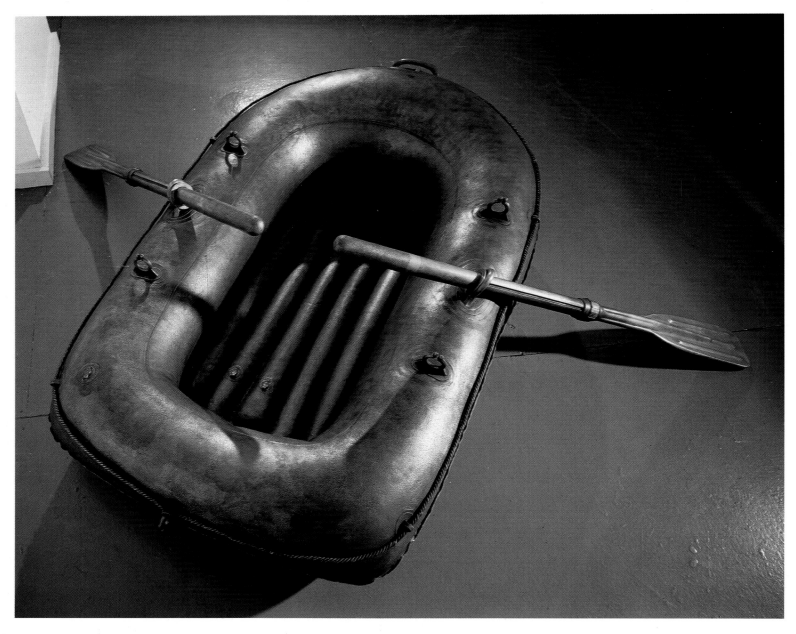

Board Room, 1985. Framed Nike poster. 30 x 40". Collection Chase Manhattan Bank, New York. Collection Estelle Schwartz, New York.
Courtesy International with Monument Gallery. *(top)*

The Boat, 1985. Bronze. Actual size. Collection Melvin Estrin, Washington, D.C. Collection Robert Kaye, New York.
Courtesy International with Monument Gallery.

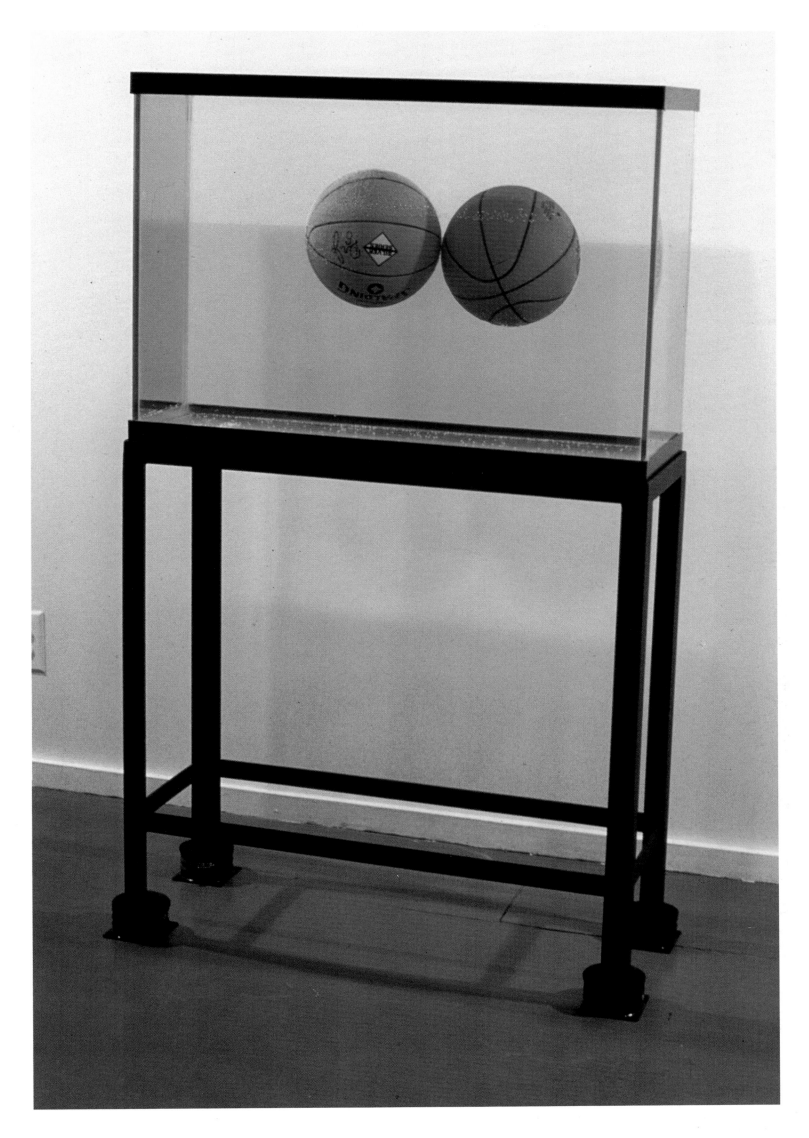

Two Ball Total Equilibrium, 1985. Glass, iron, water, and basketball. 62¾ × 36¾ × 13¼″. Collection Lois Plehn, New York. Collection Thea Westreich, Washington, D.C. Courtesy International with Monument Gallery.

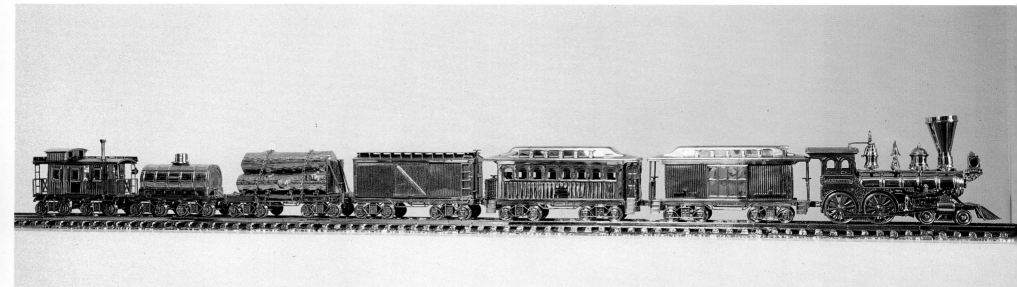

Jim Beam Train, J. B. Turner Model, 1986. Cast stainless steel, Jim Beam bourbon decanters with cast stainless steel train track. 9'6" long x 6½" wide x 11" high. Collection Robert and Adrian Mnuchin, New York. Saatchi Collection, London. Courtesy International with Monument Gallery.

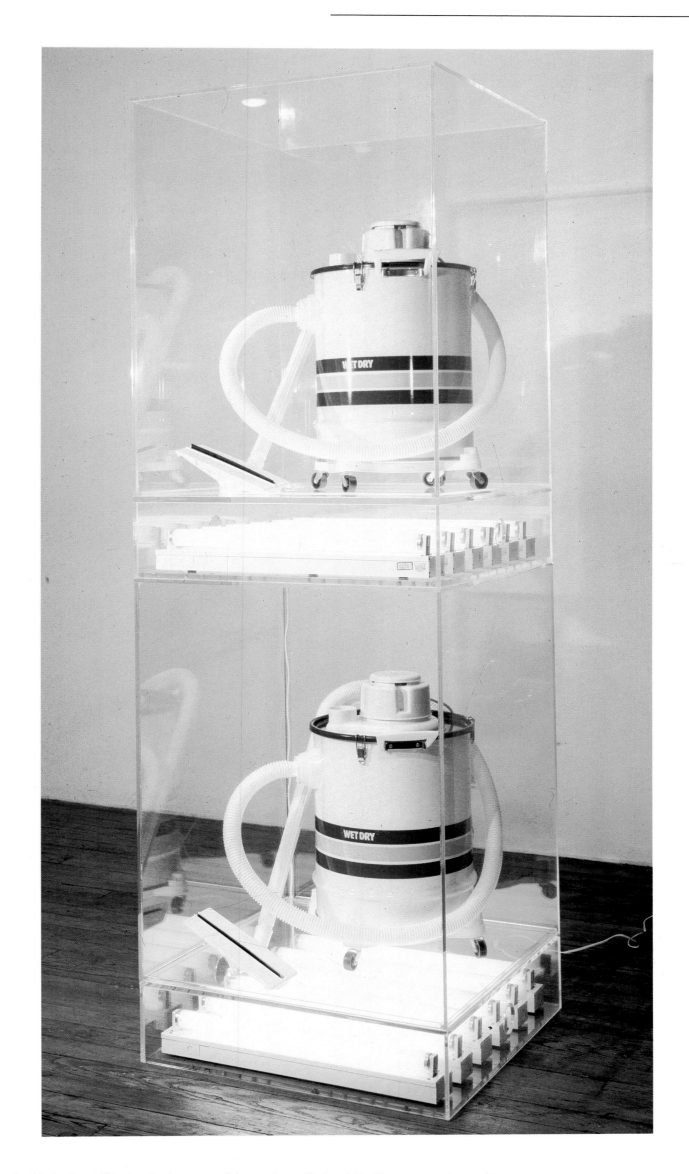

New Shelton Wet/Dry Double Decker, 1981. Acrylic, fluorescent lights, and two Shelton Wet/Dry vacuum cleaners. 82 × 28 × 28″. Collection Elaine Dannheisser, New York. Courtesy International with Monument Gallery.

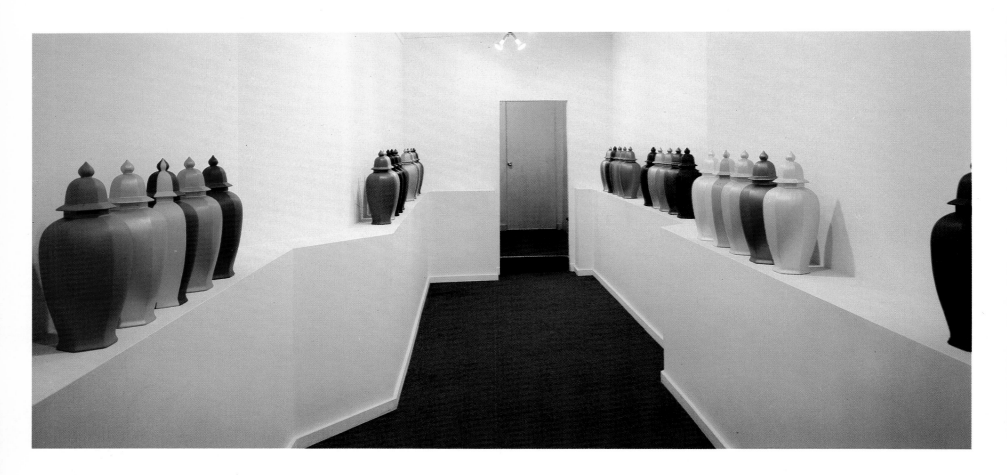

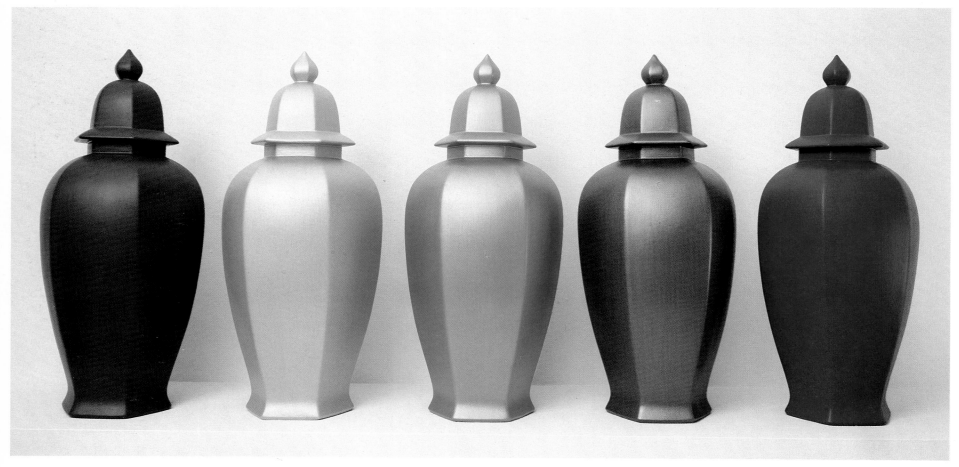

Perfect Vehicles, 1986. Enamel on solid cast hydrocal. Installation view at Cash/Newhouse Gallery. Courtesy Cash/Newhouse Gallery. *(top)*

Perfect Vehicles (#6), 1986. Enamel on solid cast hydrocal. Entire piece 19½ × 45 × 8". Collection Barbara and Eugene Schwartz, New York. Courtesy Cash/Newhouse Gallery.

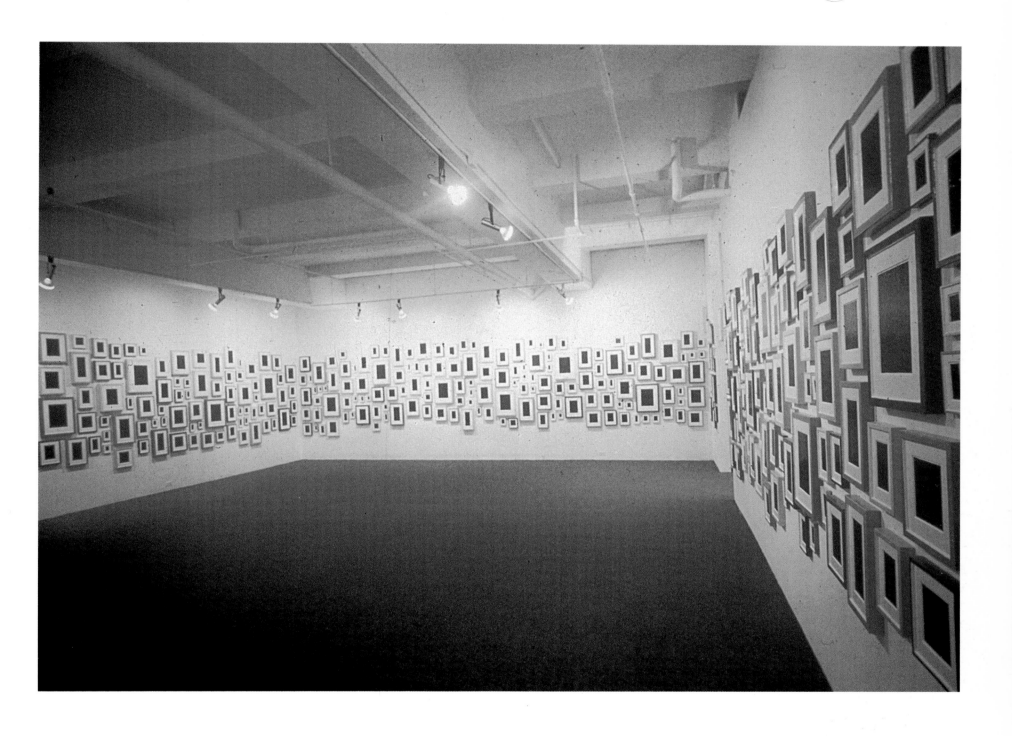

Plaster Surrogates, 1984. Enamel on hydrostone. Installation view at Marian Goodman Gallery. Courtesy Cash/Newhouse Gallery.

Cross, 1986. Laminated Cibachrome print with lacquer frame. 40 × 30″. Collection Marc and Livia Straus, New York.
Courtesy International with Monument Gallery. *(left)*

Bull, 1986. Laminated Cibachrome print with lacquer frame. 40 × 30″. Collection Liz Koury, New York. Courtesy International with Monument Gallery.

Birdwoman, 1986. Laminated Cibachrome print with lacquer frame. 40 × 30″. Collection Mel Kendrick and Mary Salter, New York.
Courtesy International with Monument Gallery. *(left)*

Virgin, 1986. Laminated Cibachrome print with lacquer frame. 40 × 30″. Collection Marc and Livia Straus, New York.
Courtesy International with Monument Gallery.

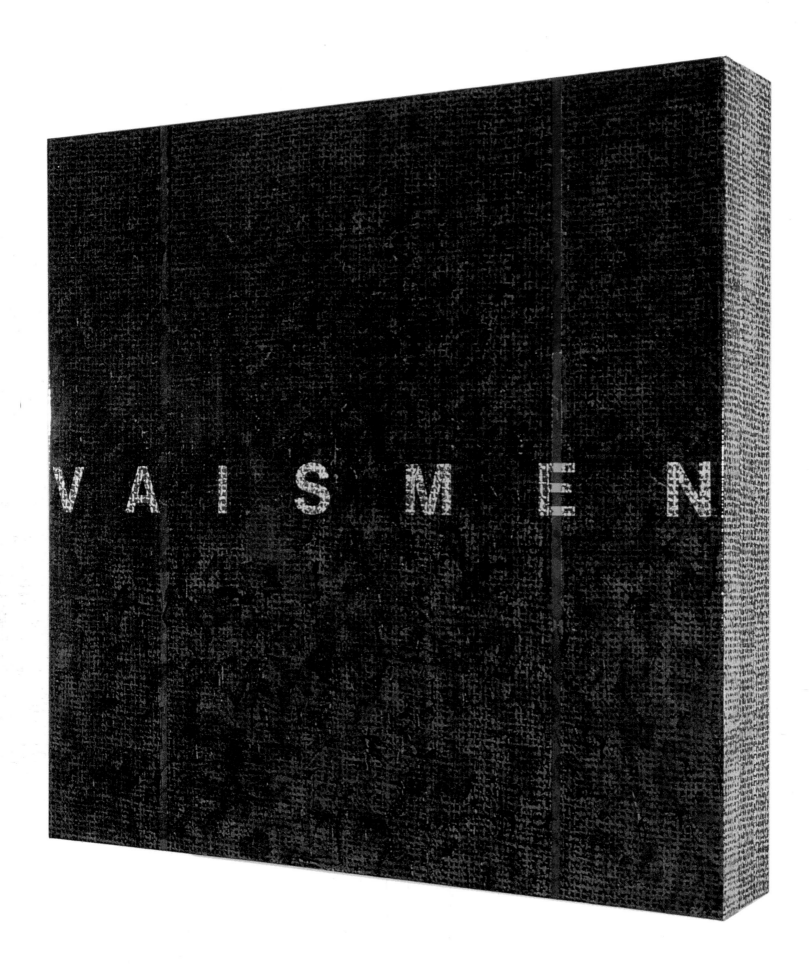

Vaismen, 1986. Laminated process inks on canvas. 61½ x 61½ x 11". Saatchi Collection, London. Courtesy Jay Gorney Gallery.

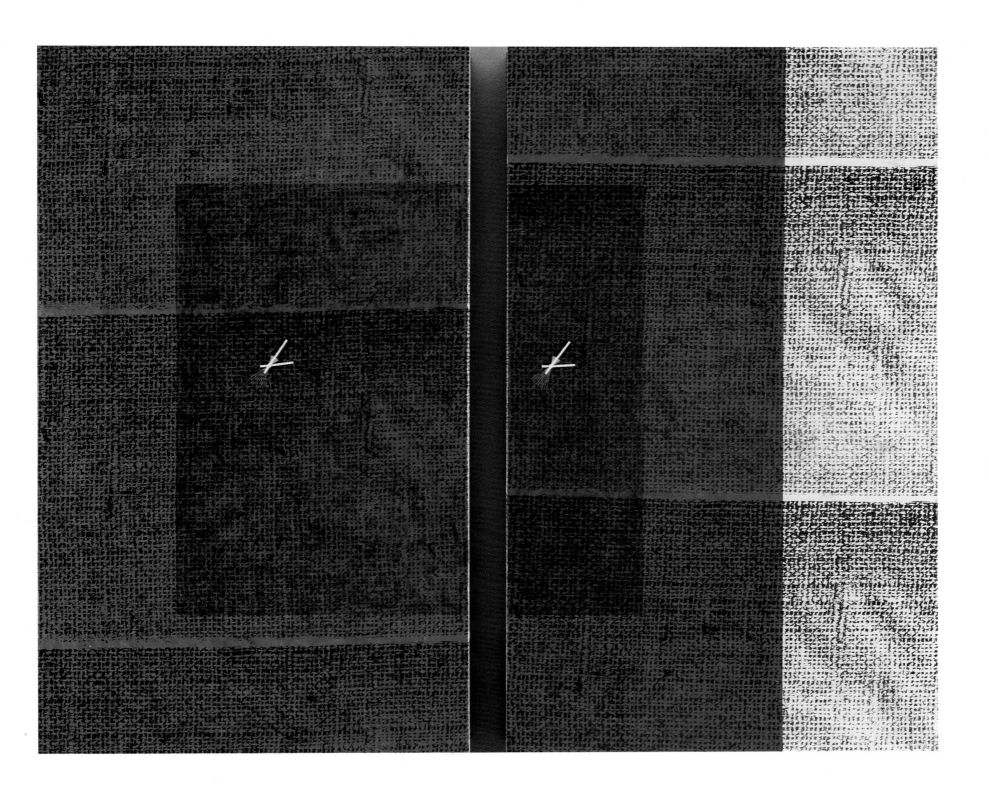

Live the Dream, 1986. Laminated process inks on canvas with backward-running clock. 76½ × 46½ × 7″ each. Saatchi Collection, London.
Courtesy Jay Gorney Gallery.

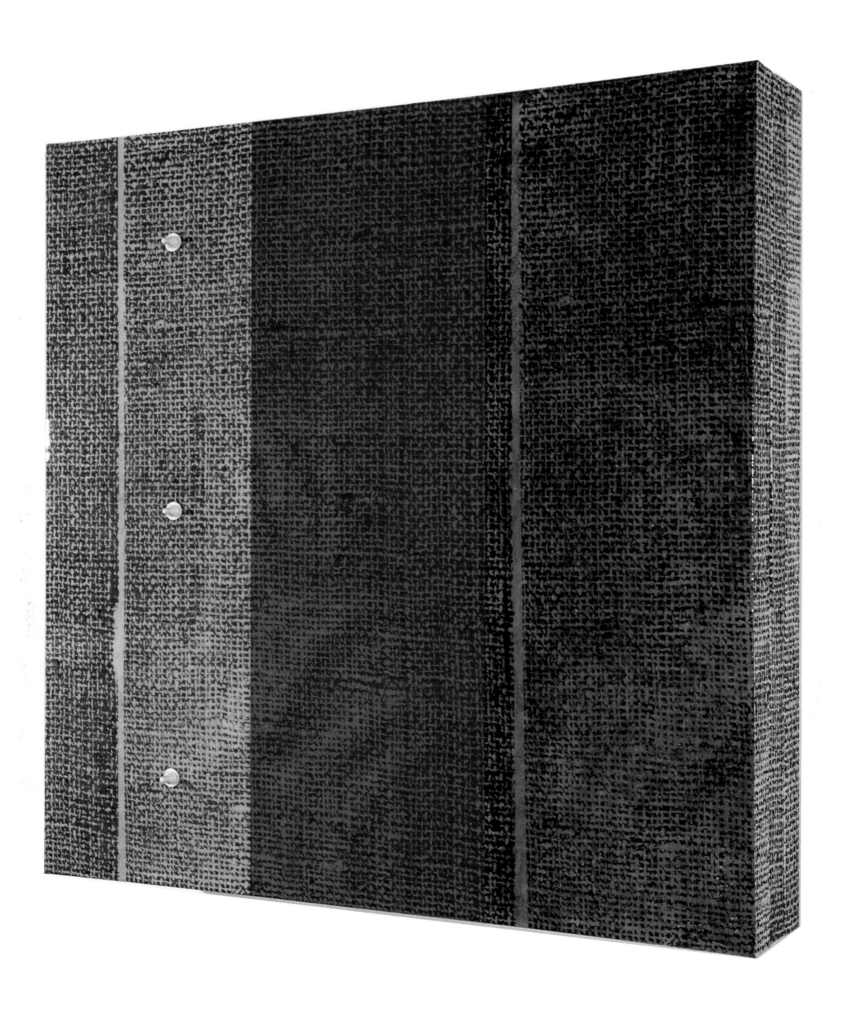

Great Painting with Nipples, 1986. Laminated process inks on canvas with rubber nipples. 61½ × 61½ × 11″. Collection Linda and Harry MacLowe, New York. Courtesy Jay Gorney Gallery.

Untitled *(What big muscles you have!)*, 1986. Photograph. 60 × 81¾". Collection Musée National d'Art Moderne, Centre Georges Pompidou, Paris.
Courtesy Annina Nosei Gallery.

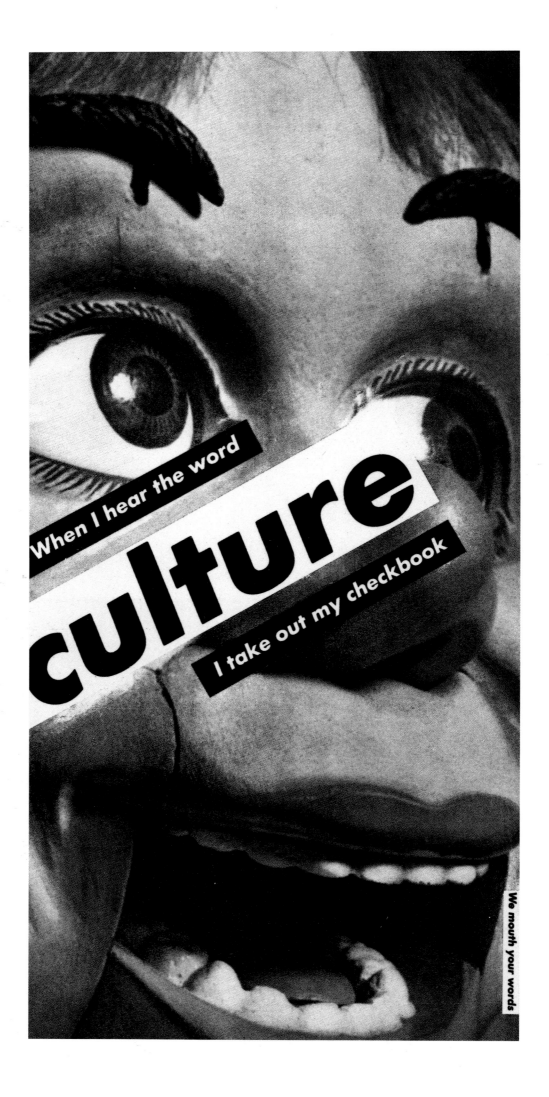

When I hear the word Culture I take out my checkbook, 1985. Photograph. 120 x 60″. Collection Veronica Pastel, New York.
Courtesy Annina Nosei Gallery.

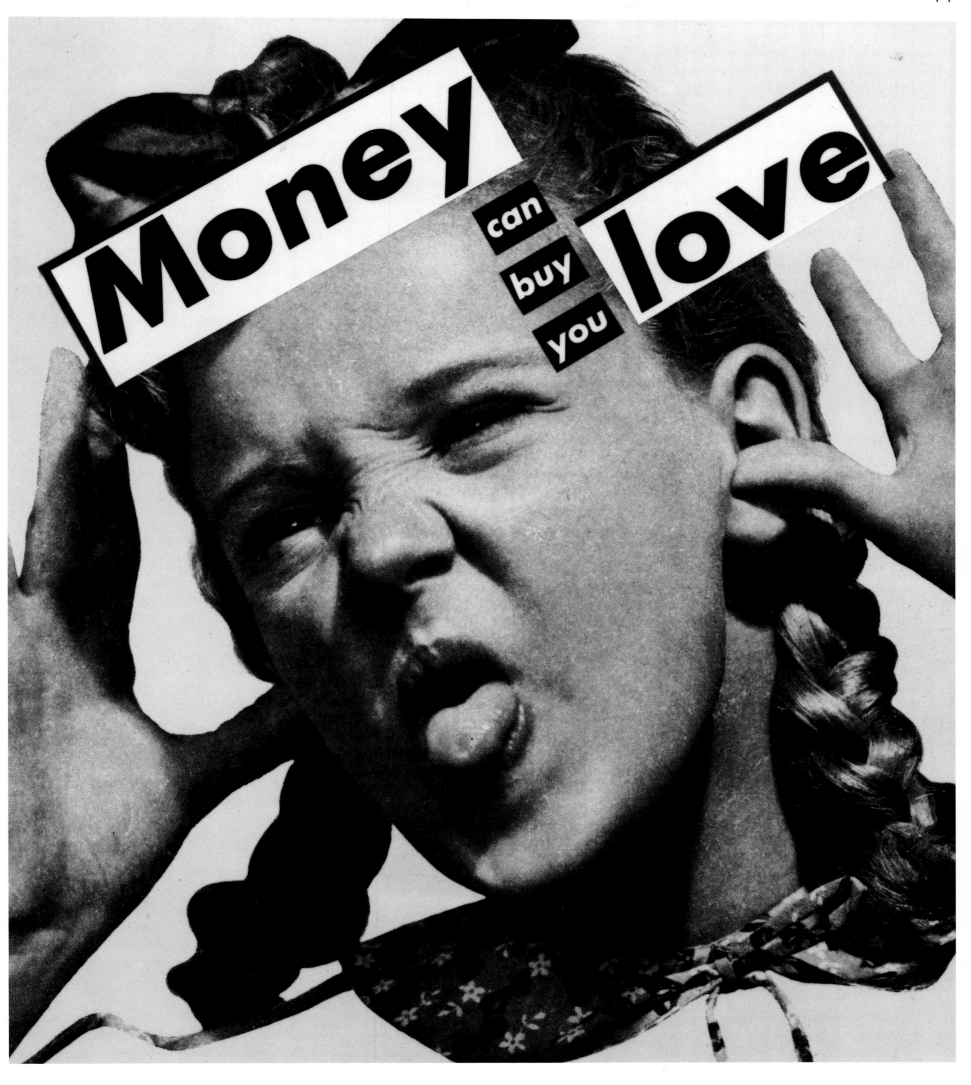

Untitled *(Money can buy you love)*, 1985. Photograph. 96 x 87″. Collection Dr. Marvin Mordes, Maryland. Courtesy Annina Nosei Gallery.

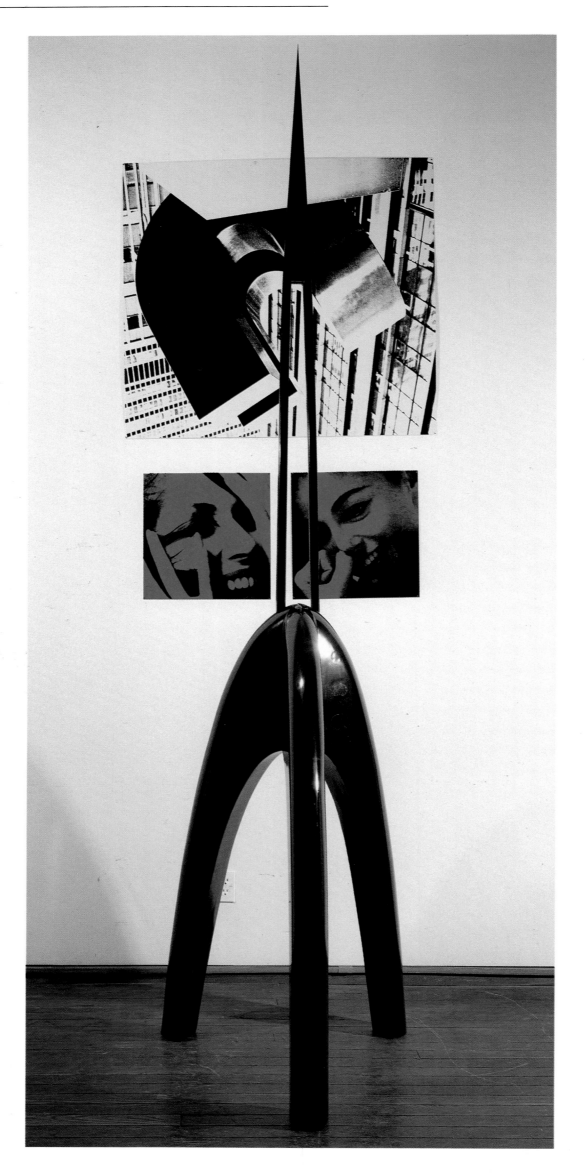

Untitled, 1981. Lacquered wood with silk screen on tin wall panels. 102 x 54 x 38″. Courtesy Nature Morte Gallery.

Total Recall, 1985. Steel, fluorescent lights, and film strip. 6′ x 6′. Courtesy Nature Morte Gallery. *(top)*
Total Recall (detail of film strip), 1985. Courtesy Nature Morte Gallery.

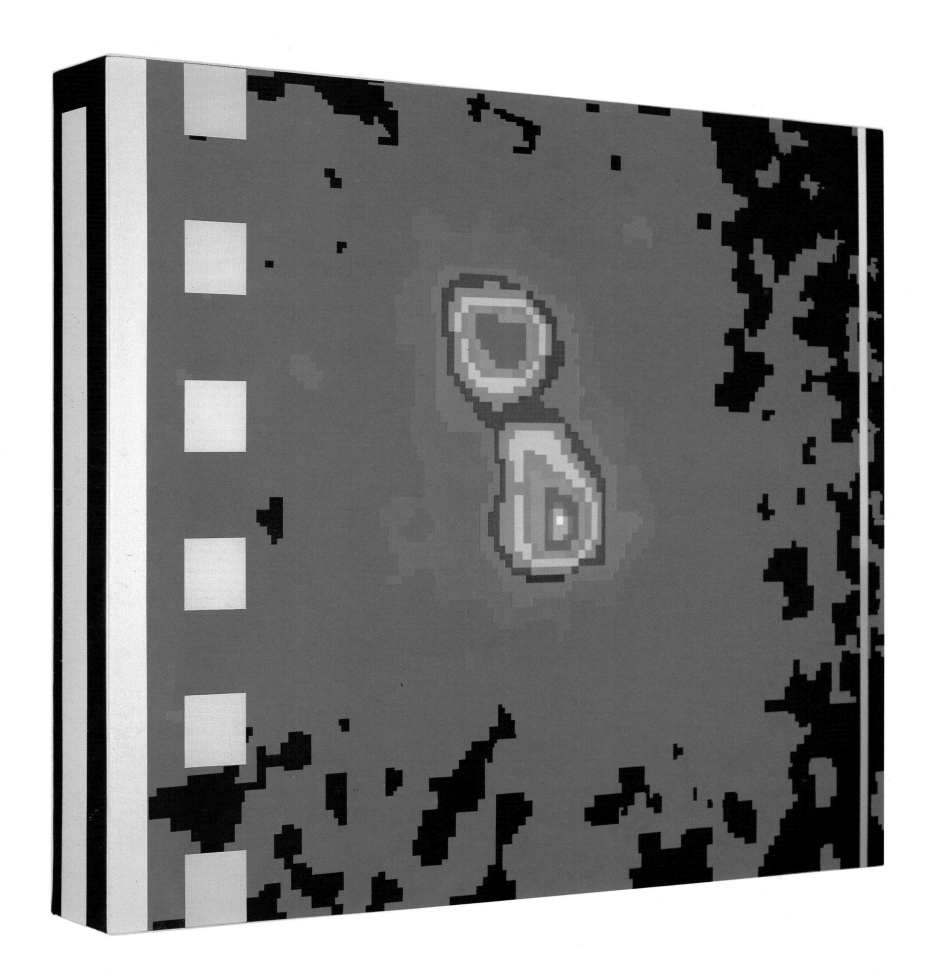

Untitled, 1986. Acrylic on canvas. 60 × 72 × 8″. Collection Dakis Joannou, Athens, Greece. Courtesy Josh Baer Gallery.

Untitled, 1986. Acrylic on canvas. 73 x 73 x 8″. Collection Raymond J. Learsy. Courtesy Josh Baer Gallery.

SHERRIE LEVINE

22

After Ilya Chasnick, 1984. Casein and wax on mahogany. 24 x 20″. Collection of the artist. Courtesy Baskerville + Watson Gallery.

*After Piet Mondrian,*1983. Watercolor. 14 x 11". Private collection. Courtesy Baskerville + Watson Gallery. *(top)*

After Fernand Léger, 1983. Watercolor. 14 x 11". Collection Terence McNally. Courtesy Baskerville + Watson Gallery.

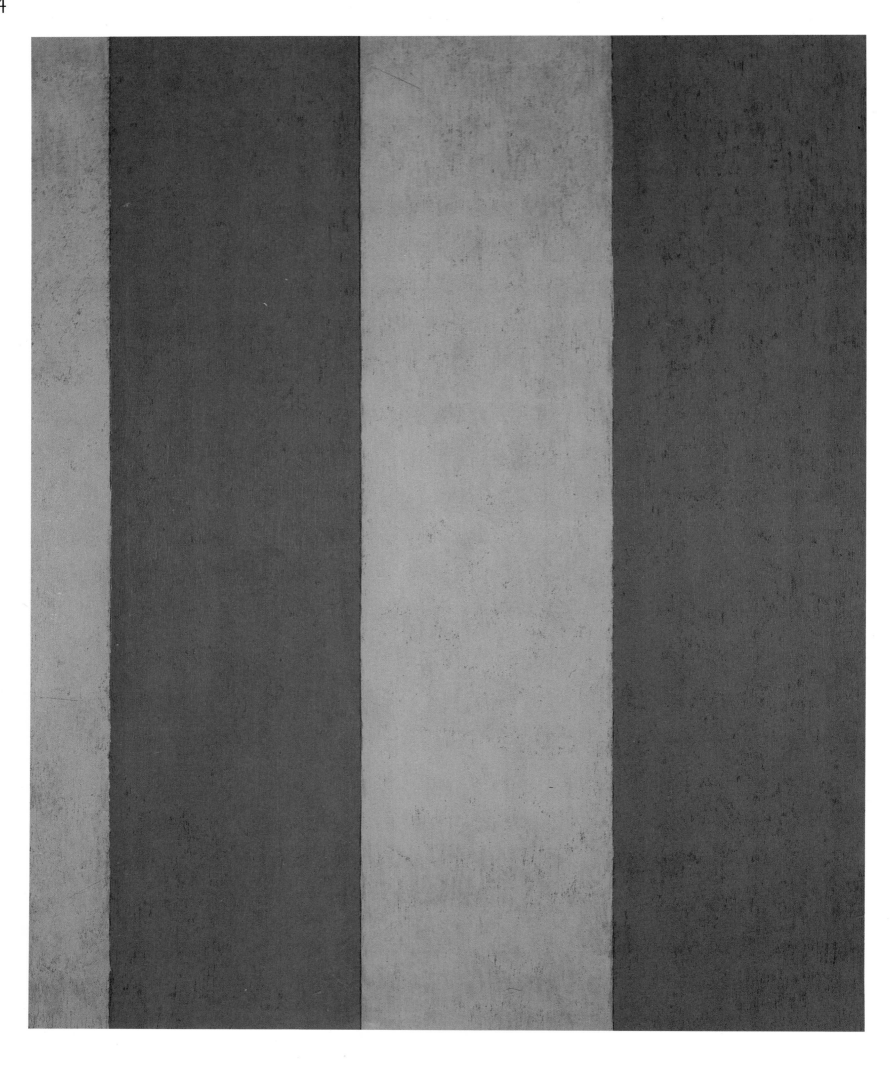

Broad Stripe #5, 1985. Casein and wax on mahogany. 24 x 20″. Collection Raymond J. Learsy, New York. Courtesy Baskerville + Watson Gallery.

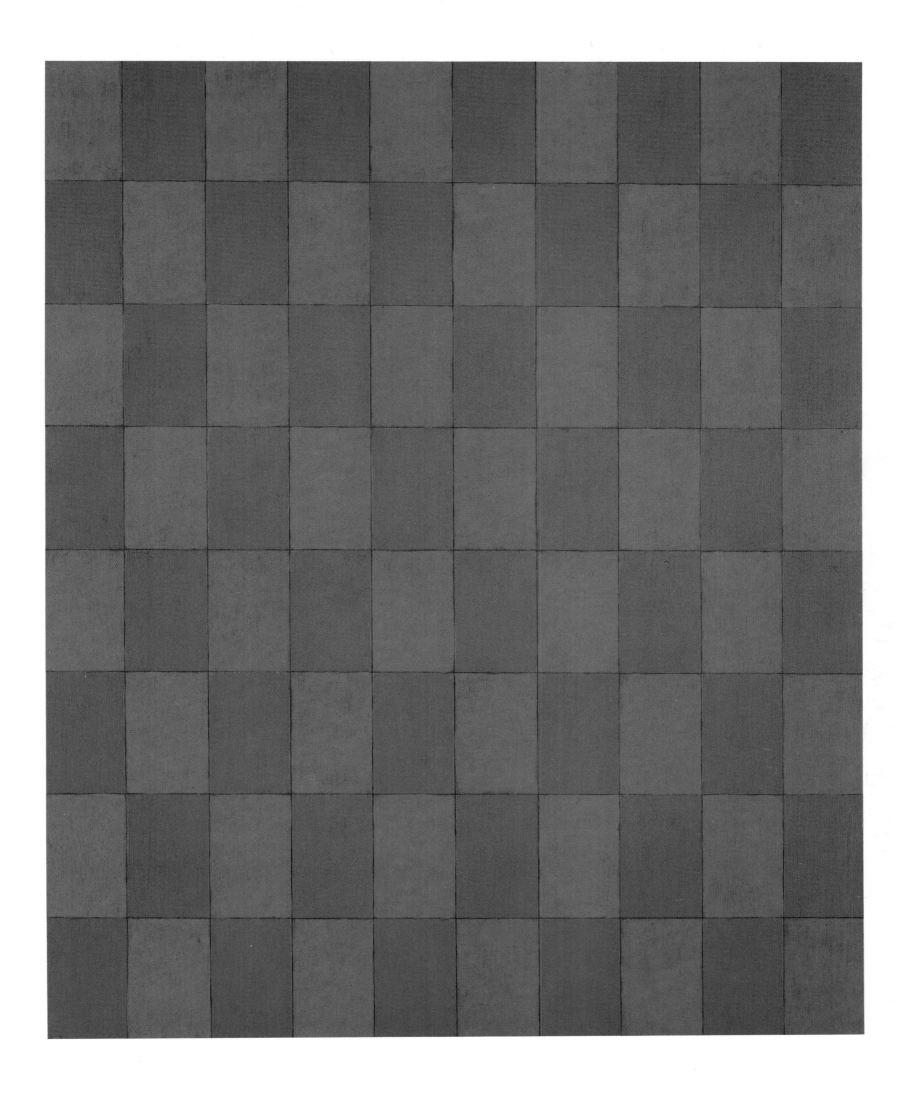

Check #8, 1986. Casein and wax on mahogany. 24 x 20″. Collection Bette Ziegler, New York. Courtesy Baskerville + Watson Gallery.

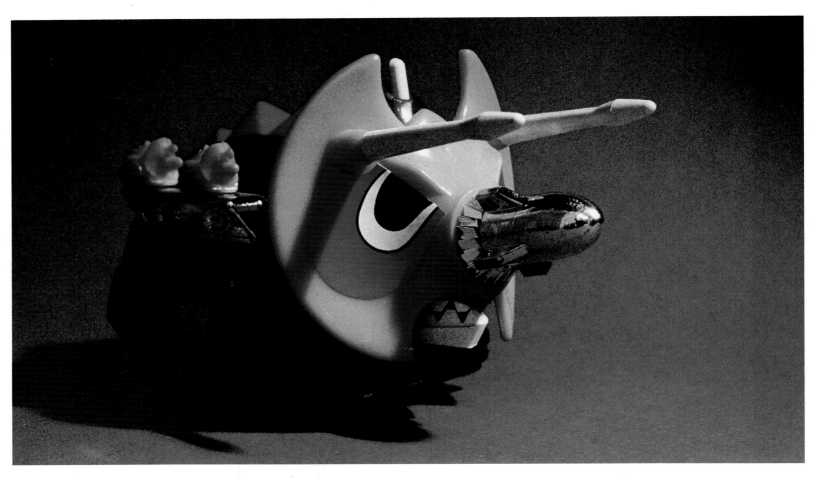

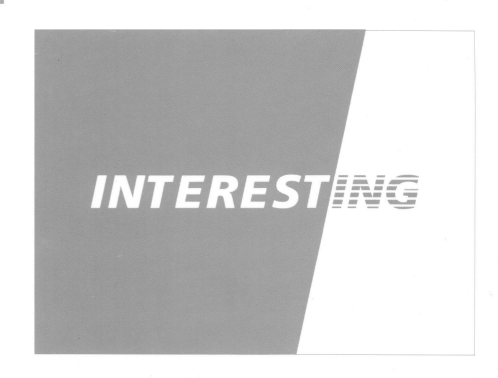

Gaiking Bazoler Portrait (royal), 1983. Cibachrome. 20 x 24″. Installed in *Interesting* exhibition, Nature Morte Gallery, May 1985. Courtesy Metro Pictures Gallery. *(top)*

Text on wall. Installed in *Interesting* exhibition, Nature Morte Gallery, May 1985. Courtesy Metro Pictures Gallery. *(left)*

Announcement, *Interesting* exhibition, Nature Morte Gallery, May 1985.

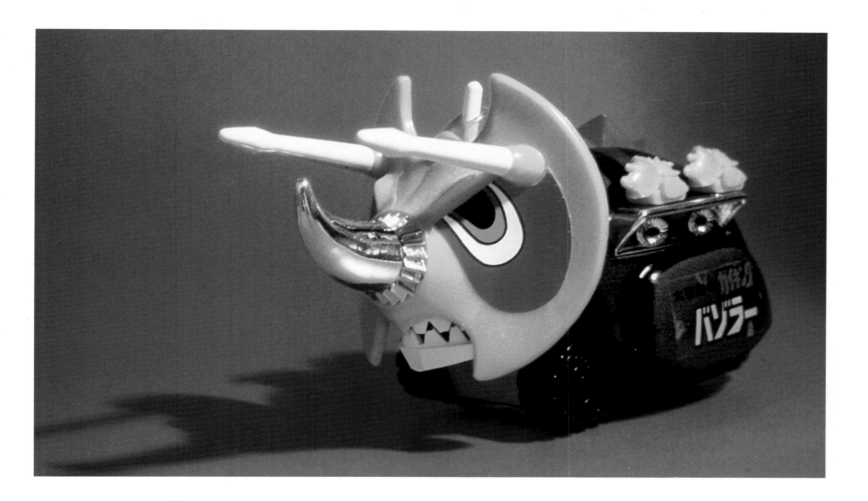

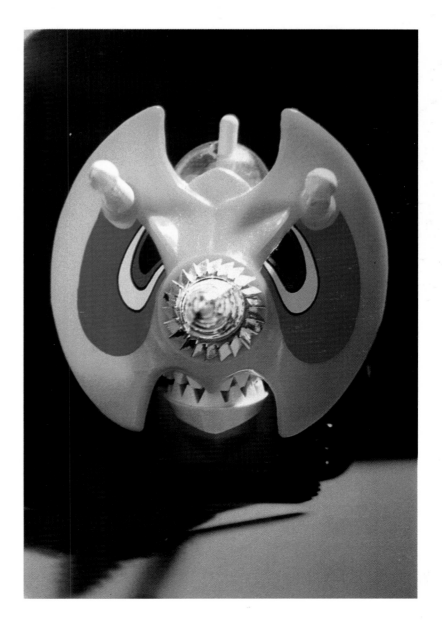

Gaiking Bazoler Portrait (cherry), 1983. Cibachrome. 20 x 24″. Installed in *Interesting* exhibition, Nature Morte Gallery, May 1985. Courtesy Metro Pictures Gallery. *(top)*

Gaiking Bazoler Portrait (kelly), 1983. Cibachrome. 24 x 20″. Installed in *Interesting* exhibition, Nature Morte Gallery, May 1985. Courtesy Metro Pictures Gallery.

See also the press release for the *Interesting* exhibition (page 124).

PETER HALLEY

Two Cells with Circulating Conduit, 1986. Acrylic, day-glo acrylic roll-a-tex on canvas. 64 x 104". Collection Susan and Richard Hatcherd.
Courtesy International with Monument Gallery.

Blue Cell with Triple Conduit, 1986. Acrylic, day-glo acrylic roll-a-tex on canvas. 77 x 77″. Collection Robert and Adrian Mnuchin, New York. Courtesy International with Monument Gallery. *(top)*

Glowing Cell with Conduits, 1985. Acrylic, day-glo acrylic roll-a-tex on canvas. 63 x 63″. Collection Estelle Schwartz, New York. Courtesy International with Monument Gallery.

Yellow Cell with Triple Conduit, 1986. Acrylic, day-glo acrylic roll-a-tex on canvas. 77 × 77". Collection Ellen and Dennis Schweber.
Courtesy International with Monument Gallery.

White Cell with Triple Conduit, 1986. Acrylic, day-glo acrylic roll-a-tex on canvas. 68 x 112". Collection Charles and Doris Saatchi, London.
Courtesy International with Monument Gallery.

Sign of Malignancy, 1985. Ink on gessoed canvas. 48 x 48″. Collection Frederick Roos, Sweden. Courtesy International with Monument Gallery. *(top left)*

Léger, 1986. Acrylic on canvas. 48 x 48″. Collection Margo Leavin Gallery, Los Angeles. Courtesy International with Monument Gallery. *(bottom left)*

EST Graduate, 1984. Xerox on canvas. 40 x 24″. Collection Michael Schwartz, New York. Courtesy International with Monument Gallery.

The 8-Hour Day, 1983. Black-and-white photocopy, unlimited edition. 11 x 8½". Courtesy International with Monument Gallery.

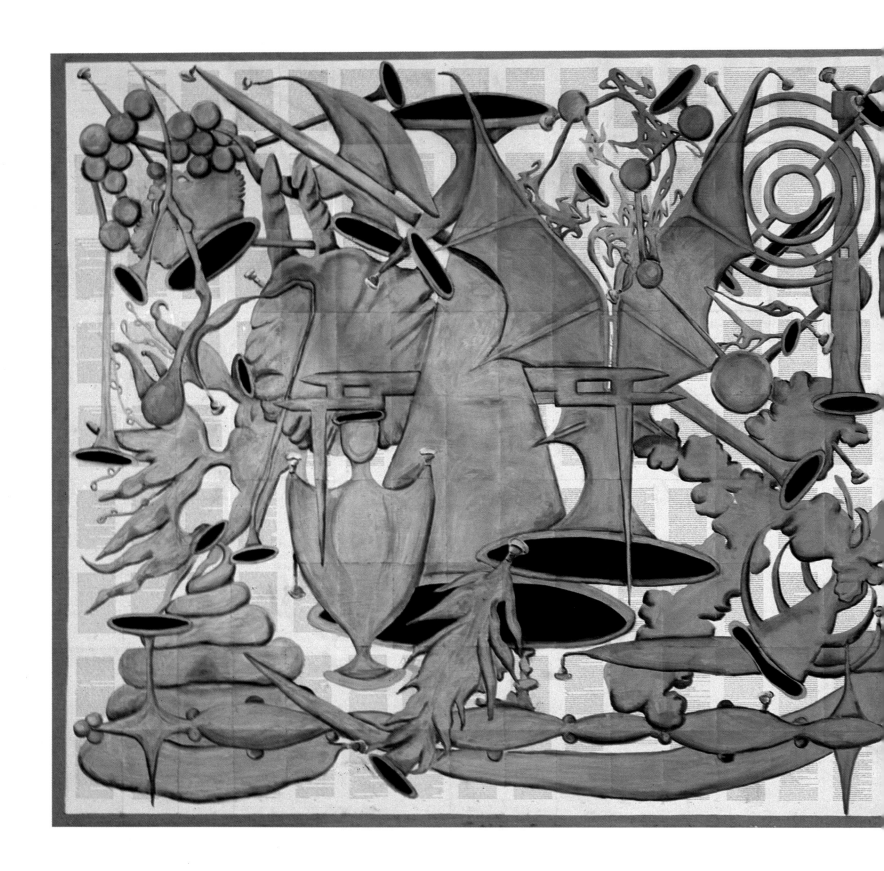

Amerika III, South Bronx, 1985–86. China marker on book pages on linen. 74 × 164". Collection Lawrence and Deborah Mangel, Philadelphia.
Courtesy Jay Gorney Gallery.

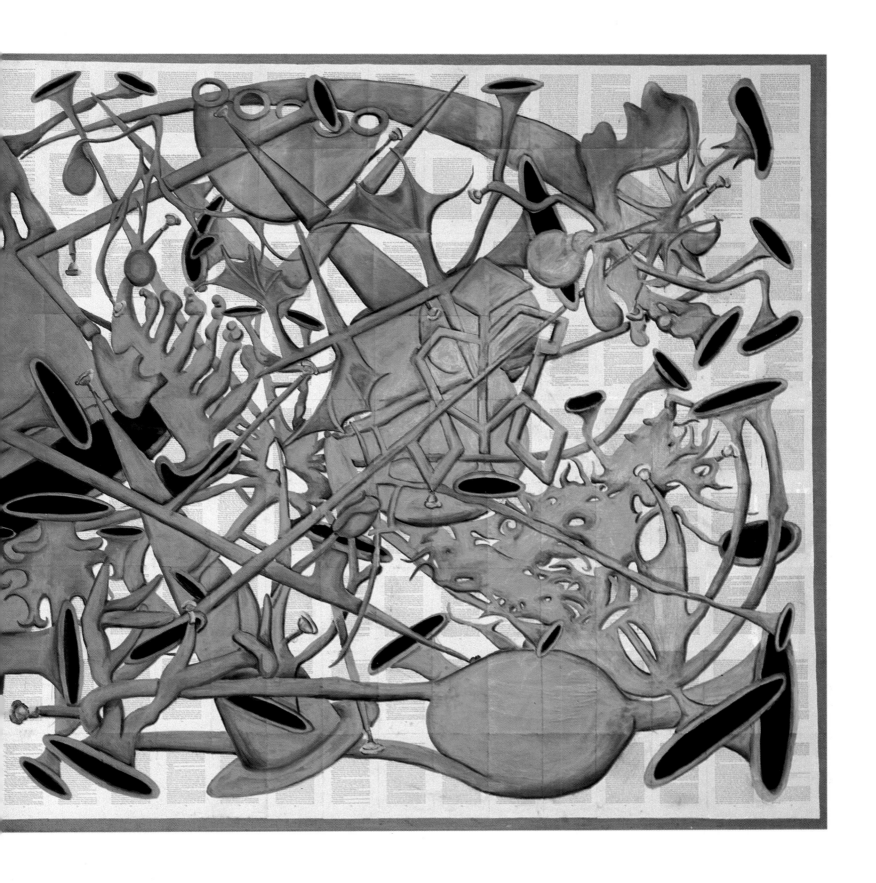

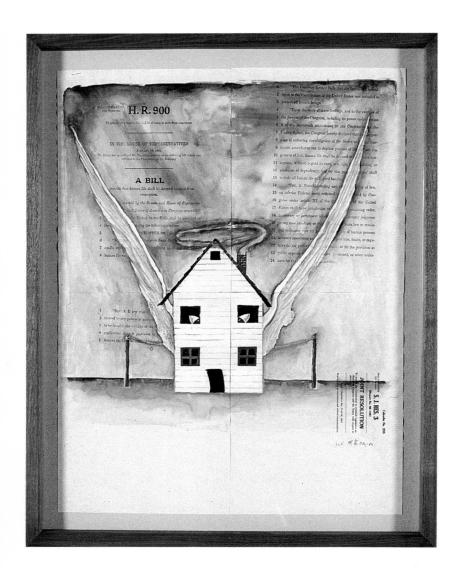

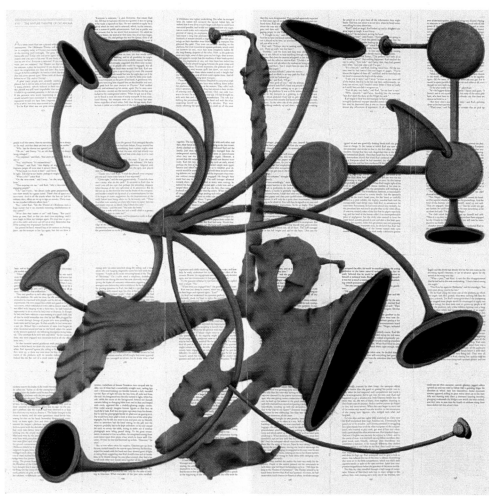

Four Paintings About Abortion: House of Angels, South Bronx, 1981–84.
(With Lissette Vargas.) Watercolor on antiabortion legislation. 22 × 17".
Courtesy Jay Gorney Gallery. *(top)*

The Nature Theatre of Oklahoma I, South Bronx, 1985–86.
Oil and china marker on book pages (Kafka's *Amerika*) on linen.
32 × 32". Courtesy Jay Gorney Gallery.

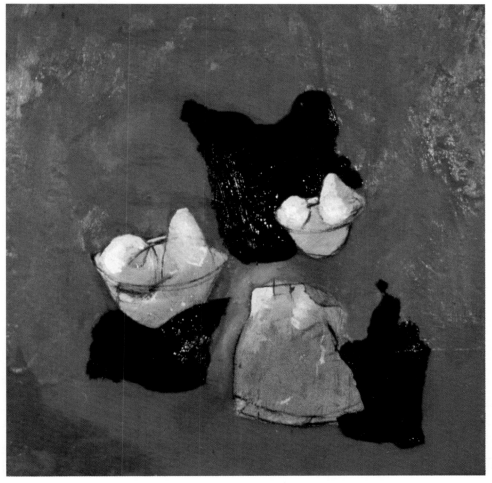

Yellow Figure, 1984. Oil on canvas. 20 x 16". Collection Rudolf Zwirner,
Cologne. Courtesy Nature Morte Gallery. *(top)*

Final Kiss, Last Goodbye, 1985. Oil on canvas. 12 x 12".
Collection Andrew Walker, Detroit. Courtesy Nature Morte Gallery.

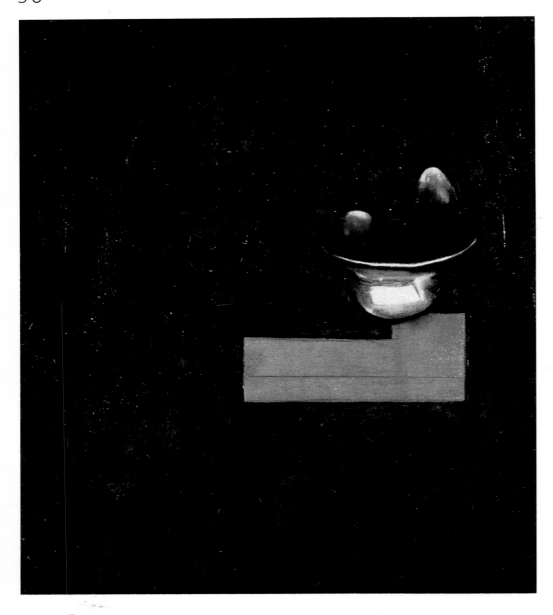

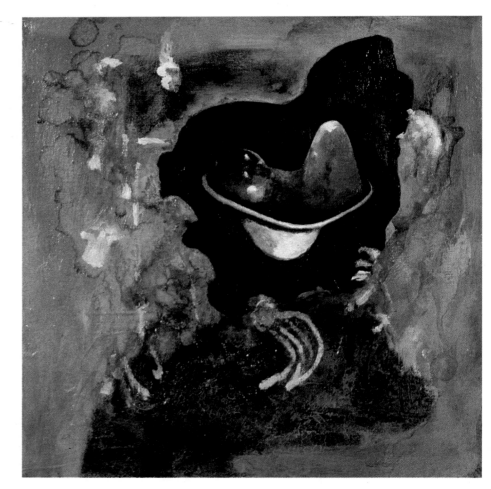

Division, 1986. Oil on canvas. 17 × 15″. Collection Leslie and Ron Rosenzweig, New Jersey. Courtesy Curt Marcus Gallery. *(top)*

Backwards Machine, 1985. Oil on canvas. 12 × 12″. Collection Andrew Walker, Detroit. Courtesy Nature Morte Gallery.

A View of Algiers from New Orleans, 1985. Oil on acrylic on masonite. 10 x 13¾". Collection Mr. and Mrs. Franklin Koningsberg, Los Angeles.
Courtesy Curt Marcus Gallery.

Brooklyn Seen from the East River Park, 1985. Oil on acrylic on board. 17¼ x 21¾". Collection The Solomon R. Guggenheim Museum, New York.
Courtesy Curt Marcus Gallery.

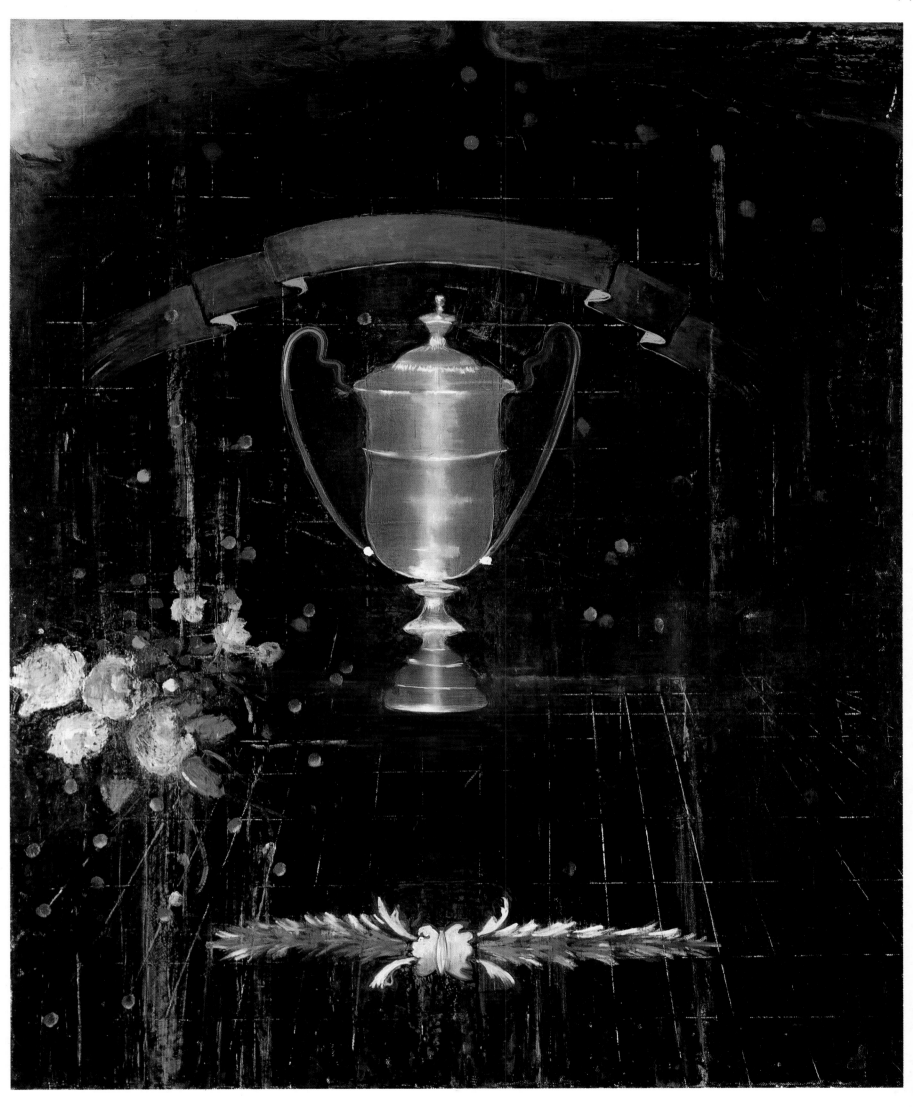

Memoriam, 1985. Oil on linen. 48 x 40". Collection George Katz. Courtesy Mary Boone Gallery.

Untitled, 1984. Oil on canvas. 26 × 38″. Private collection. Courtesy Mary Boone Gallery. *(top)*
Hummingbird, 1984. Oil on linen. 48 × 40″. Collection Elaine Dannheisser, New York. Courtesy Mary Boone Gallery.

Entrance, 1986. Oil on canvas. 9′ × 6′. Private collection. Courtesy Mary Boone Gallery.

44

Steel Curtain, 1986. Enamel on metal. 73½ × 48″. Collection Bud Bernstein, Chicago. Courtesy Cable Gallery. *(left)*
Ecstatic, 1986. Enamel on metal. 72 × 48″. Collection Donald Young, Chicago. Courtesy Cable Gallery.

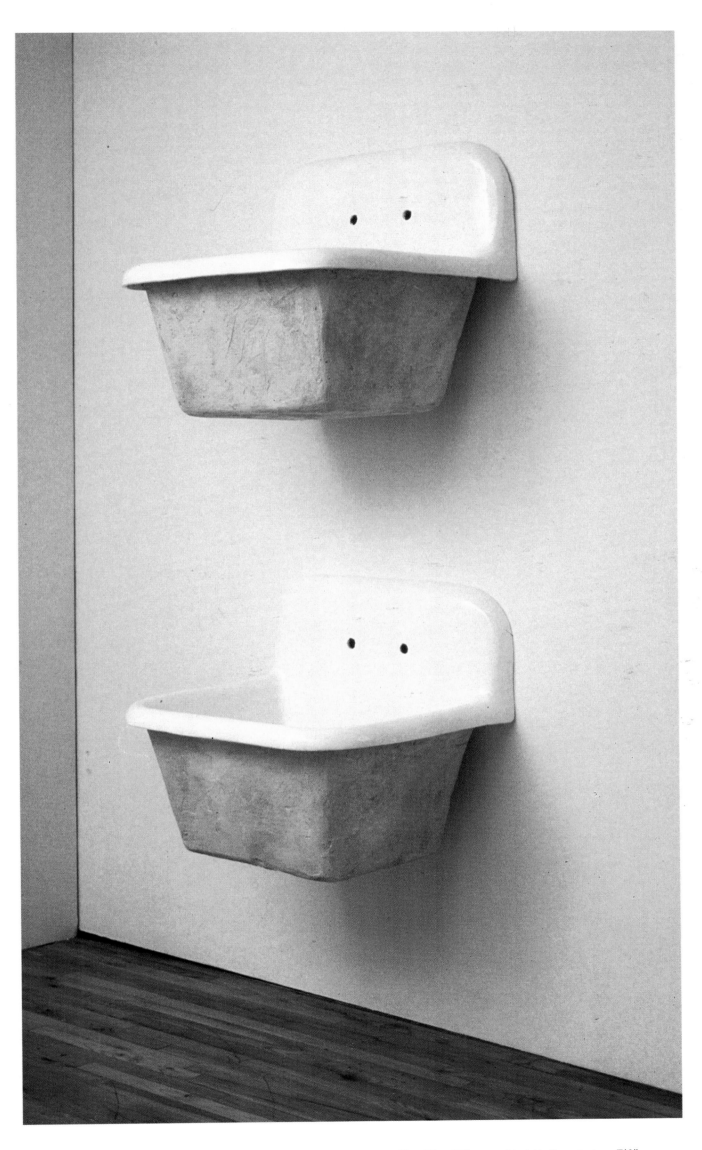

The Ascending Sink, 1985. Plaster, wood, steel, wire lath, and semigloss enamel paint. Each piece 30 × 33 × 27″; overall height, floor to top, 7′8″.
Collection Thea Westreich, Washington, D.C. Courtesy Paula Cooper Gallery.

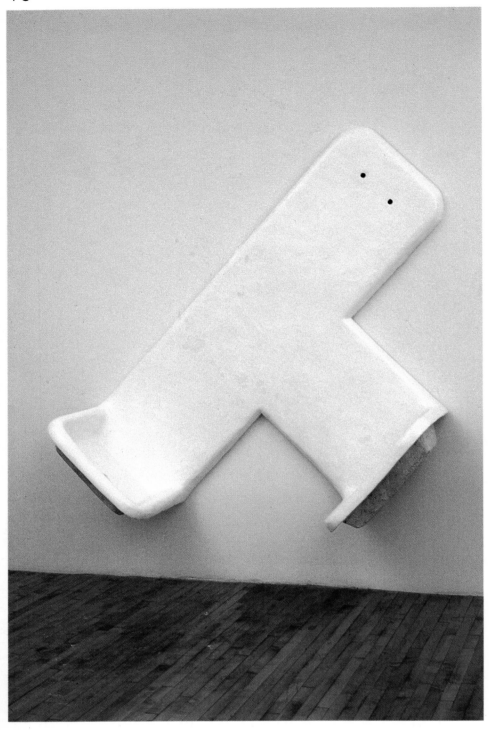

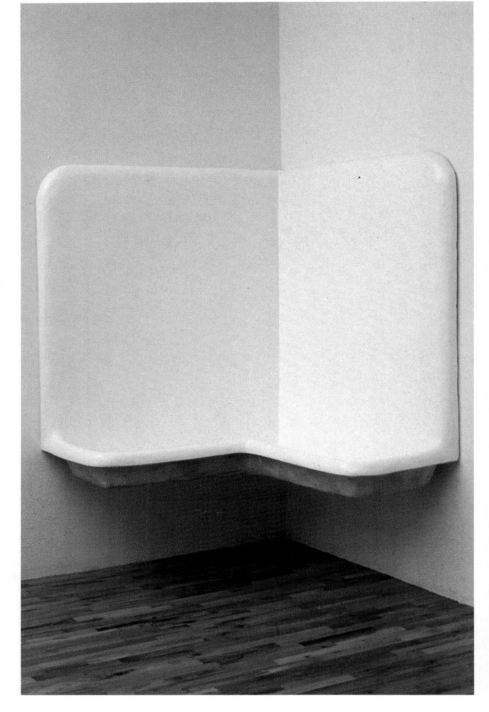

The Split-Up Conflicted Sink, 1985. Plaster, wood, steel, wire lath, and semigloss enamel paint.
81 x 81½ x 25". Collection Gregory Clark, New York.
Courtesy Paula Cooper Gallery. *(left)*.

The Scary Sink, 1985. Plaster, wood, steel, wire lath, and semigloss enamel paint.
60 x 78 x 55". Collection Edward R. Downe, New York.
Courtesy Paula Cooper Gallery.

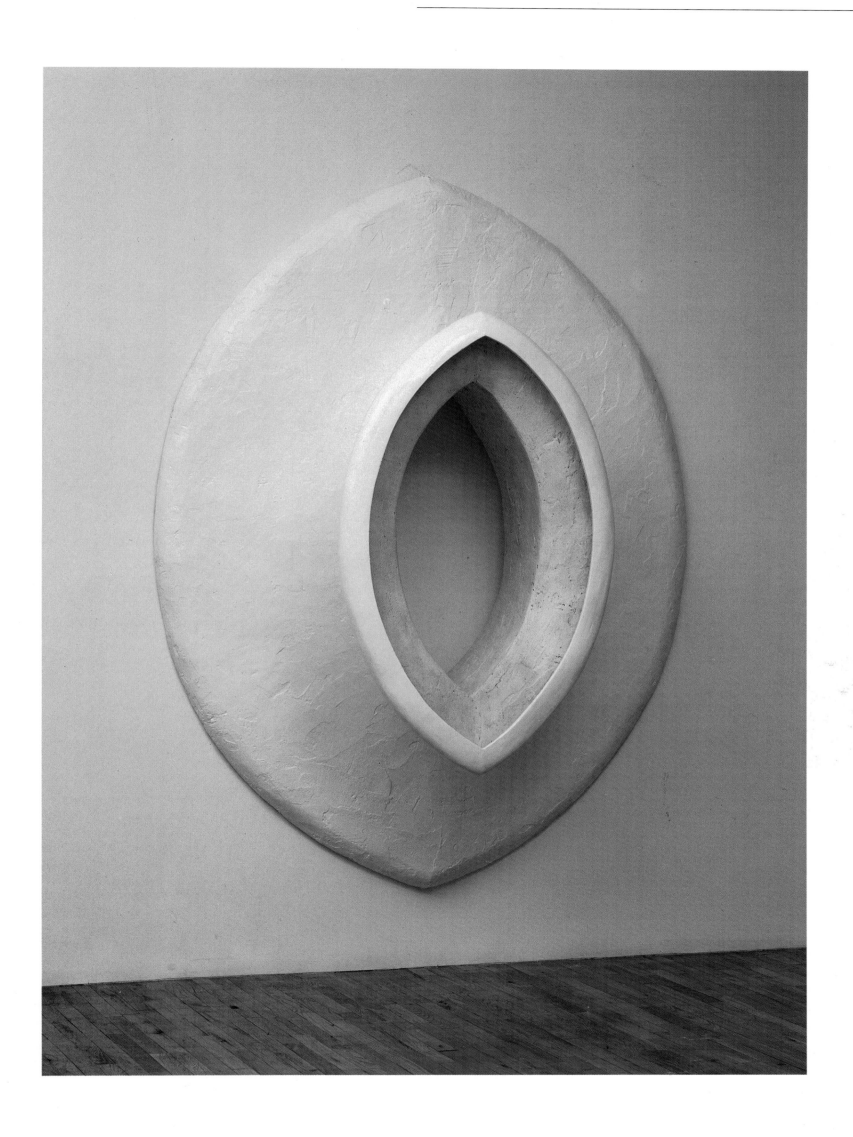

Two Bent Sinks, 1985. Plaster, wood, steel, wire lath, semigloss enamel paint, and latex paint. 96¼ × 75 × 26". Saatchi Collection, London.
Courtesy Paula Cooper Gallery.

JOEL OTTERSON

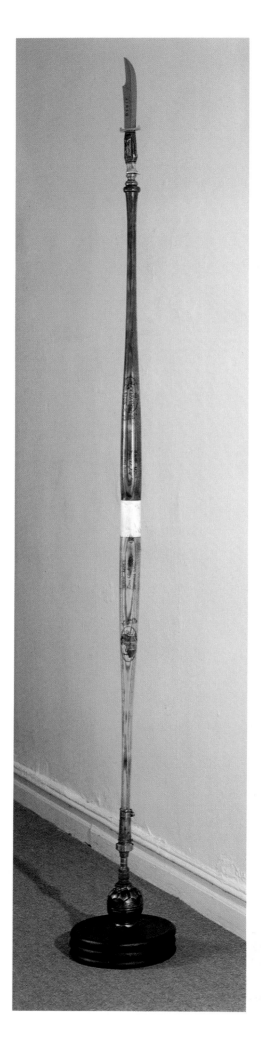

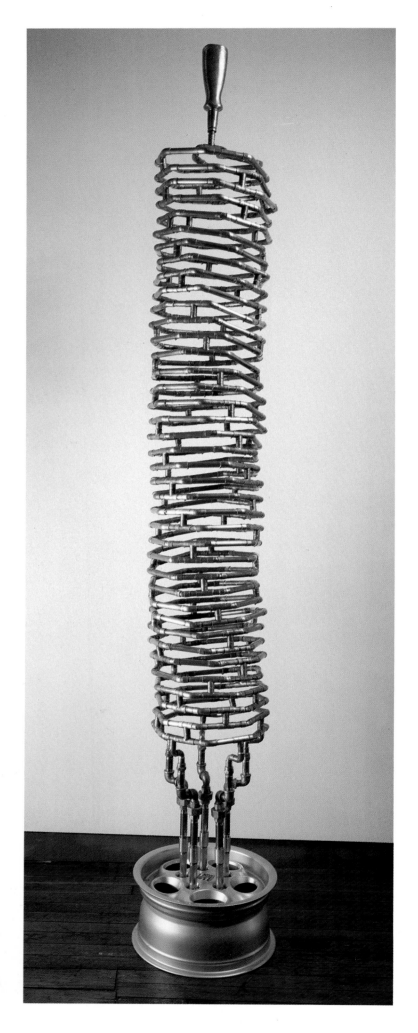

Fetish Perfect, 1986. Wood, steel, brass, iron, and copper. 99 x 11 x 11". Private collection. Courtesy Nature Morte Gallery. *(left)*

Designer Nucleic Acid, 1986. Copper, steel, magnesium, and bronze. 9'3" x 16" x 16". Collection Emily and Jerry Spiegel, Kingspoint, New York. Courtesy Nature Morte Gallery.

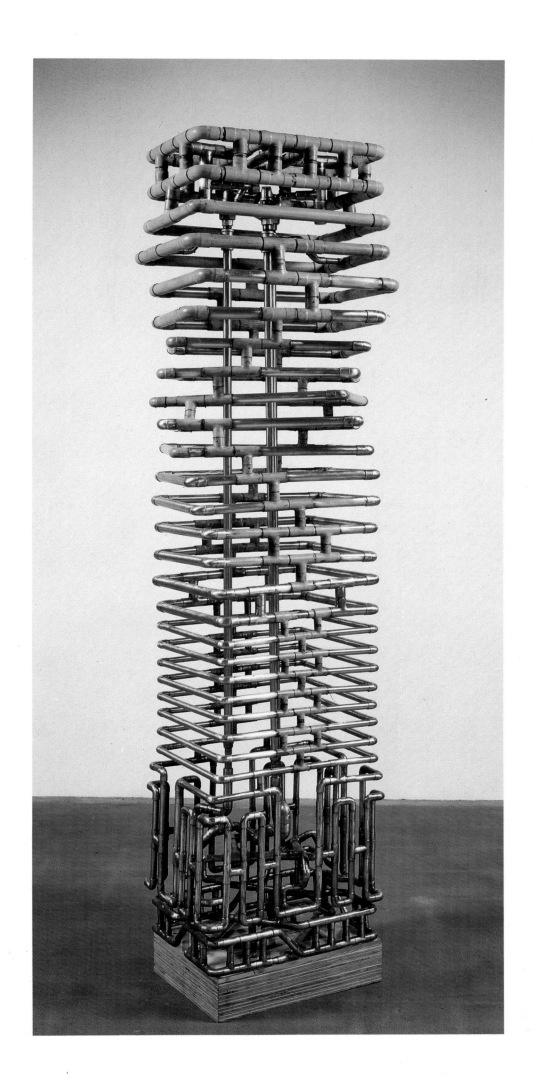

Scientifiquèment Vivant, 1985. Copper, brass, wood, plastic, and Cibachrome photograph. 81 × 19 × 15". Collection Margo Leavin, Los Angeles.
Courtesy Nature Morte Gallery.

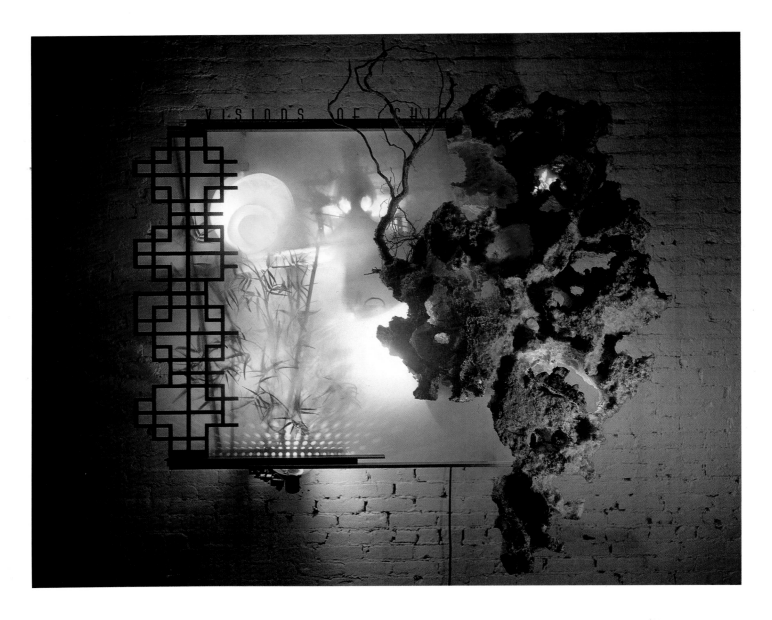

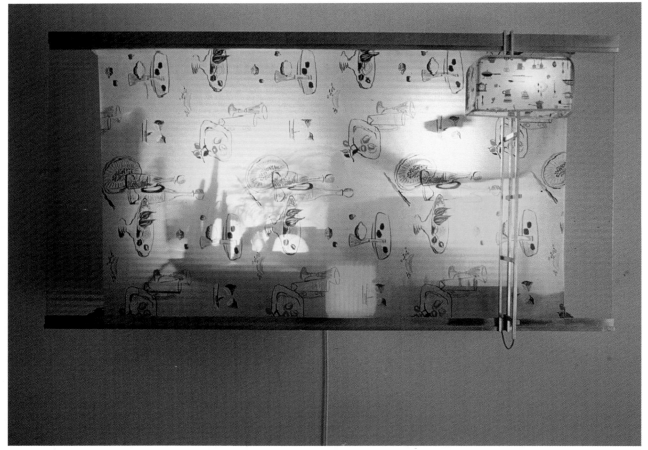

Visions of China, 1984. Mixed-media construction with lights and motors. 70 × 80 × 20". Collection of the artist.
Courtesy Luhring, Augustine, & Hodes Gallery. *(top)*

Blues and the Abstract Truth, 1985. Mixed-media construction with lights, motors, and digital computer. 37 × 70 × 31". Collection Eli Broad Family
Foundation, Los Angeles. Courtesy Luhring, Augustine, & Hodes Gallery.

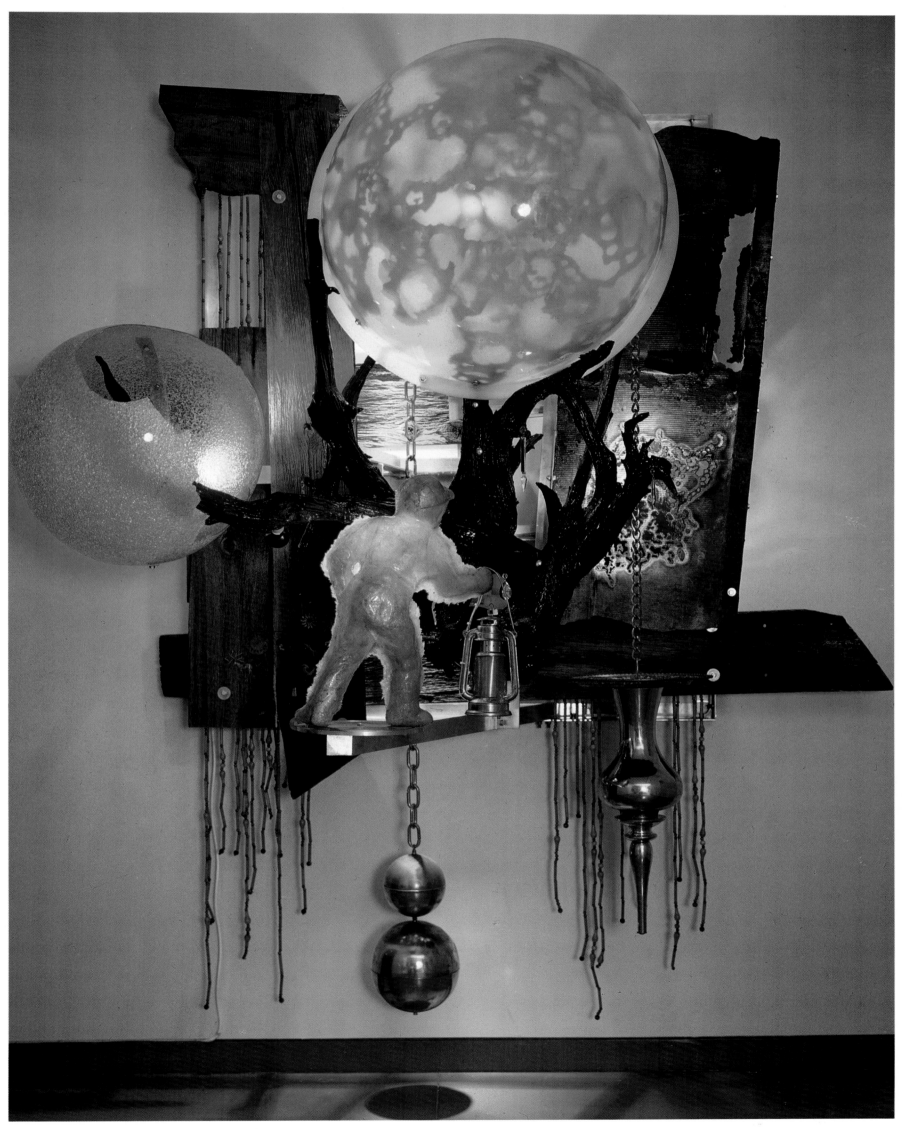

S.W.A.M.P., 1985. Mixed-media construction with lights, motors, and digital computer. 105 x 110 x 47". Collection Frederick R. Weisman Foundation of Art, Los Angeles. Courtesy Luhring, Augustine, & Hodes Gallery.

set off, 1986. Mixed-media construction. 25 x 77 x 13½". Collection Bette Ziegler, New York. Courtesy Jay Gorney Gallery. *(top)*
supremely black, 1985. Mixed-media construction. 29 x 66 x 13". Collection Eddo A. Bult, New York. Courtesy Jay Gorney Gallery.

vinyl that already looks wet #1, 1986. Mixed-media construction. 49½ x 77 x 19". Collection Los Angeles County Museum of Art. Courtesy Jay Gorney Gallery.

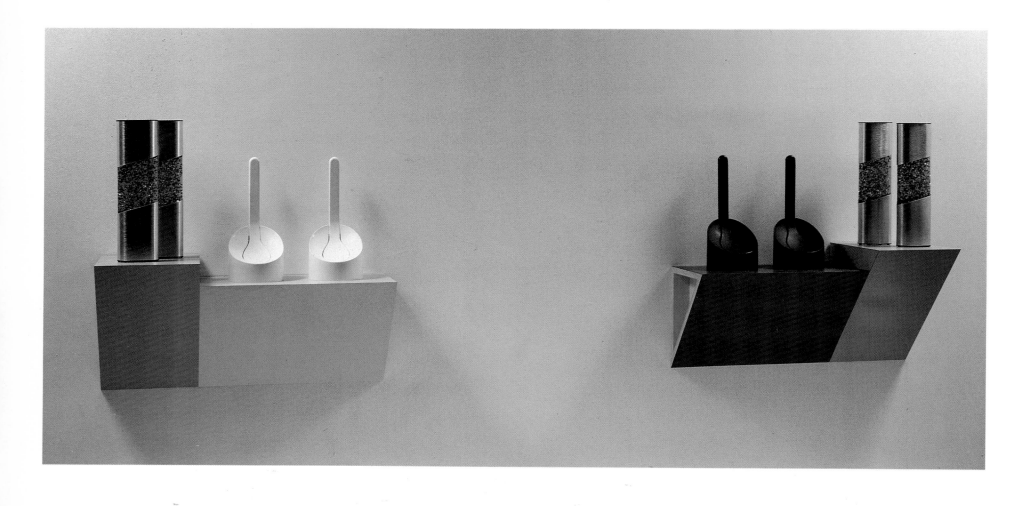

security and serenity, 1986. Mixed-media construction. Two units, 30 x 31 x 13" each. Collection Arthur and Carol Goldberg, New York.
Courtesy Jay Gorney Gallery.

Index, 1986. Oil on canvas. 22 x 30". Private collection, London. Courtesy Josh Baer Gallery. *(top)*
Schizotypal, 1986. Oil on canvas. 22 x 30". Collection Warren and Barbara Phillips, New York. Courtesy Josh Baer Gallery.

Spring—1972, 1986. Oil on canvas. 48 x 60″. Courtesy Massimo Audiello Gallery. *(top left)*
Winter—1972, 1986. Oil on canvas. 48 x 60″. Courtesy Massimo Audiello Gallery. *(top right)*
Summer—1972, 1986. Oil on canvas. 48 x 60″. Courtesy Massimo Audiello Gallery. *(bottom left)*
Fall—1972, 1986. Oil on canvas. 48 x 60″. Courtesy Massimo Audiello Gallery.

Twentieth Century Time Map—1972, 1986. Oil on canvas. 108 x 72″. Courtesy Massimo Audiello Gallery.

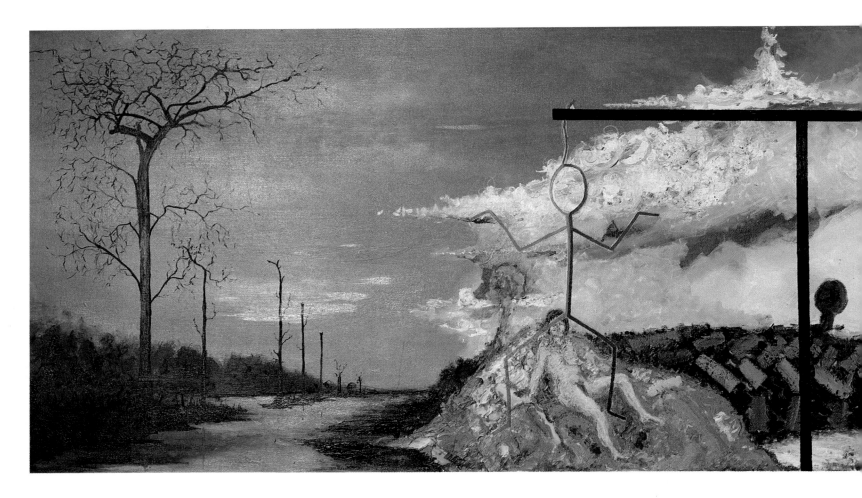

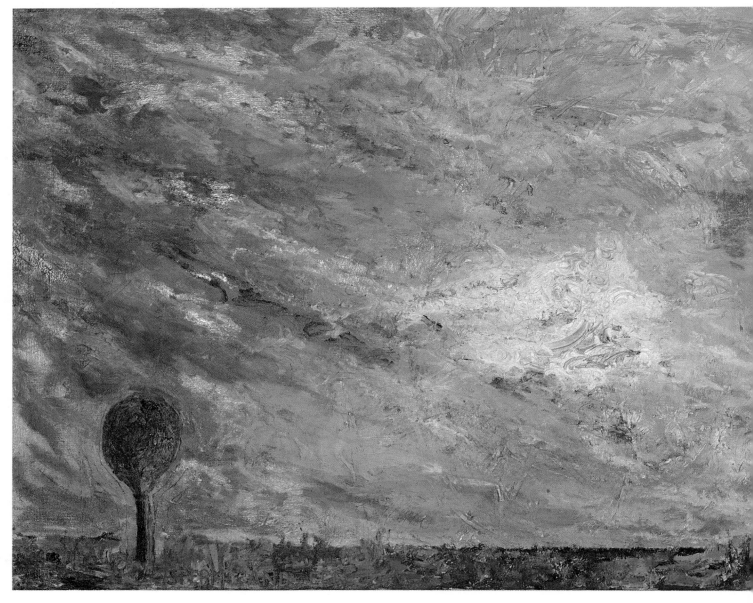

Two Continents Connected by Phone, or I've heard it said, or somewhere read, all things living may soon be dead, 1984. Oil on canvas. Private collection.
Courtesy of the artist. *(top)*

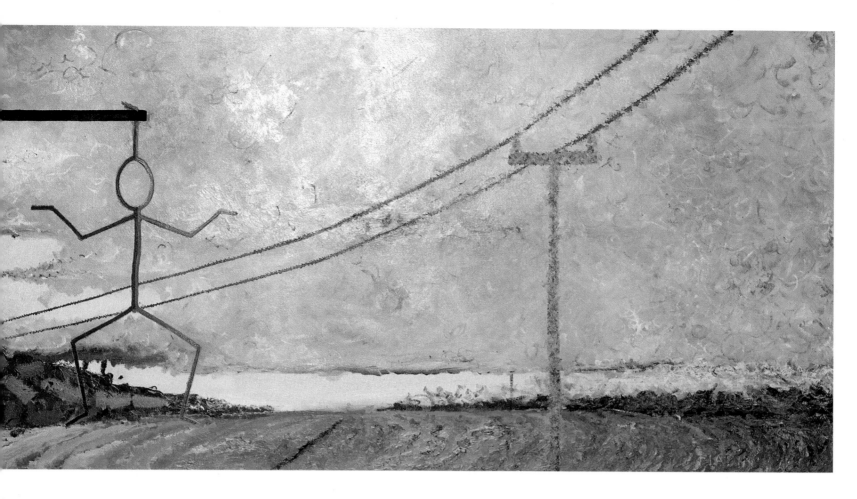

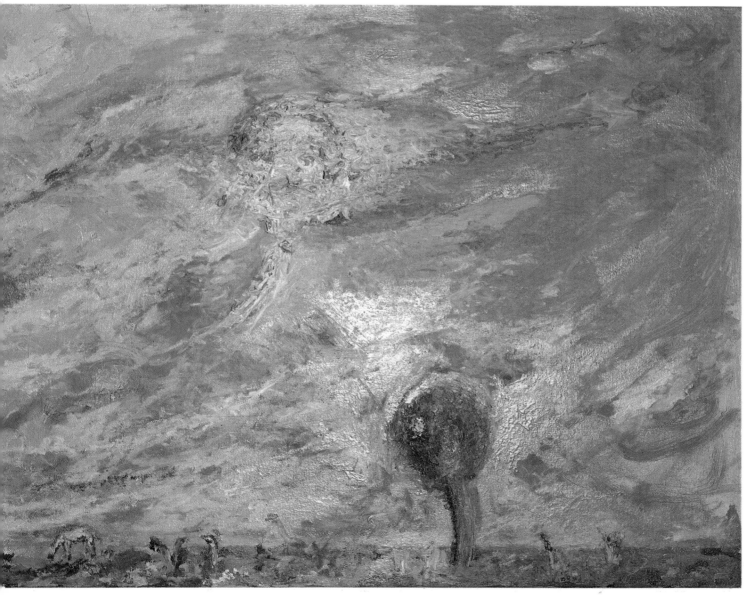

Before Birth, 1984. Oil on canvas. 24 x 69". Private collection. Courtesy of the artist. *(bottom)*

60

Theories About Exotica, 1986. Oil on canvas. 72 x 54″. Collection Stephen Jacobson, New York. Courtesy Tibor De Nagy Gallery. *(top)*

The Conscious Subconscious, 1985. Oil on canvas. 60 x 68″. Collection Martin Sklar, New York. Courtesy Tibor De Nagy Gallery.
Photo courtesy Jay Gorney Gallery.

Synthetic Flamboyance, 1985. Oil on canvas. 52 x 72″. Collection Robin Rose, Washington, D.C. Courtesy Tibor De Nagy Gallery.

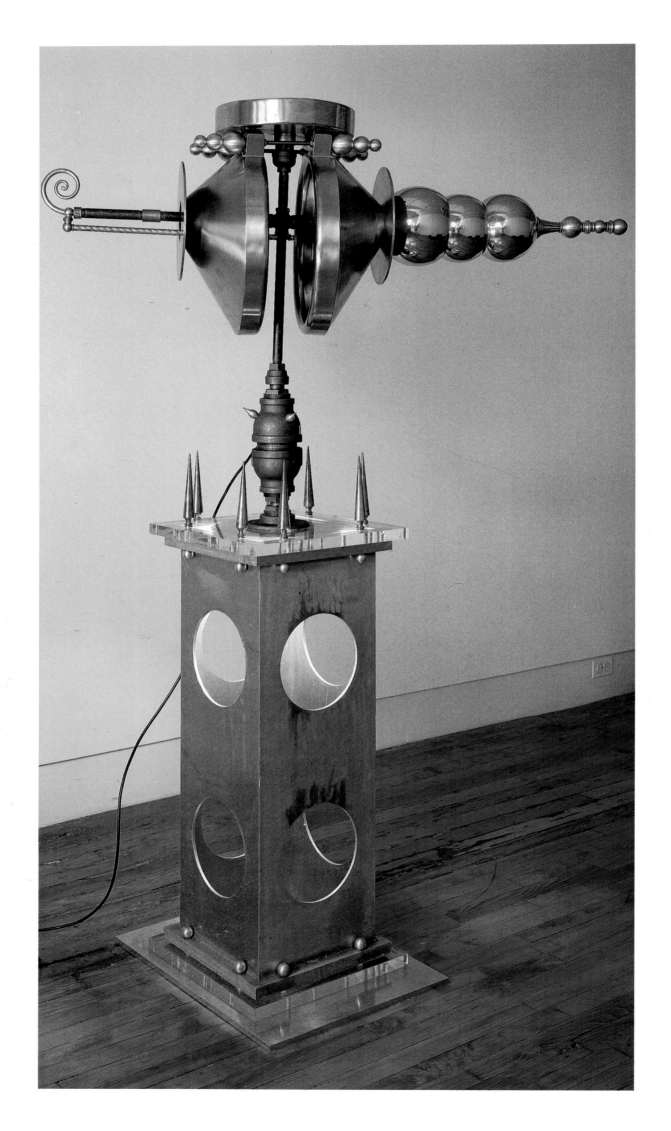

From Russia with Love, 1985. Steel, brass, galvanized metal, Plexiglas, and electric lights. 74 × 51 × 23½". Collection Robert and Adrian Mnuchin, New York. Courtesy Baskerville + Watson Gallery.

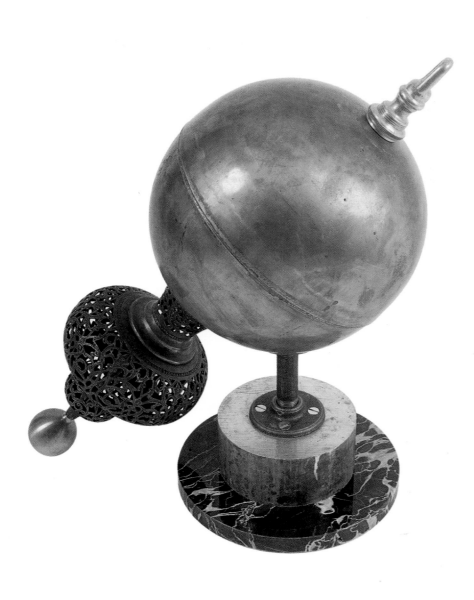

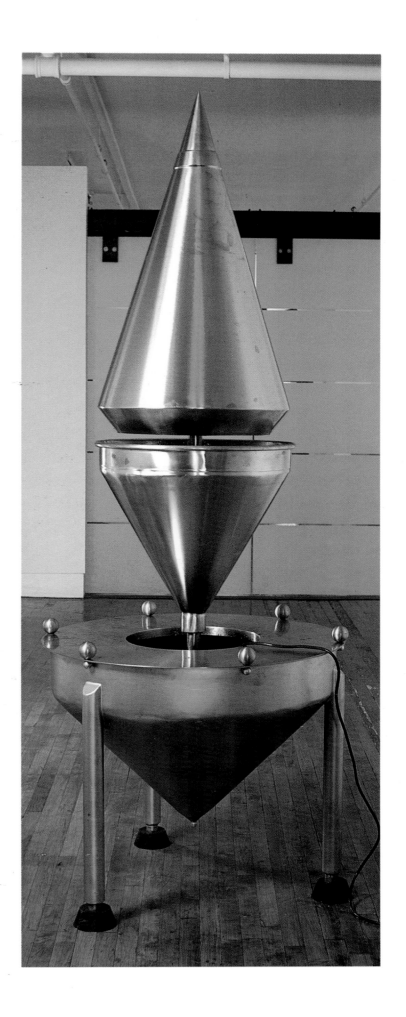

Scribe, 1985. Copper, brass, aluminum, **steel**, and marble. 19 × 16 × 10″. Collection John Sacchi, New York.
Courtesy Baskerville + Watson Gallery. *(left)*.

Fountain, 1985. Aluminum, brass, rubber, and electric pump. 95 × 36½″ in diameter. Courtesy Baskerville + Watson Gallery.

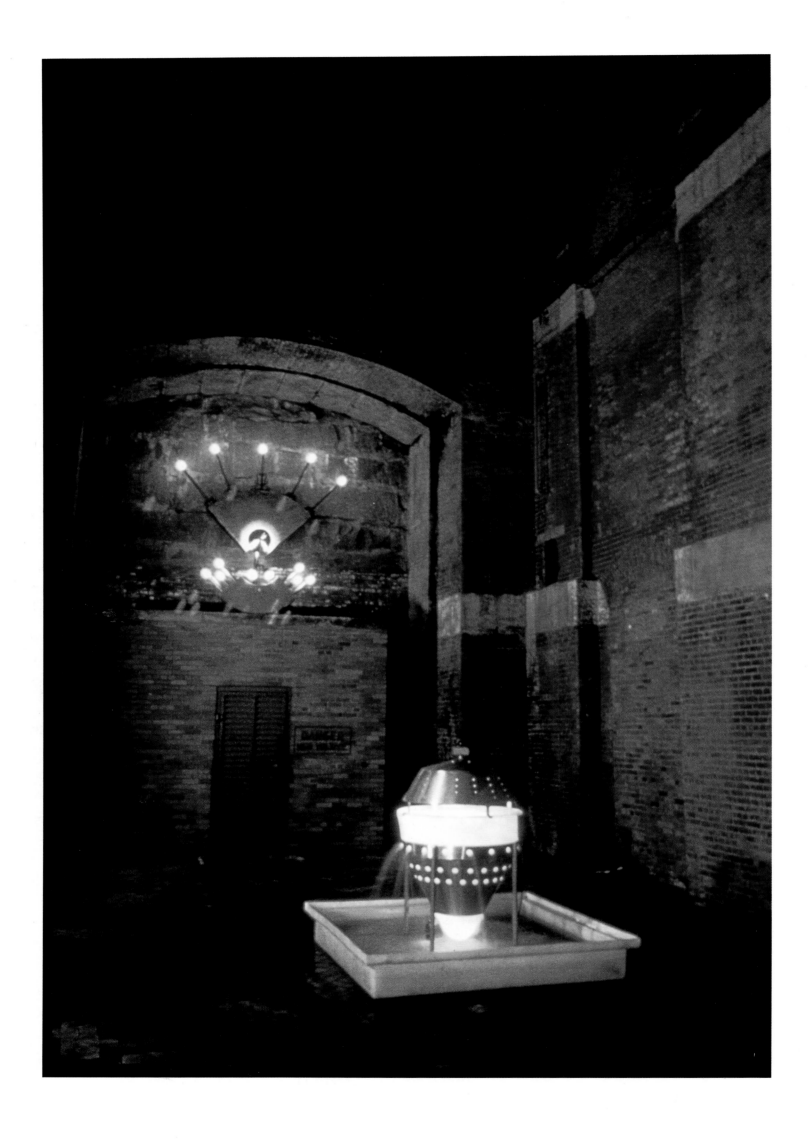

Brooklyn Bridge Anchorage Installation, 1983. Courtesy Baskerville + Watson Gallery.

Selective Amnesia, 1986. Oil on canvas. 84 x 36". Collection Robert Sosnick, Bloomfield Hills, Michigan. Courtesy Jay Gorney Gallery.

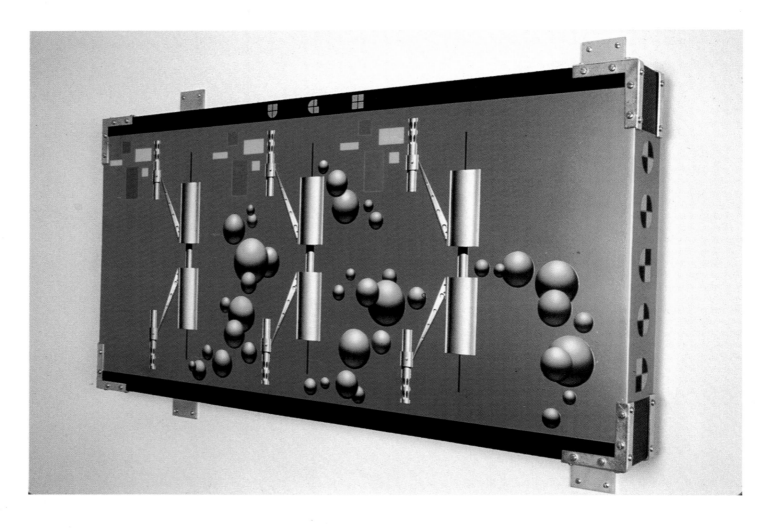

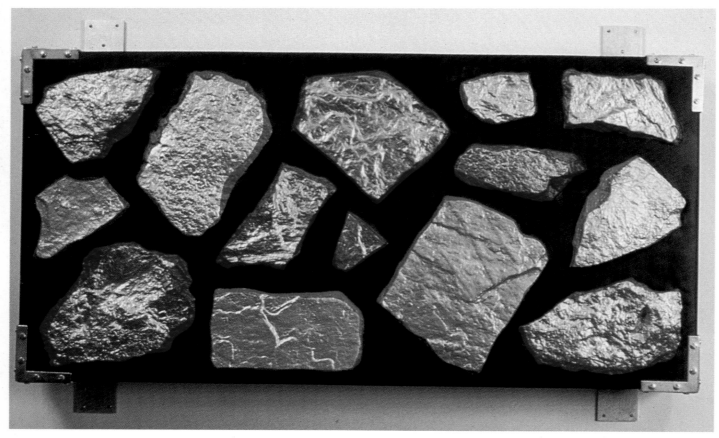

U G H, 1986. Plywood, polymer, aluminum, and metallic paint. 24 × 48 × 6½″. Collection Linda and Harry MacLowe, New York.
Courtesy Cable Gallery. *(top)*

Wall Wall, 1985. Plaster, aluminum, aluminum paint, and polymer paint on plywood. 24 × 48 × 6½″. Collection Metro Pictures, New York.
Courtesy Cable Gallery.

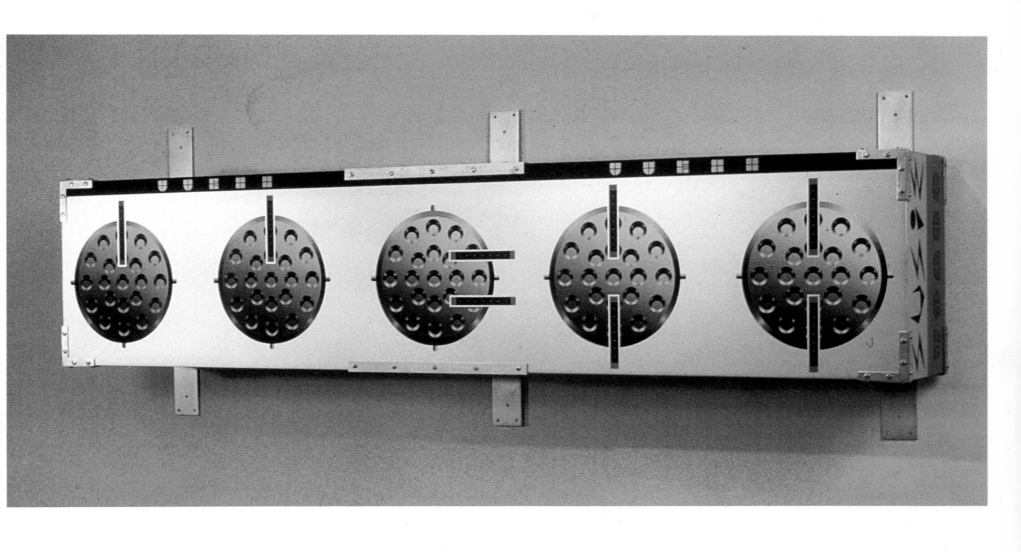

U U E H H, 1986. Mixed media. 20 × 86¼ × 14". Saatchi Collection, London. Courtesy Cable Gallery.

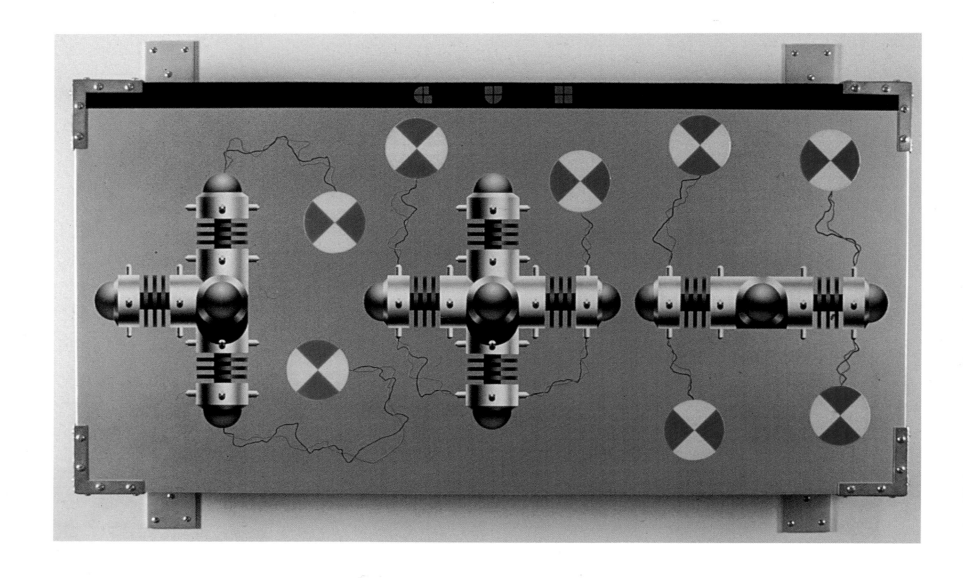

G U H, 1986. Polymer, plywood, metallic paint, and aluminum. 24 × 48 × 6½". Saatchi Collection, London. Courtesy Cable Gallery.

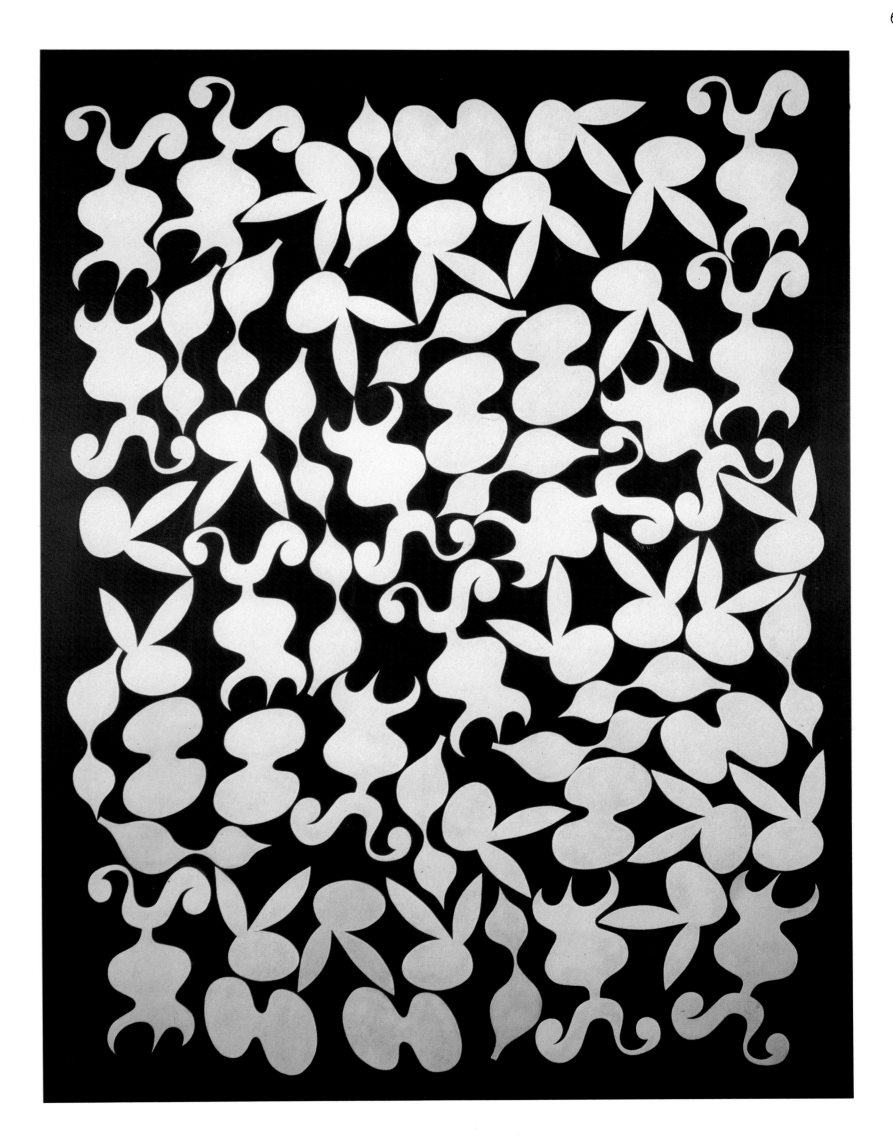

Madame Torso in Deep, 1985. Linoprint collage on awning fabric. 89½ x 68½". Collection Terry Winters, New York. Courtesy Pat Hearn Gallery.

Barge, 1986. Linoprint collage, acrylic on canvas. 18 x 24". Collection Galerie Ascan Crone, Hamburg. Courtesy Pat Hearn Gallery.

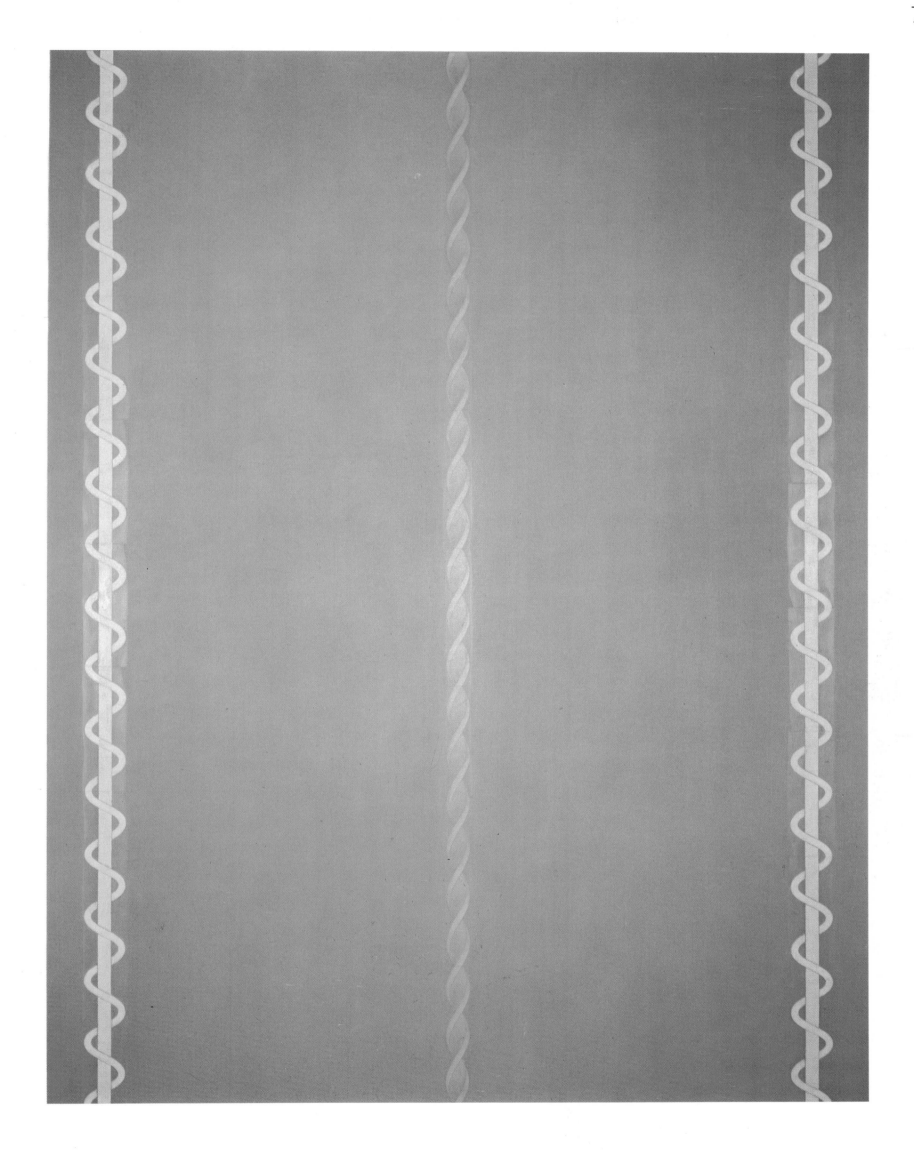

Yellow Painting, 1985. Linoprint collage, acrylic on canvas. 90 x 54". Collection Bruno Bischofberger, Zurich. Courtesy Pat Hearn Gallery.

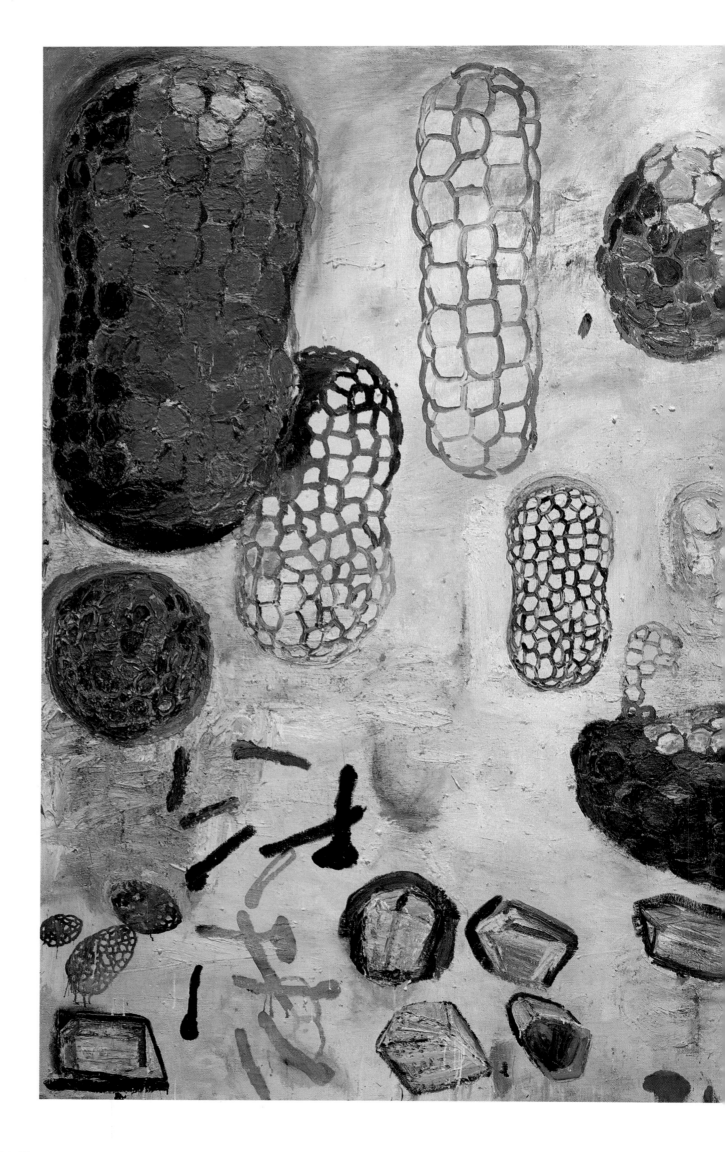

Good Government, 1984. Oil on linen. 101¼ x 136¼". Collection Whitney Museum of American Art, New York, purchase with funds from the Mnuchin Foundation and the Painting and Sculpture Committee 85.15. Courtesy Sonnabend Gallery.

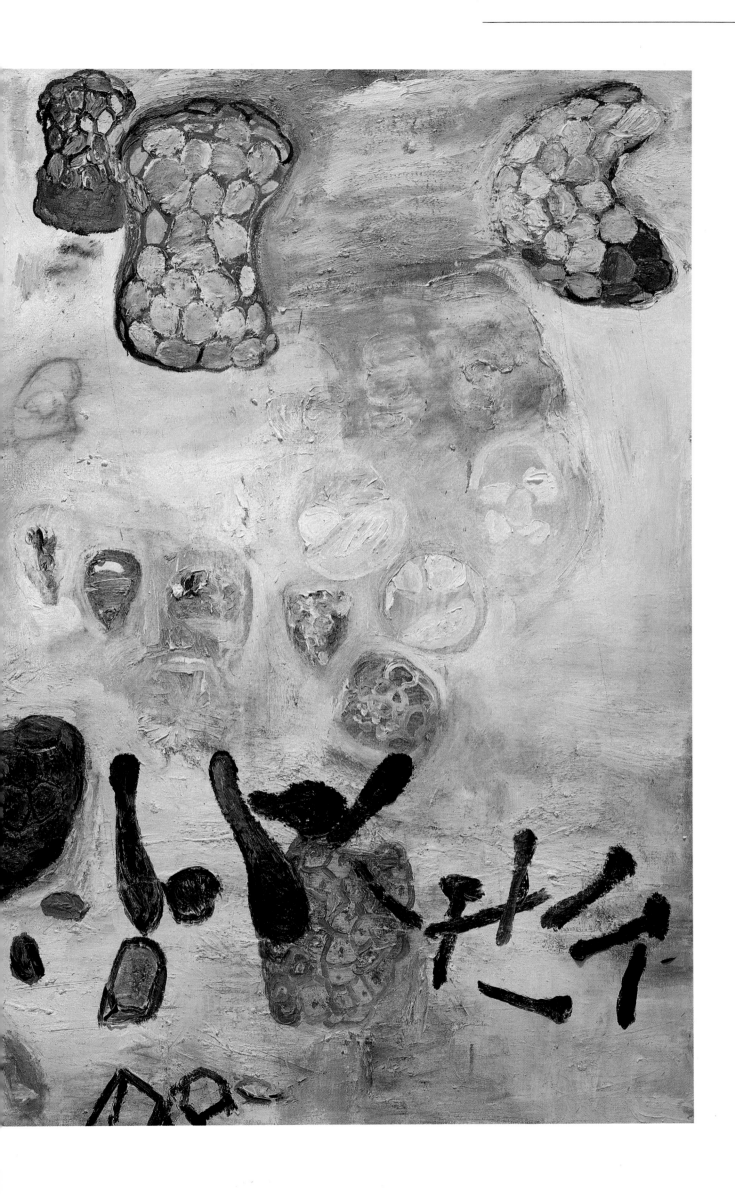

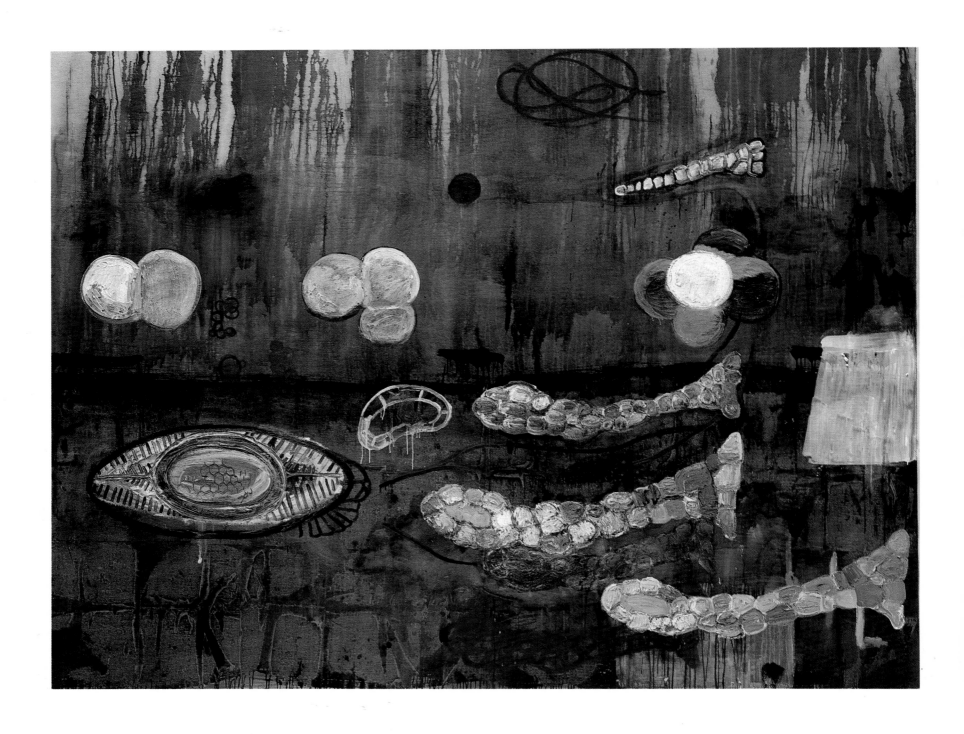

Pitch Lake, 1985. Oil on linen. 90 x 121″. The Eli and Edythe L. Broad Collection, Los Angeles. Courtesy Sonnabend Gallery.

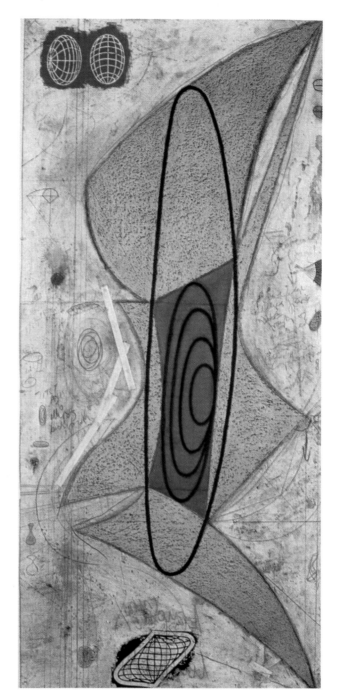

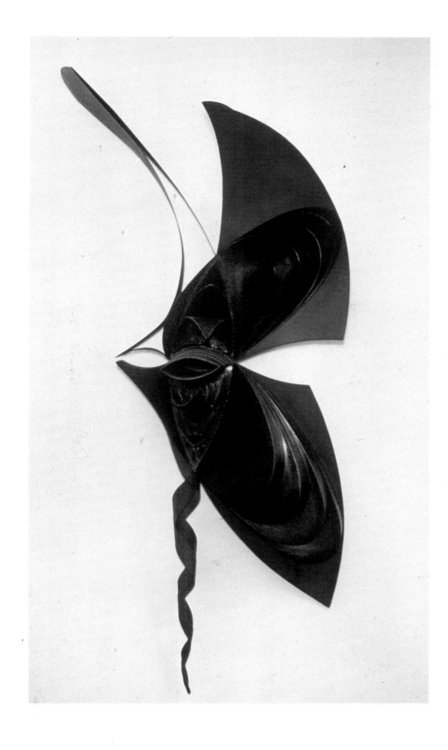

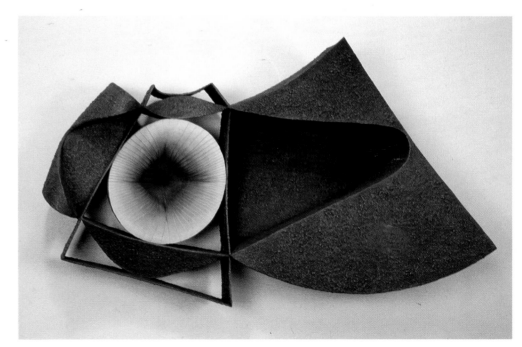

Nomen Est Numen (Naming Is Knowing), 1984. Treated steel.
100 × 36 × 33". Collection Phil Schrager, New York.
Courtesy Jeffrey Hoffeld Gallery. *(left)*

Untitled, 1985. Pastel, chalk, pencil, and linocut on paper. 89 × 40".
Collection Elaine and Werner Dannheisser, New York.
Courtesy Jeffrey Hoffeld Gallery. *(top right)*

La Peau de Chagrin, 1985–86. Aluminum with lacquered patina, unique cast.
72 × 44 × 22". Collection Martin Sklar, New York.
Courtesy Jeffrey Hoffeld Gallery.

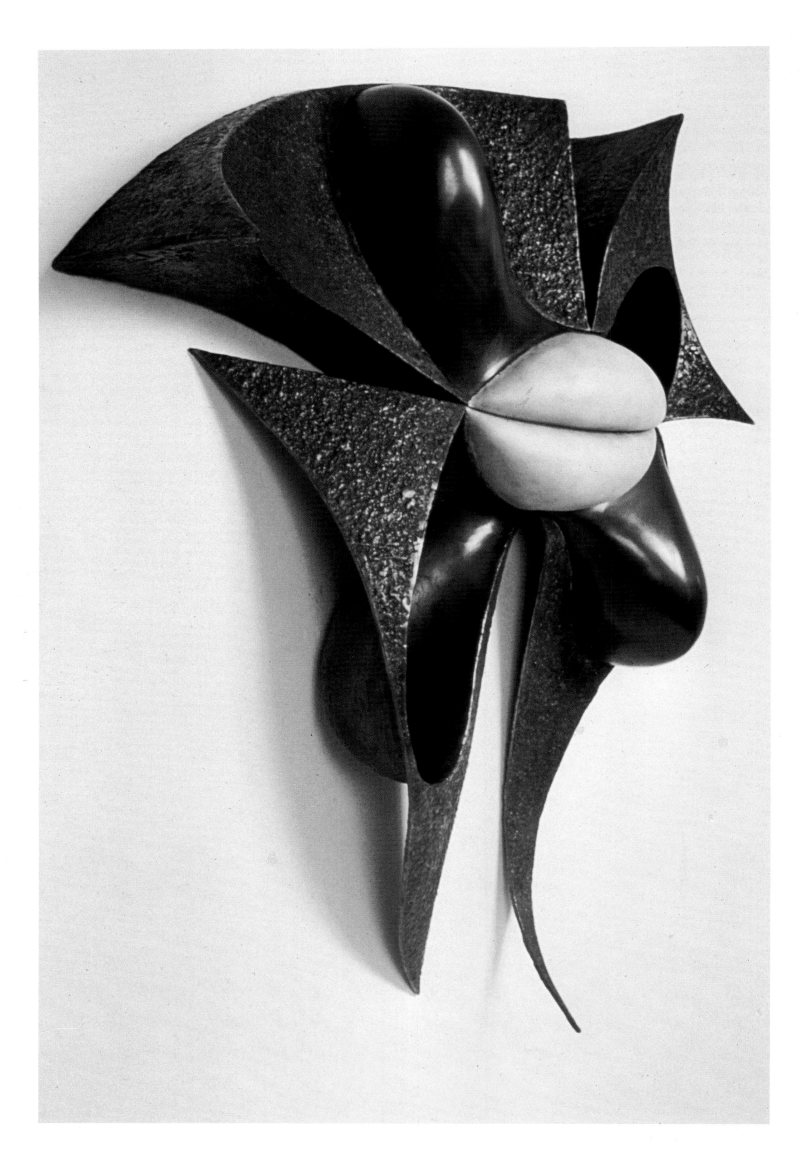

Mother Tongue, 1985. Bronze with patina, unique cast. 45 x 50 x 11". Collection George H. Waterman III, New York. Courtesy Jeffrey Hoffeld Gallery.

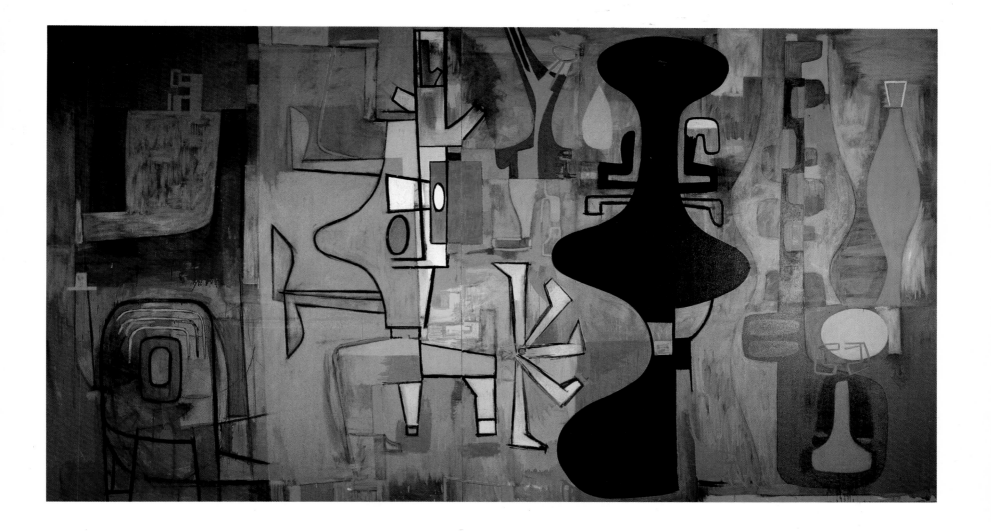

Untitled, 1985. Oil on canvas. 84 x 156". Courtesy Jay Gorney Gallery.

GARY STEPHAN

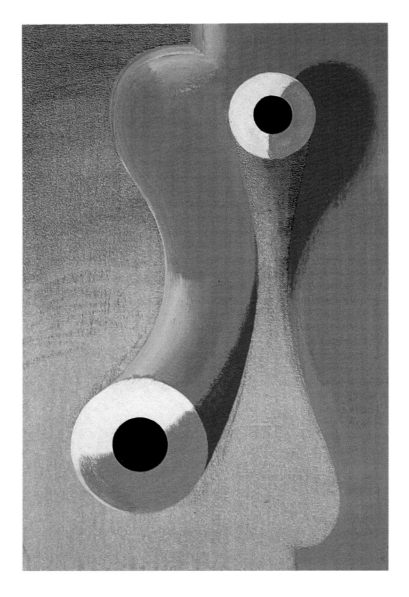

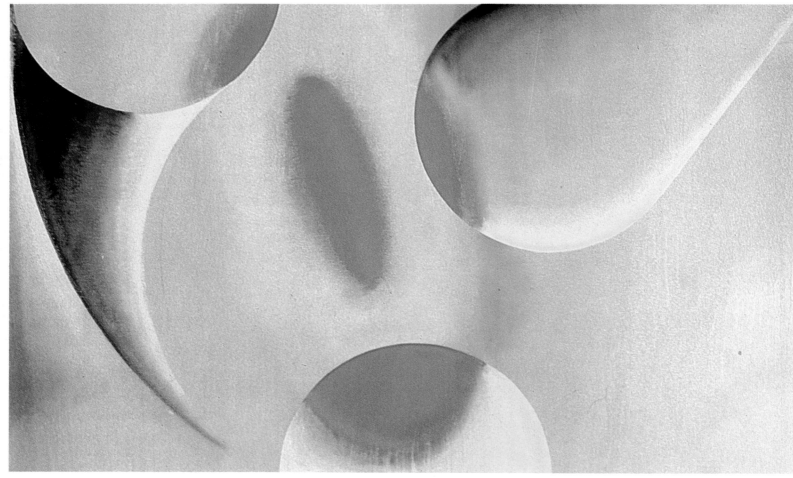

Open in Her Mind, 1985. Acrylic on canvas. 30 × 20″. Courtesy Mary Boone Gallery. (*top*)
2648, 1986. Acrylic on canvas. 48 × 78″. Collection Stanley Cohen, Atlanta. Courtesy Mary Boone Gallery.

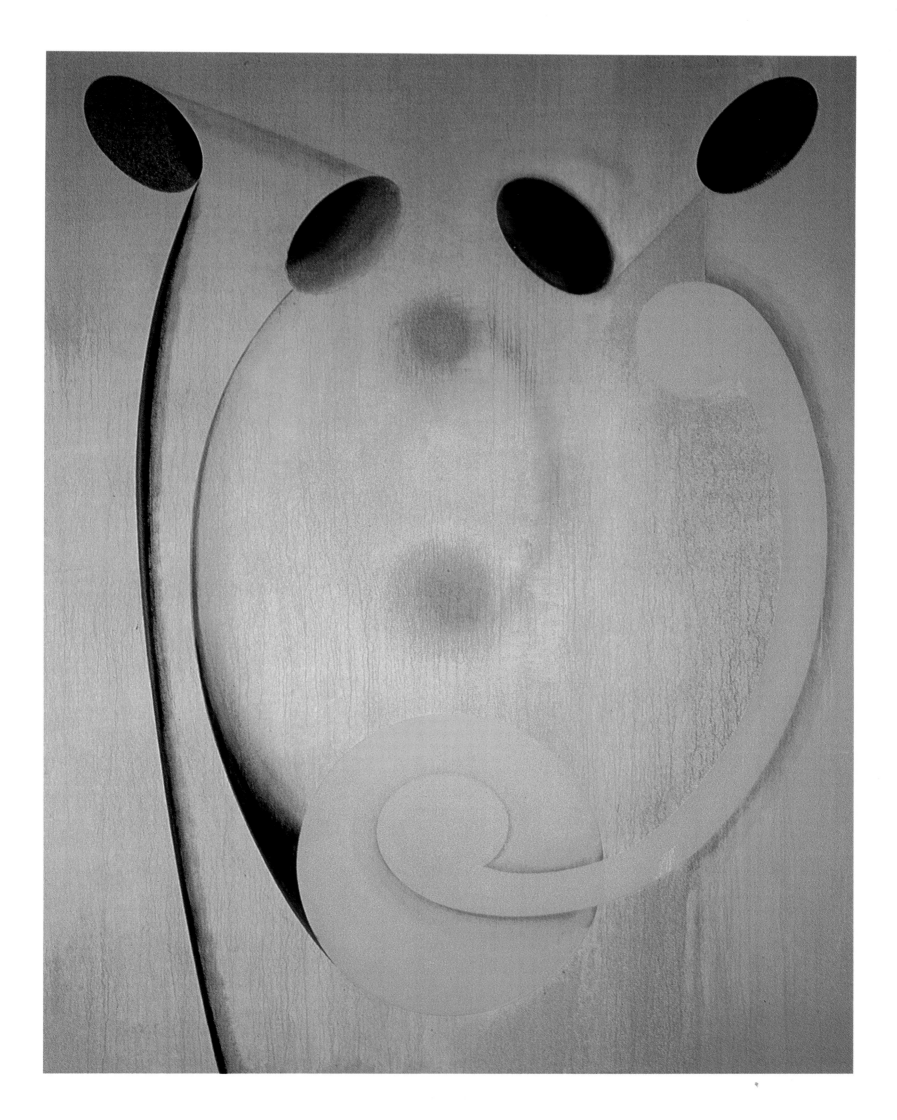

Guest Ice, 1986. Acrylic on canvas. 108 × 84". Courtesy Mary Boone Gallery.

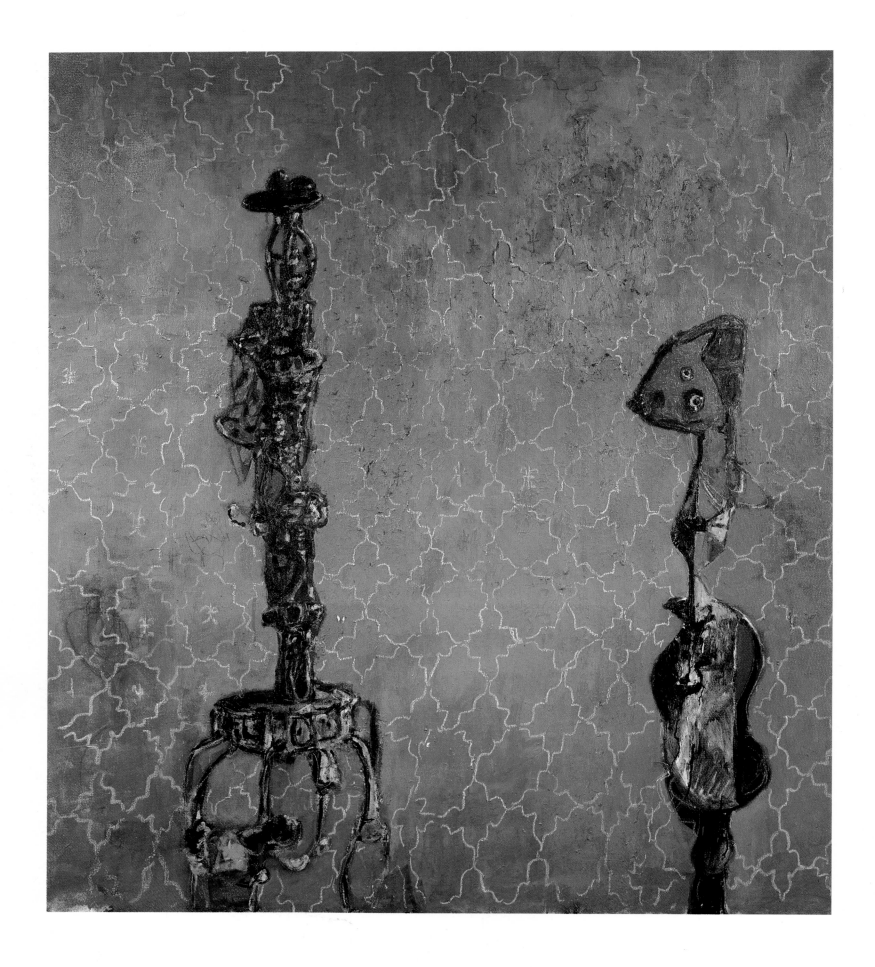

Separated by Life, 1985–86. Pencil and oil on canvas. 78¾ x 70¾". Collection Elaine Dannheisser, New York. Courtesy Barbara Gladstone Gallery.

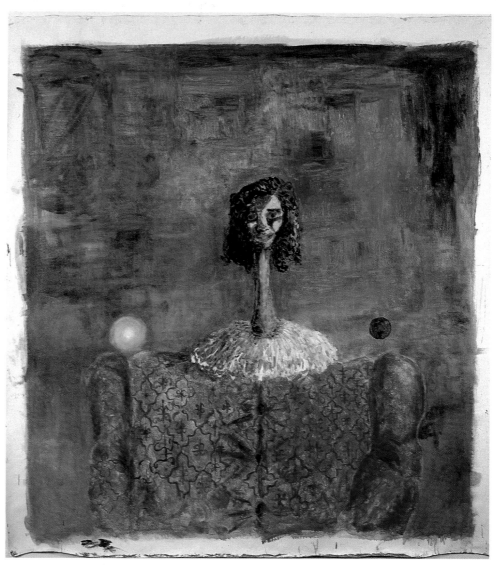

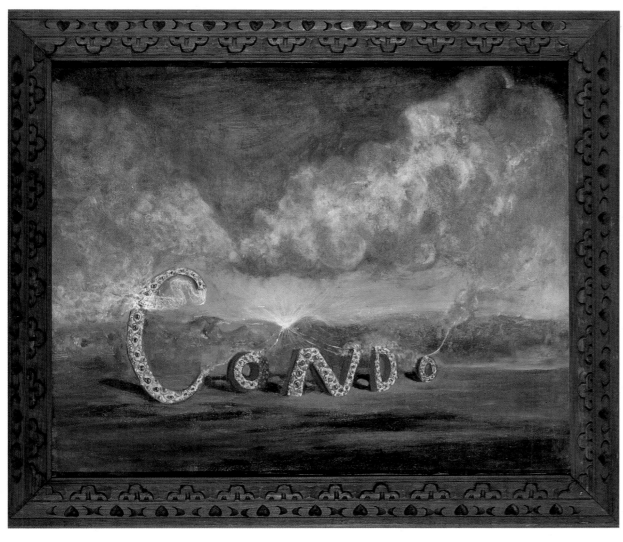

Portrait of Mabe, 1984. Oil on linen.
75 × 67½". Private collection.
Courtesy Barbara Gladstone Gallery. *(top)*

The Cloudmaker, 1984. Oil on canvas.
32¼ × 38½". Courtesy Barbara Gladstone Gallery.

Dancing to Miles, 1985–86. Oil on canvas. 110¼ × 137¾". Collection Eli Broad Family Foundation, Los Angeles. Courtesy Barbara Gladstone Gallery.

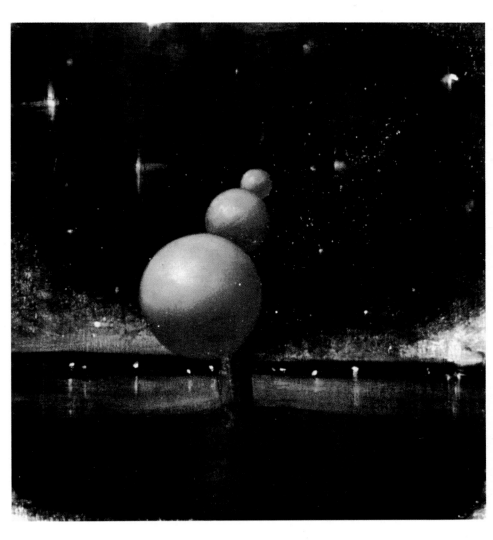

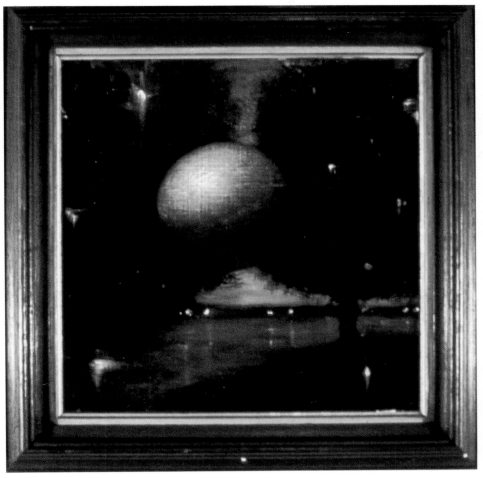

The Farmer, 1985. Oil on wood. 18 x 19". Collection Emily Landau,
New York. Courtesy Lorence • Monk Gallery. (*top*)

The Suggestion of Reception, 1985. Oil on wood. 13½ x 13½". Private collection,
New York. Courtesy Lorence • Monk Gallery.

PETER SCHUYFF

84

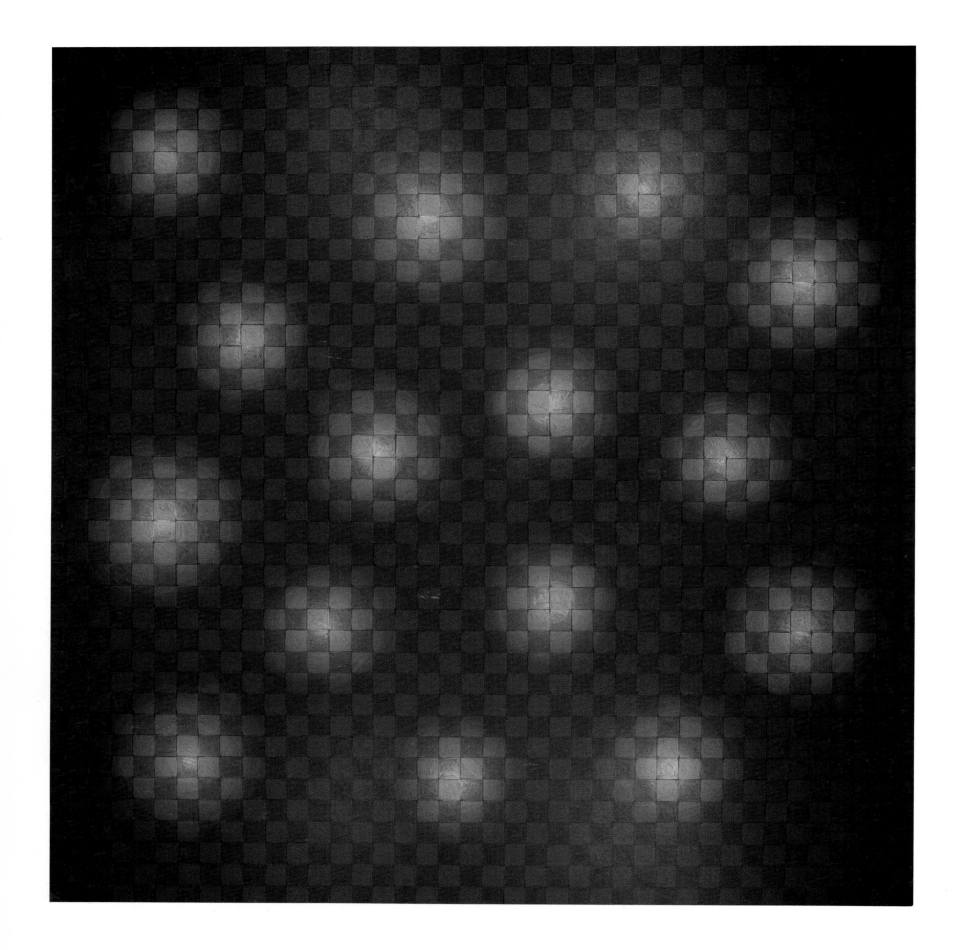

Untitled, 1985. Acrylic on linen. 120 x 120". Collection Steven M. Jacobson, New York. Courtesy Pat Hearn Gallery.

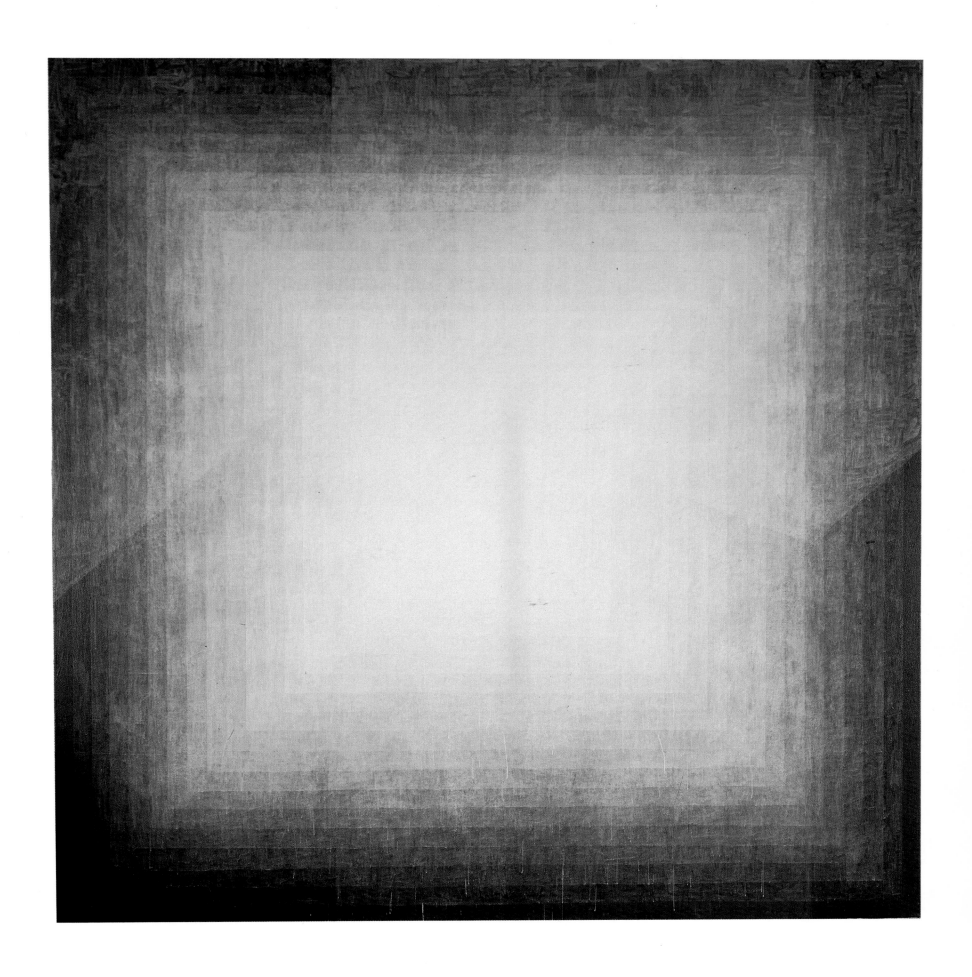

The Weld, 1985. Acrylic on linen. 120 x 120". Collection Eddo A. Bult, New York. Courtesy Pat Hearn Gallery.

DEBORAH KASS

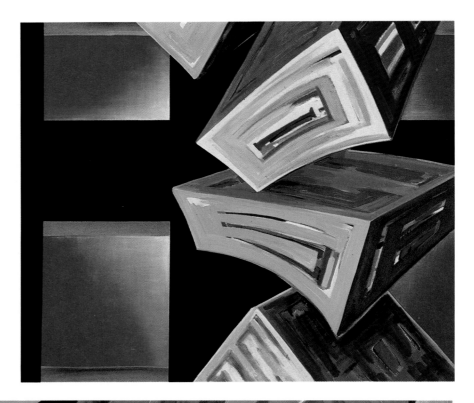

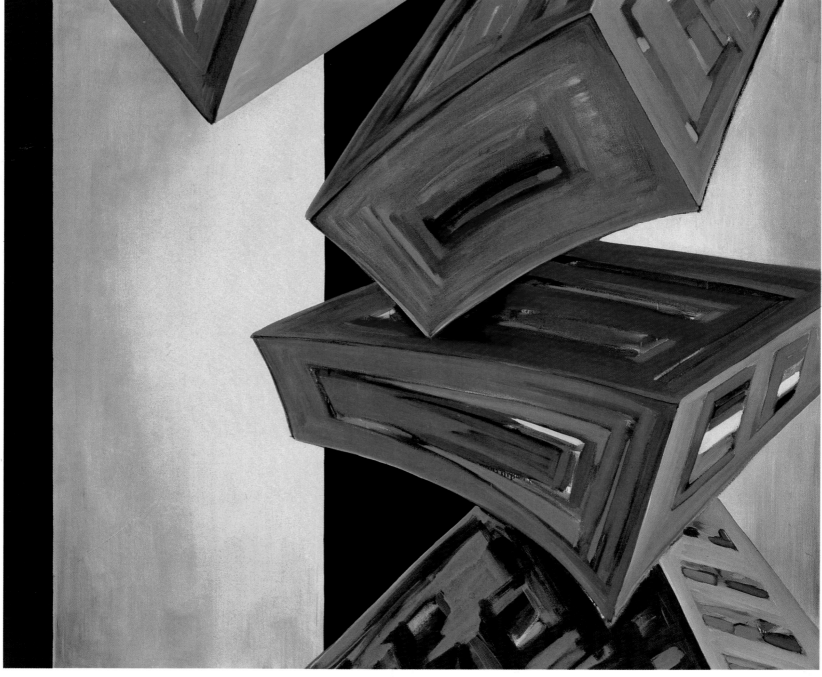

Second Nature, 1986. Oil on canvas. 72 × 86½″. Courtesy Baskerville + Watson Gallery. *(top)*
Failures of the Race, 1986. Oil on canvas. 63 × 76″. Private collection. Courtesy Baskerville + Watson Gallery.

Stack-o-rocks, 1986. Oil on canvas. 60 x 72". Courtesy Baskerville + Watson Gallery.

MARK TANSEY

Action Painting II, 1984. Oil on canvas. 76 x 110". Collection Montreal Museum of Fine Art. Courtesy Curt Marcus Gallery. *(top)*
Occupation, 1984. Oil on canvas. 56 x 80". Collection Raymond J. Learsy, New York. Courtesy Curt Marcus Gallery.

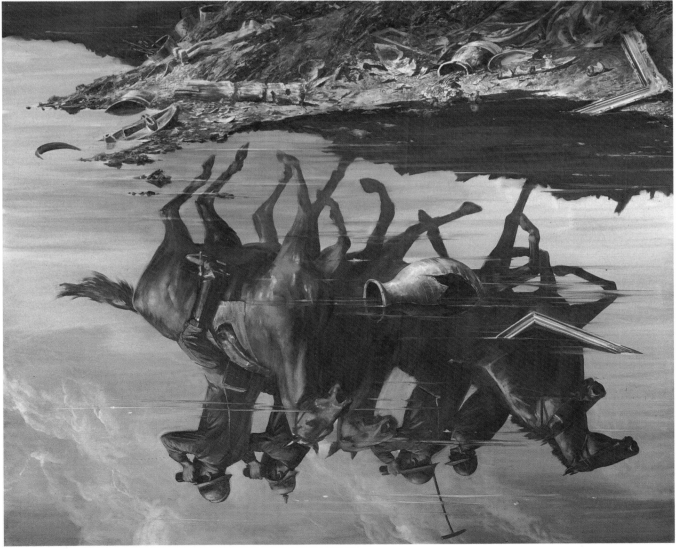

Triumph of the New York School, 1984. Oil on canvas. 74 x 120″. Collection Whitney Museum of American Art, promised gift of Robert M. and Nancy L. Kaye. Courtesy Curt Marcus Gallery. *(top)*

Forward Retreat, 1986. Oil on canvas. 94 x 116″. Collection Eli Broad Family Foundation, Los Angeles. Courtesy Curt Marcus Gallery.

FREYA HANSELL

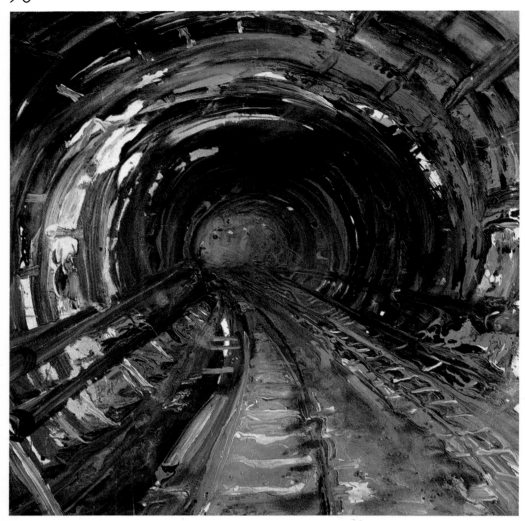

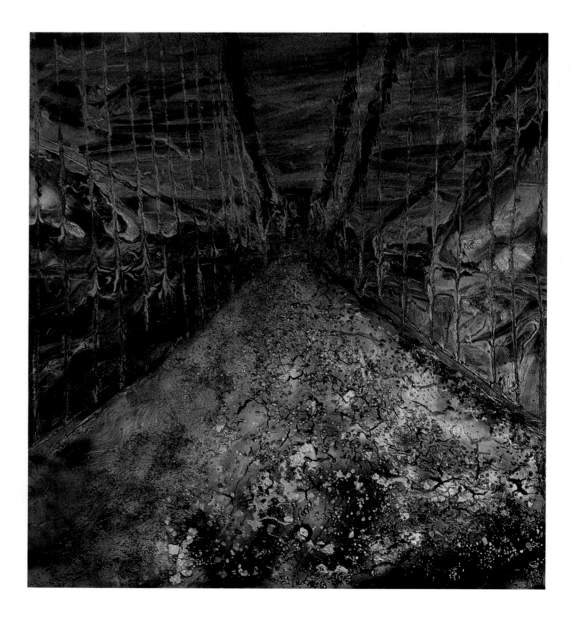

Tunnel, 1985. Oil, acrylic, and stones on canvas. 69 x 69".
Speyer Family Collection, New York.
Courtesy Piezo Electric Gallery. *(top)*

Gold Rush, 1986. Oil, acrylic, sand, charcoal, and stones on canvas.
84 x 78". Courtesy Piezo Electric Gallery.

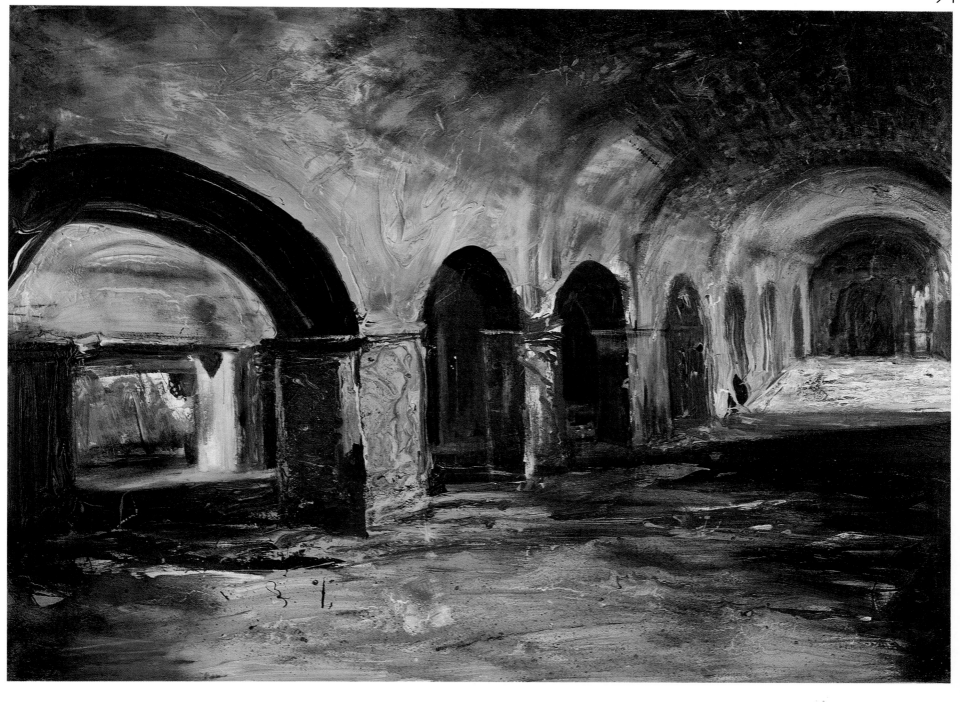

Gold Corridor, 1985. Oil and acrylic on canvas. 60 x 84". Collection Burt Minkoff, New York. Courtesy Piezo Electric Gallery.

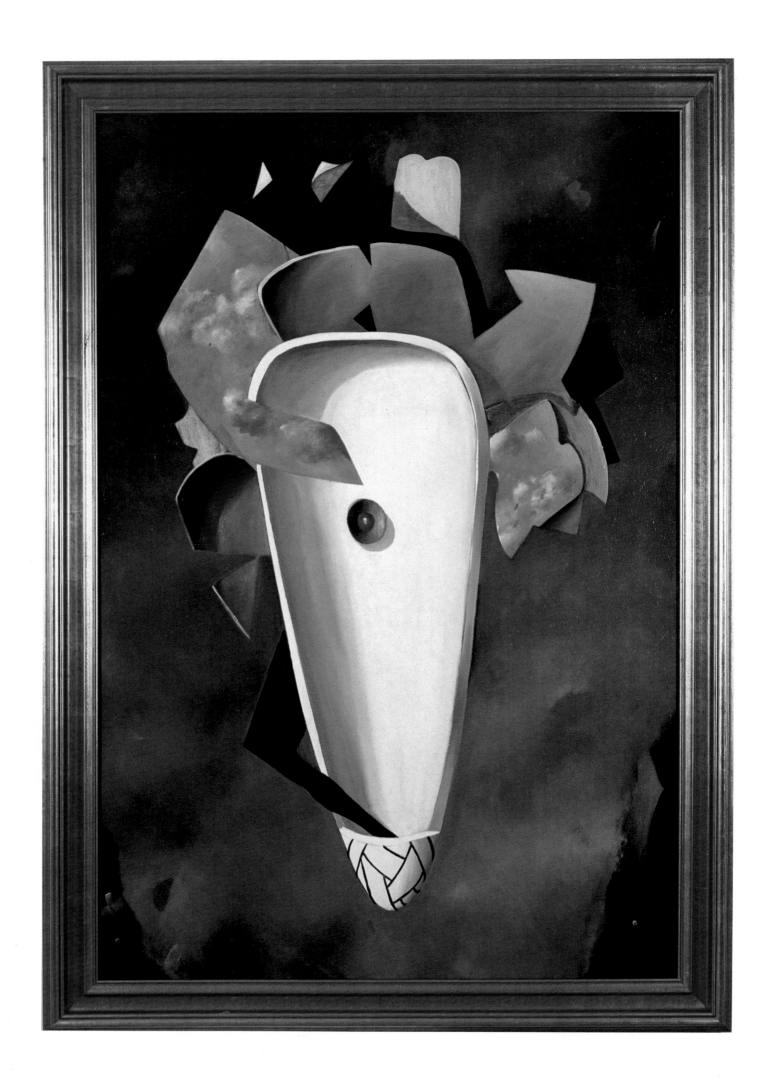

One of the eight spheres of Yoga: the sphere of posture, 1985. Oil on canvas. 81 × 57". Private collection. Courtesy Wolff Gallery.

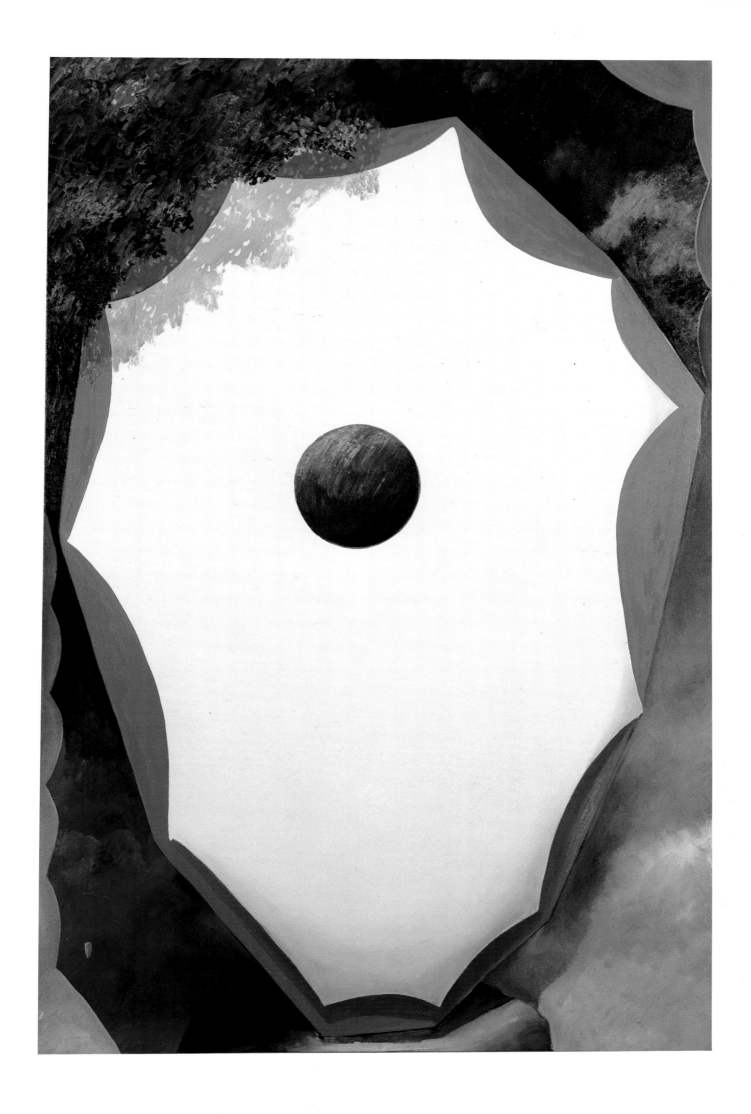

One of the eight spheres of Yoga: the sphere of individual breath, 1985. Oil on canvas. 81 × 57″. Collection Barbara and Eugene Schwartz, New York. Courtesy Wolff Gallery.

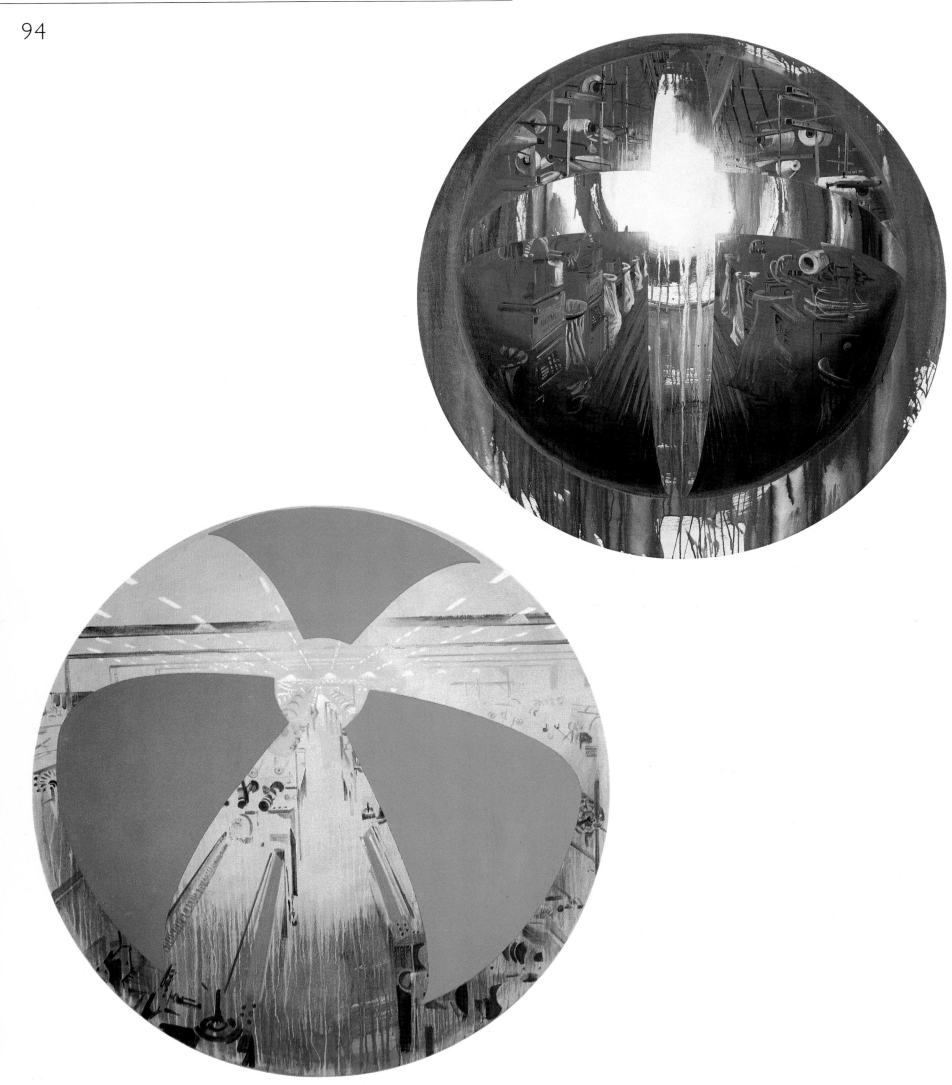

Knitting for Tomorrow, 1986. Acrylic on canvas. 60" in diameter. Courtesy Wolff Gallery. *(top)*
The Ultimate Development, 1986. Acrylic on canvas. 60" in diameter. Courtesy Wolff Gallery.

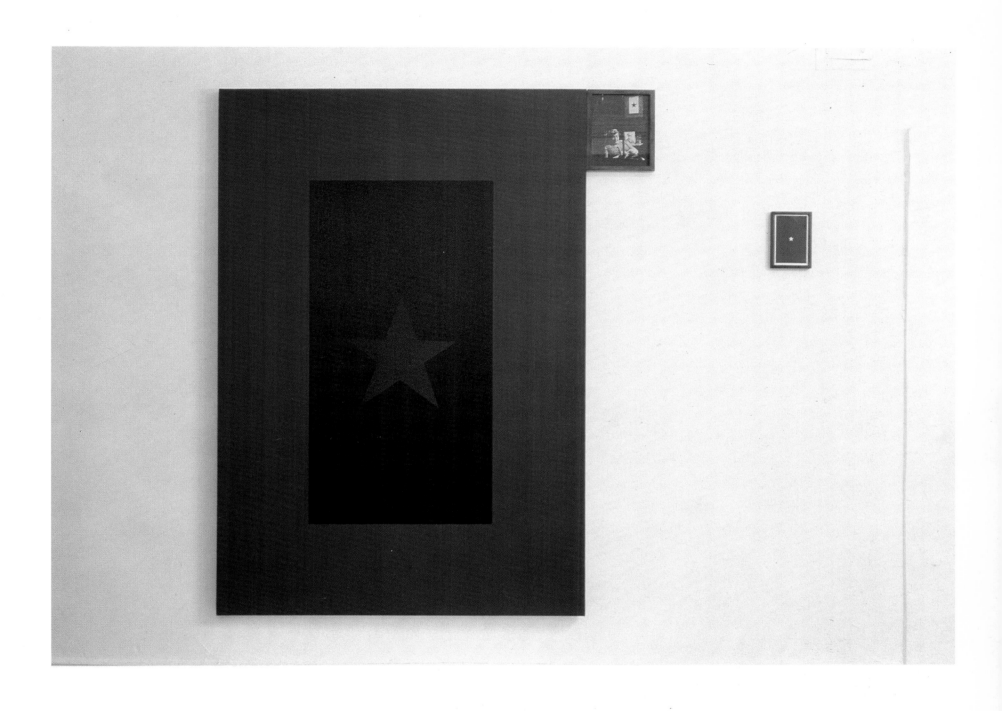

Homecoming, 1985. Oil on canvas with framed black-and-white photograph and framed book cover. 79 x 55". Collection Michel Tournadre, New York.
Courtesy Cash/Newhouse Gallery.

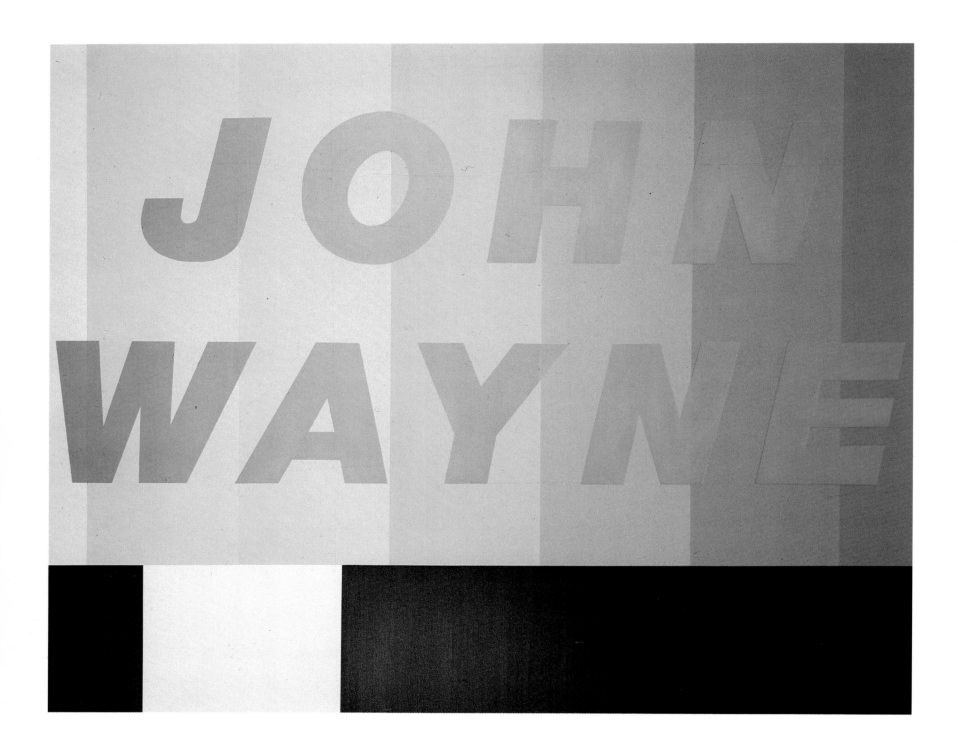

John Wayne, 1986. Oil on canvas. 6′ x 7′8″. Private collection. Courtesy Cash/Newhouse Gallery.

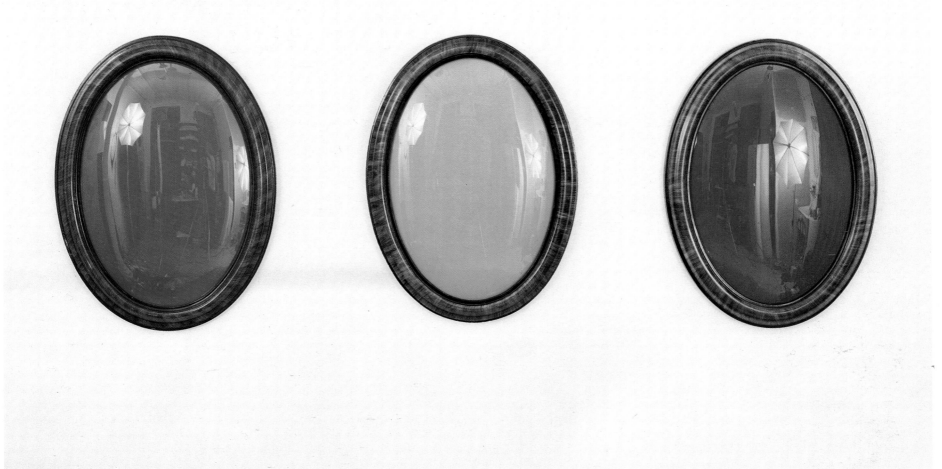

Showing One's Colors, 1986. Oil on glass with frame. Each oval 22 x 16". Private collection. Courtesy Cash/Newhouse Gallery.

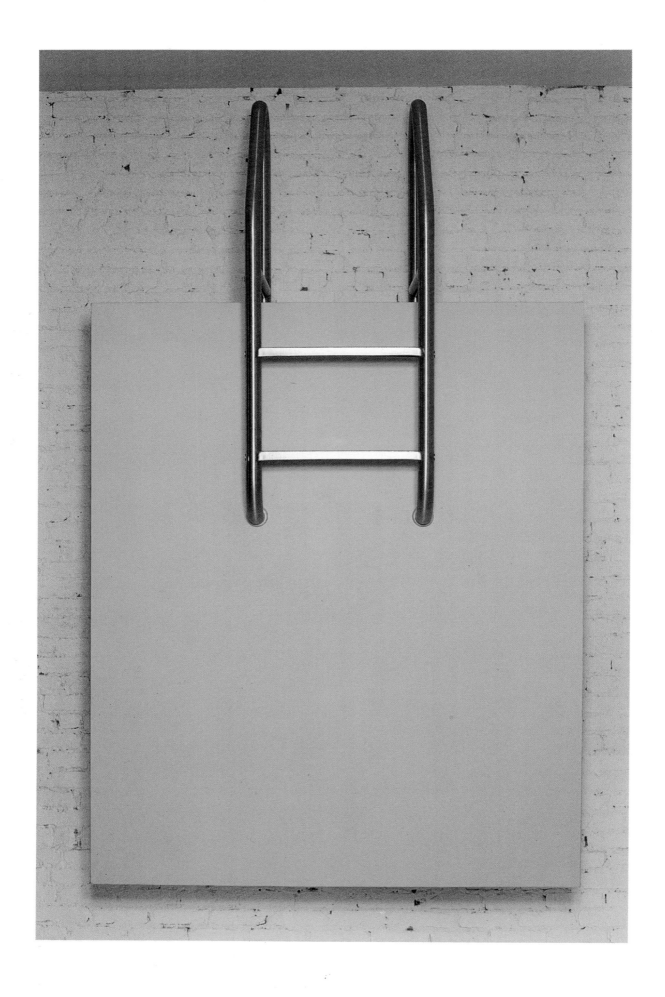

The Pool Ladder Painting, 1986. Latex on canvas with stainless steel pool ladder. 60 x 99 x 19". Courtesy Postmasters Gallery.

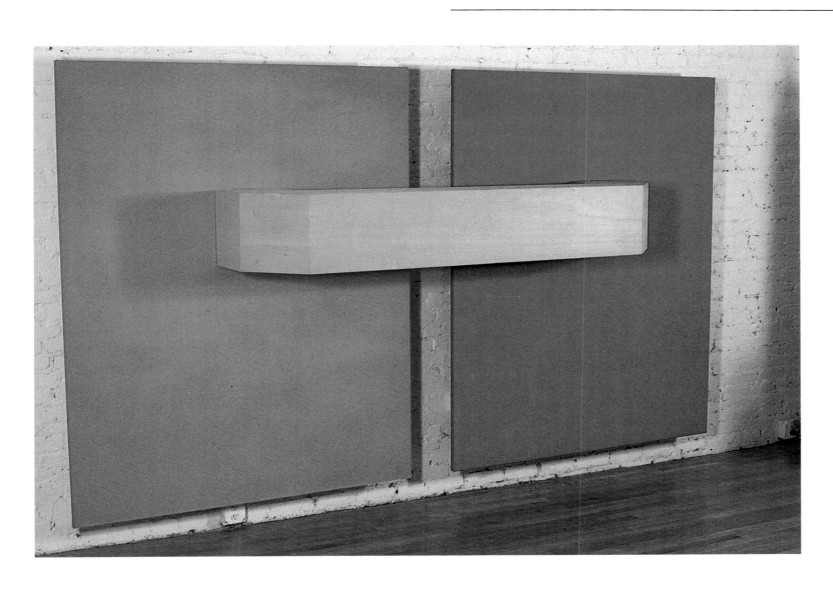

The Obdurate Fortitude with Which Our Slender Innuendos Become Fatuous, 1986.
Latex on canvas with wood conduit. 72 × 129 × 25".
Courtesy Postmasters Gallery. *(top)*

Existential Freedom, 1985. Latex on canvas. 60 × 72".
Collection Margo Leavin, Los Angeles. Courtesy Postmasters Gallery.

Live Free or Die, 1985. Color photograph. 86 × 45″. Collection Paula Greif, New York. Courtesy International with Monument Gallery.

Bitches and Bastards, 1985. Color photograph. 86 x 45". Private collection, New York. Courtesy International with Monument Gallery.

JAMES CASEBERE

102

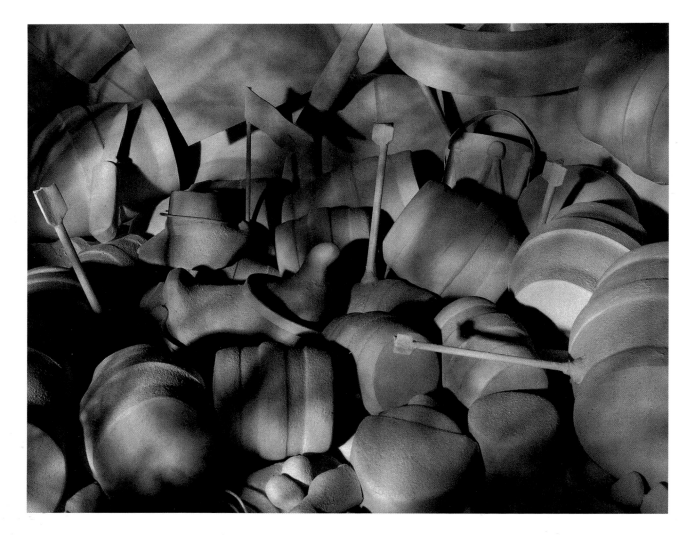

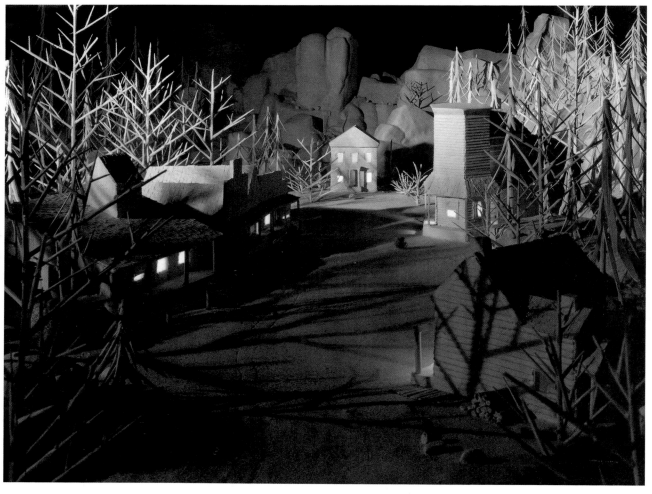

Western Warplay, 1986. Silverprint. 30 × 40". Courtesy Michael Klein Gallery. *(top)*
Western Street, 1986. Silverprint. 30 × 40". Courtesy Michael Klein Gallery.

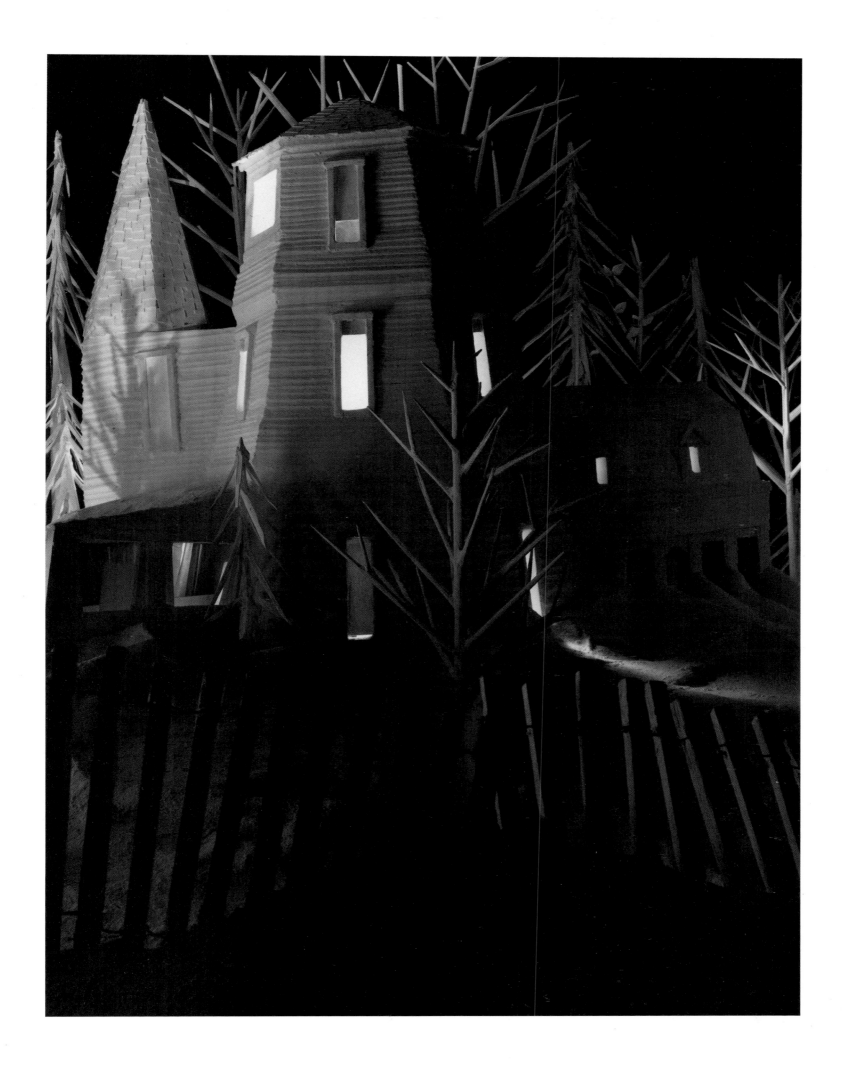

Winterhouse, 1985. Silverprint. 40 x 30". Courtesy Michael Klein Gallery.

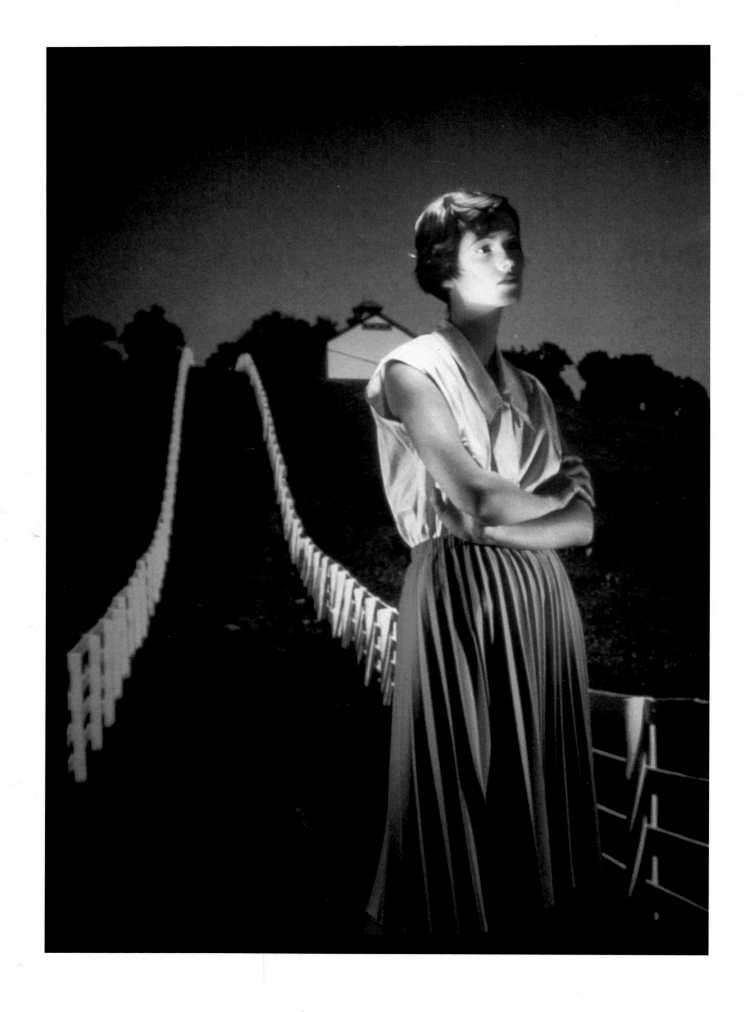

Country Road (In Kentucky), 1984. Cibachrome. 60 x 45". Courtesy International with Monument and Metro Pictures galleries.

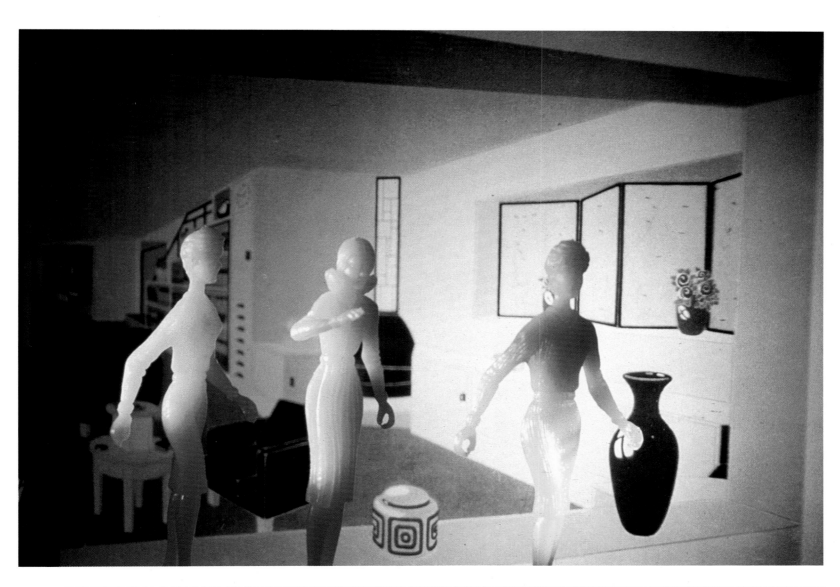

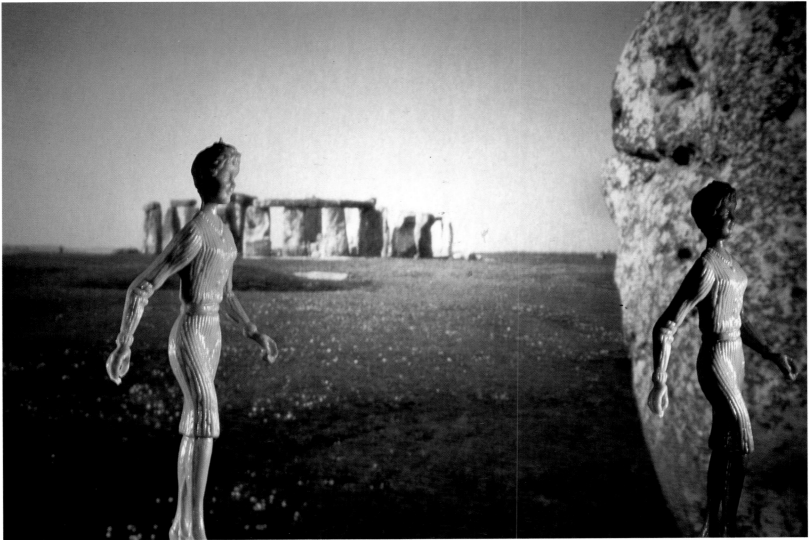

Yellow Smoking Room, 1983. Cibachrome. 29½ x 49". Courtesy International with Monument and Metro Pictures galleries. *(top)*
Tourism: Stonehenge (Green), 1984. Cibachrome. 40 x 60". Courtesy International with Monument and Metro Pictures galleries.

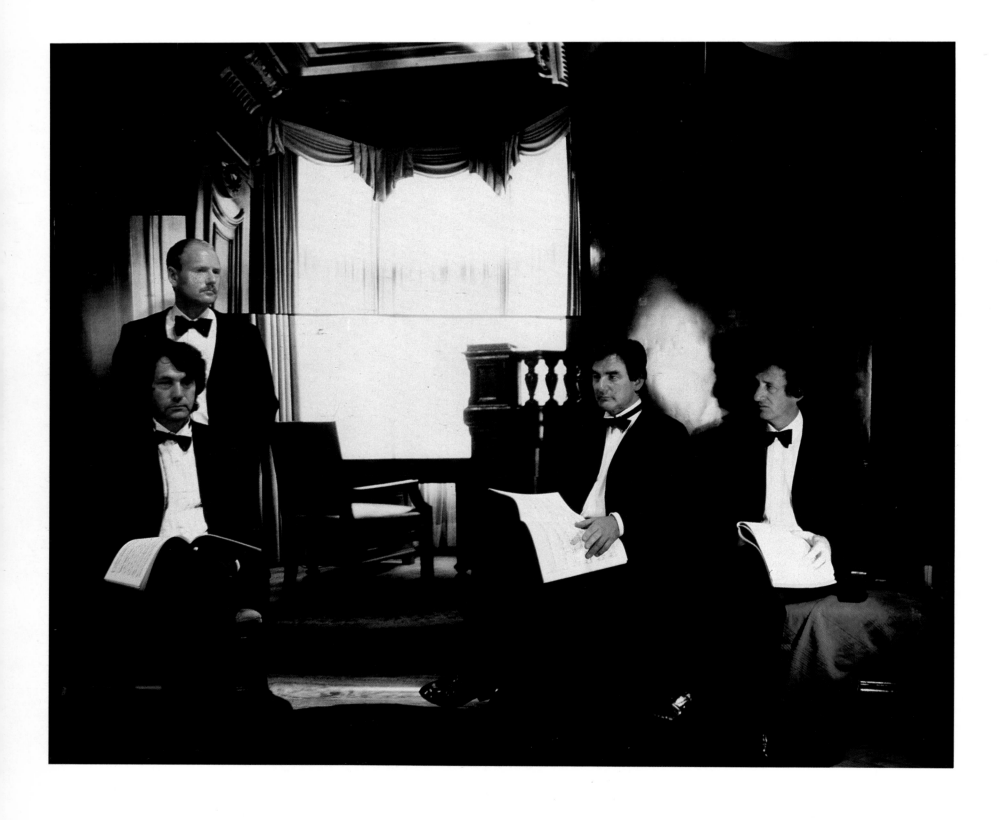

Corporate Music, 1985. Cibachrome. 96 x 72". Courtesy Cable Gallery.

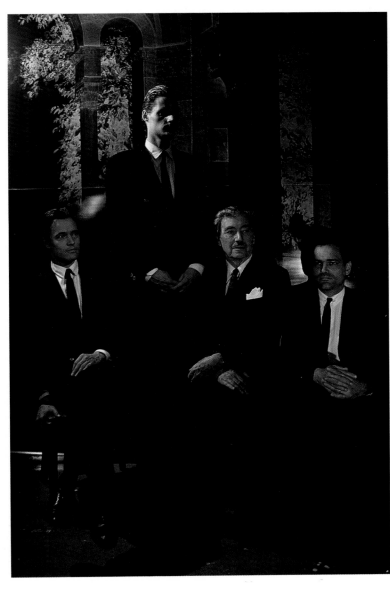

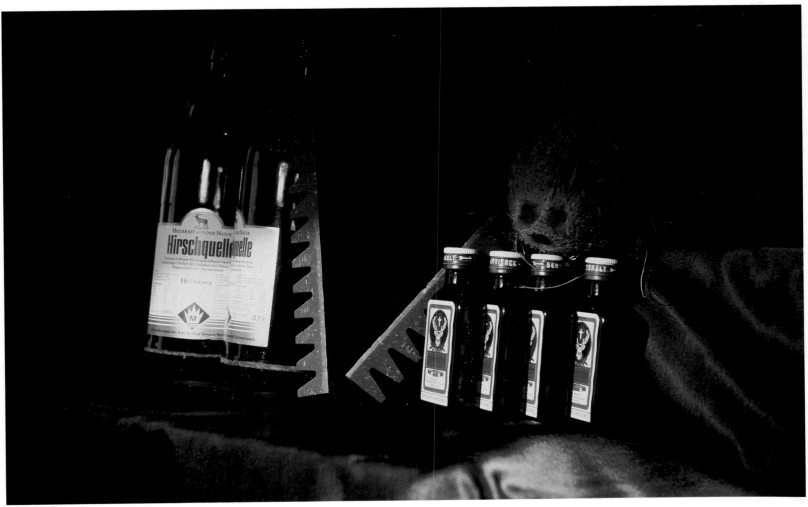

Et in Arcadia Ego and Co., 1982. Cibachrome. 65 × 80". Collection Mönchengladbach Museum, West Germany. Courtesy Cable Gallery. *(top)*

Hirschquellequelle, 1985. Cibachrome. 30 × 23". Collection Joshua Smith, Washington, D.C. Courtesy Cable Gallery.

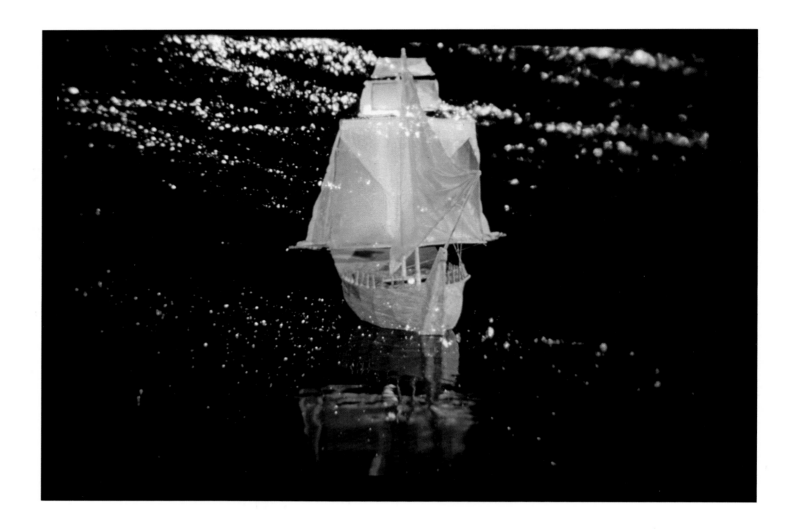

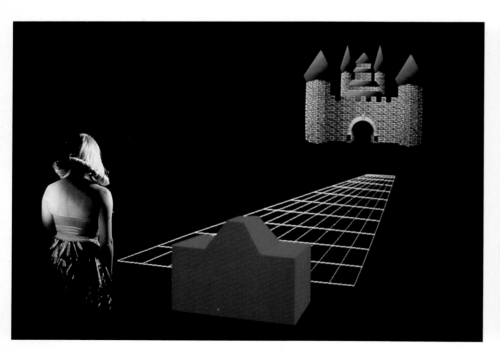

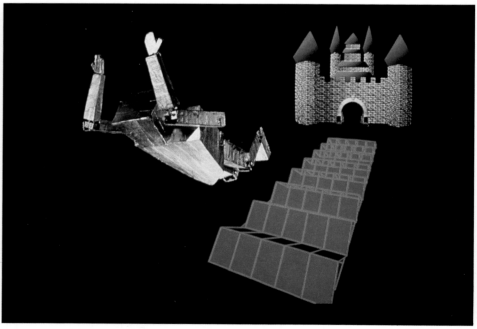

Lucky Charm, 1984. Ektacolor photograph. 30 x 40". Courtesy of the artist. *(top)*

Cinderella Game, 1986. Ektacolor photographs. Four parts, each 30 x 40". Collection Chase Manhattan Bank, New York.
Courtesy of the artist. *(bottom, both pages)*

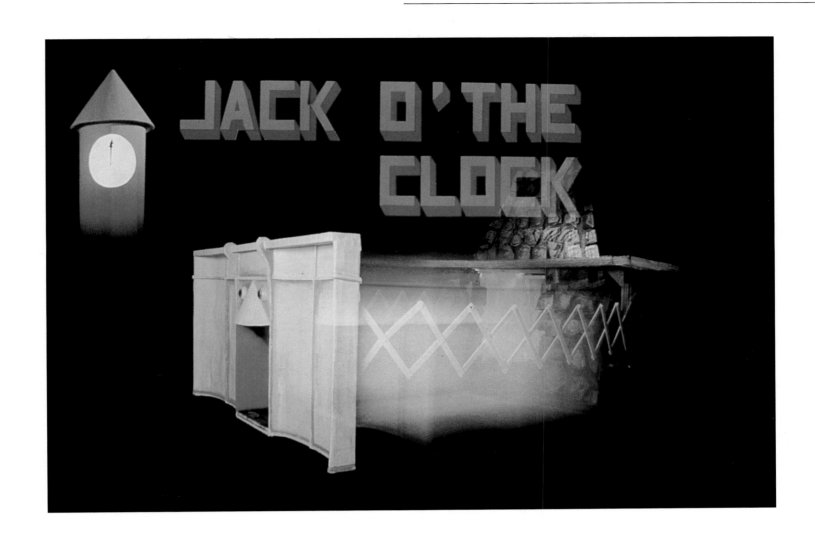

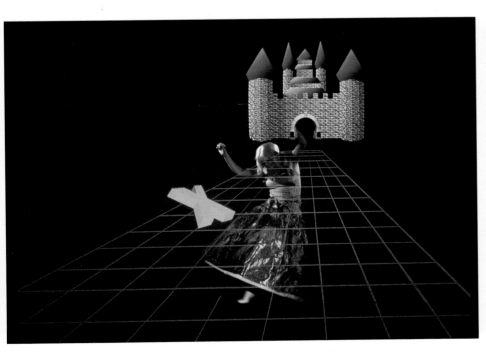

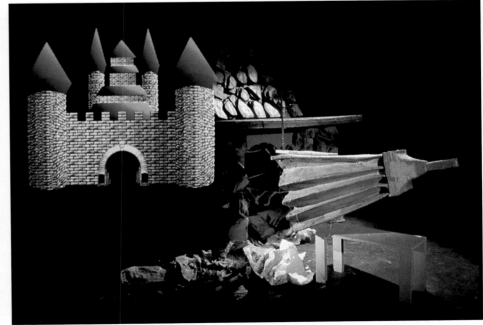

Jack o' the Clock, 1986. Ektacolor photograph. 30 x 40″. Courtesy of the artist. *(top)*

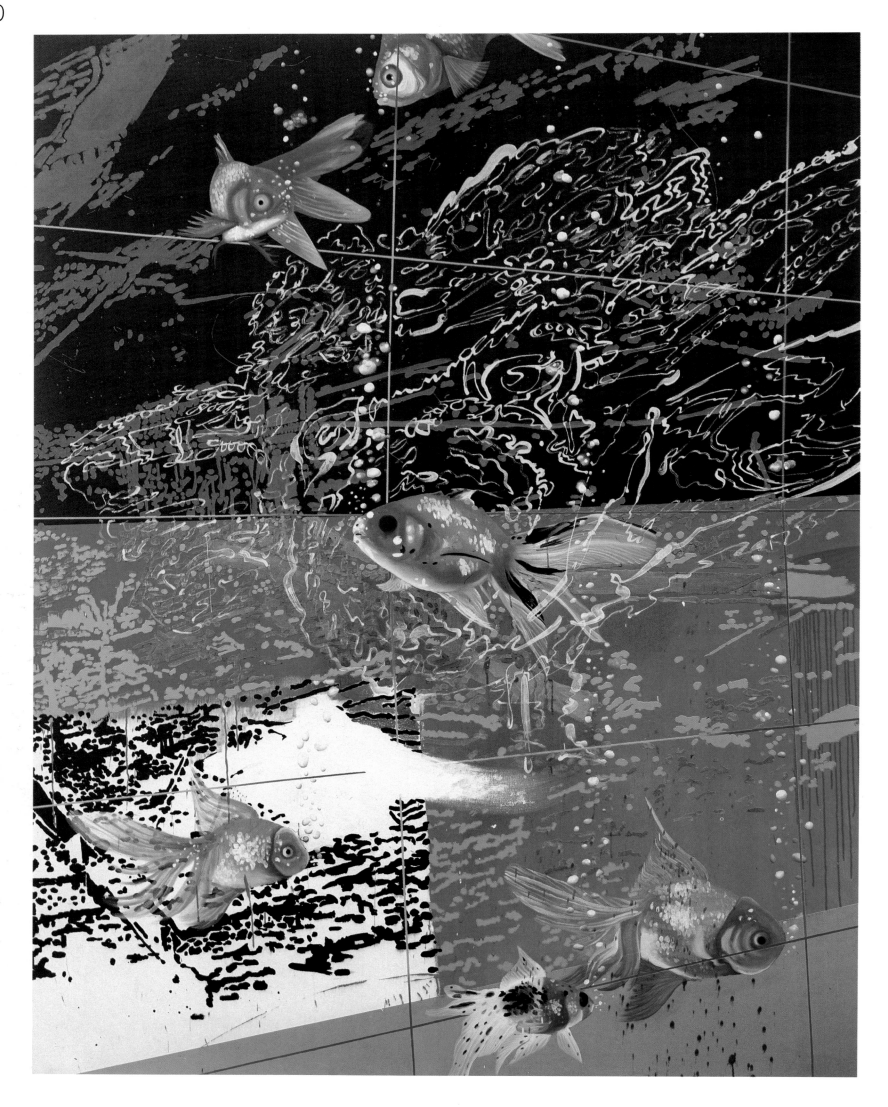

Fried Sushi, 1986. Mixed media on canvas. 85 x 67". Courtesy Gracie Mansion Gallery.

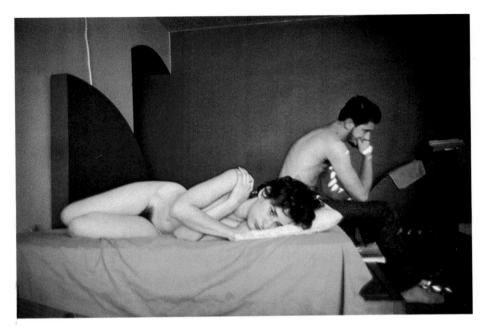

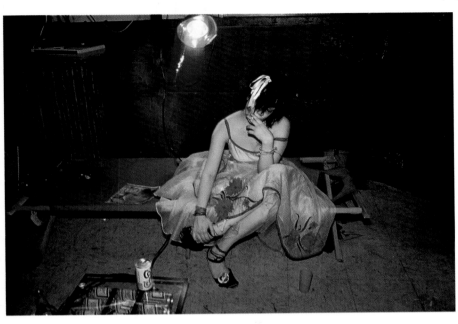

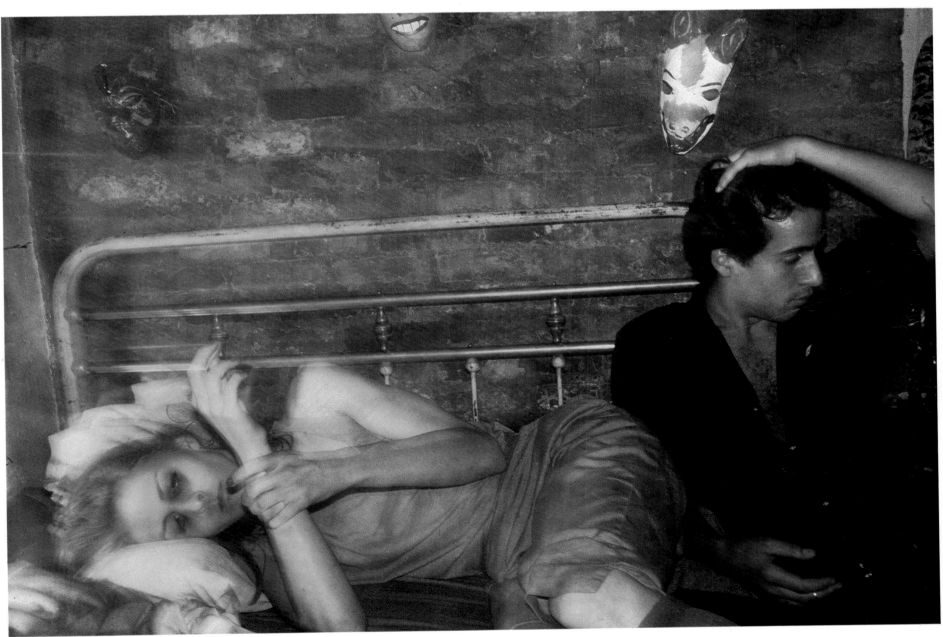

Couple on Bed, Chicago, 1979. Ektacolor photograph. 16 × 20″. Courtesy Marvin Heiferman. *(top left)*
Trixie on the Cot, New York City, 1980. Ektacolor photograph. 16 × 20″. Courtesy Marvin Heiferman. *(top right)*
Greer and Robert, New York City, 1983. Ektacolor photograph. 20 × 24″. Courtesy Marvin Heiferman.

ALAN BELCHER

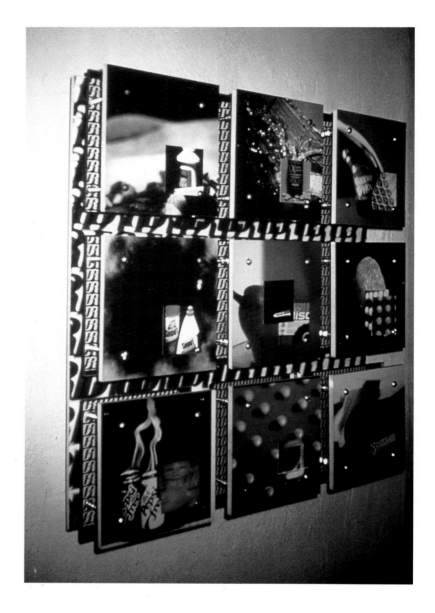

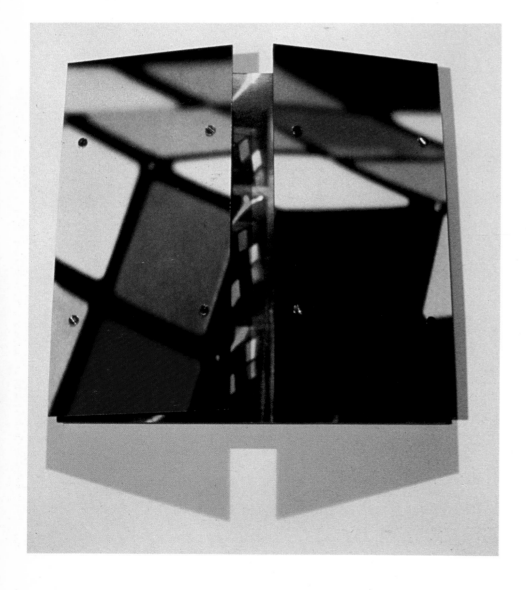

Duane Reade (Be All You Can Be), 1986. Cibachrome on Plexiglas with hardware. 20 x 20 x 4″. Collection Ross Bleckner, New York.
Courtesy Cable Gallery. *(top)*

Rubic-cube, 1985. Color photograph on Plexiglas. 17 x 17 x 3½″. Courtesy Cable Gallery.

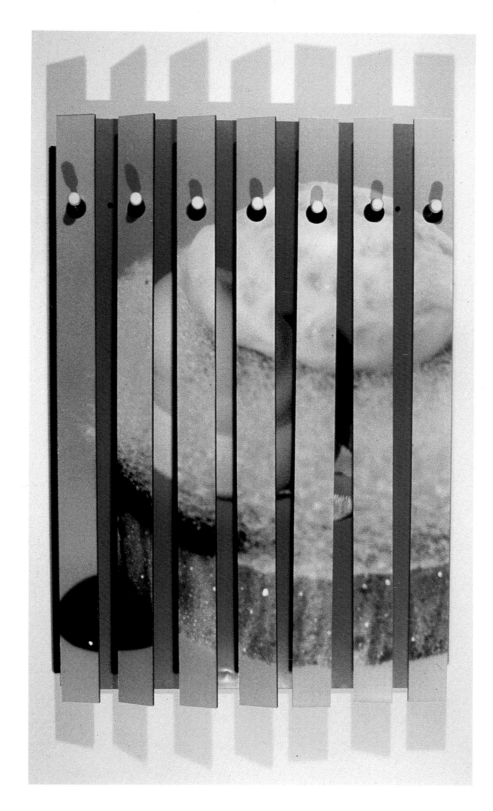

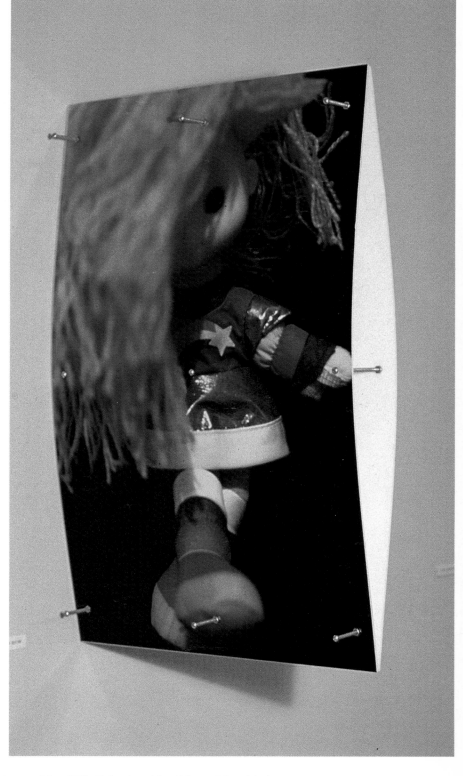

HOUSEHOLD SCIENCES Buff Puff/Today Mousse, 1985. Color photograph on Plexiglas with hardware. 30 × 20″. Collection Alice Albert, New York. Courtesy Cable Gallery. *(left)*

Snork, 1985. Color photograph on Plexiglas with hardware. 30 × 20 × 4″. Courtesy Cable Gallery.

DARA BIRNBAUM

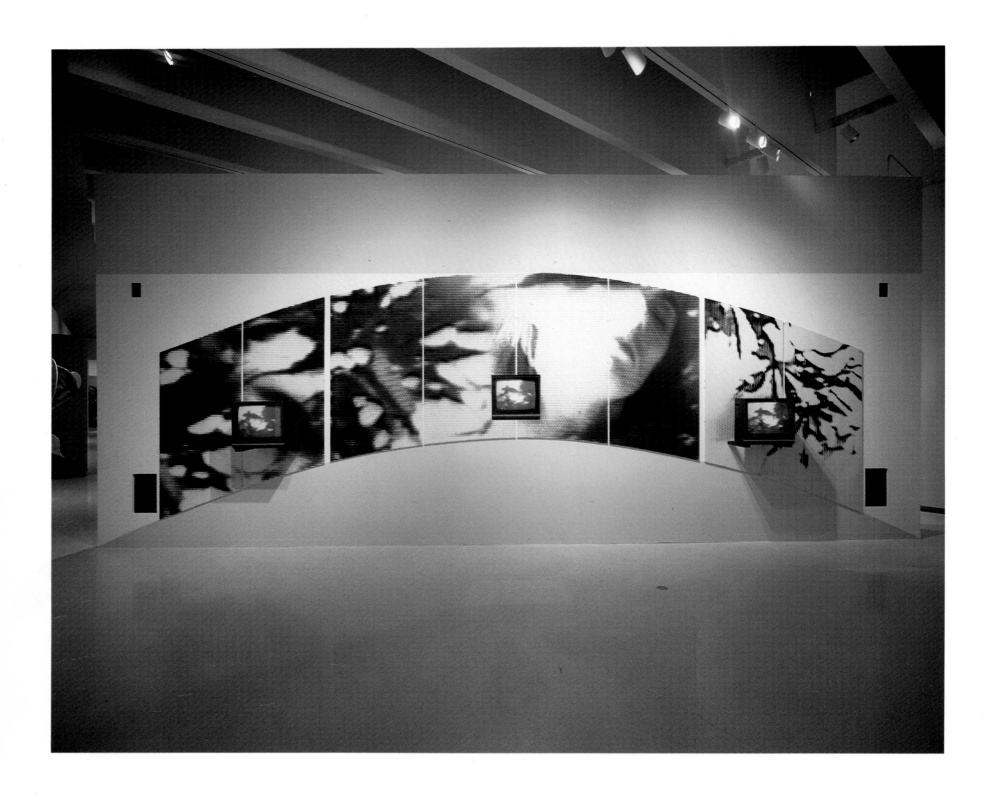

Damnation of Faust, will-o'-the-wisp, 1985. Video installation from The 1985 Carnegie International Exhibition. Collection Museum of Art, Carnegie Institute, Pittsburgh. Museum purchase: Gift of Mr. and Mrs. Milton Fine and The Carnegie International Acquisition Fund.

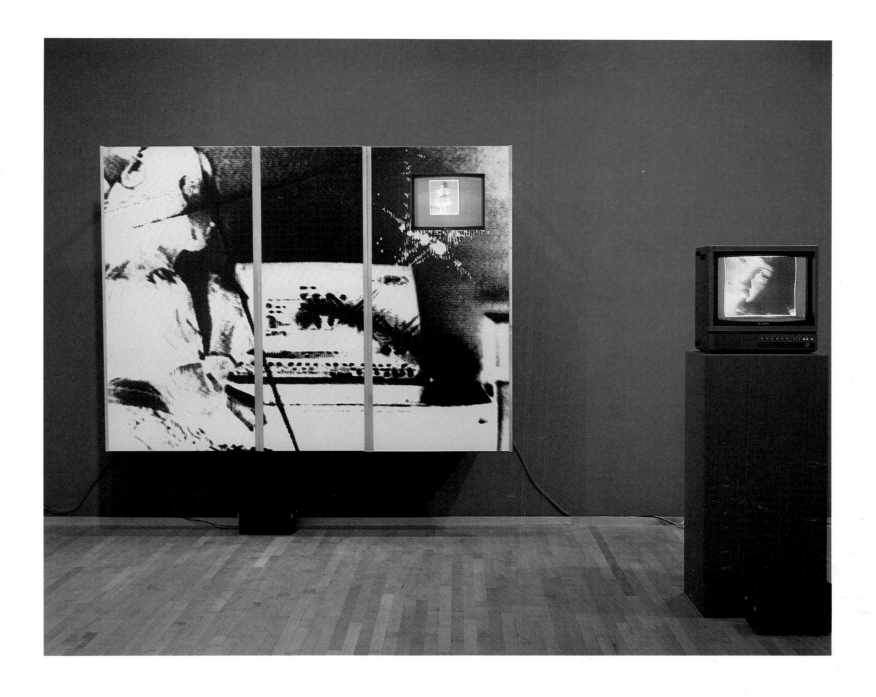

PM Magazine, 1982. Video installation. Courtesy Josh Baer and Curt Marcus galleries.

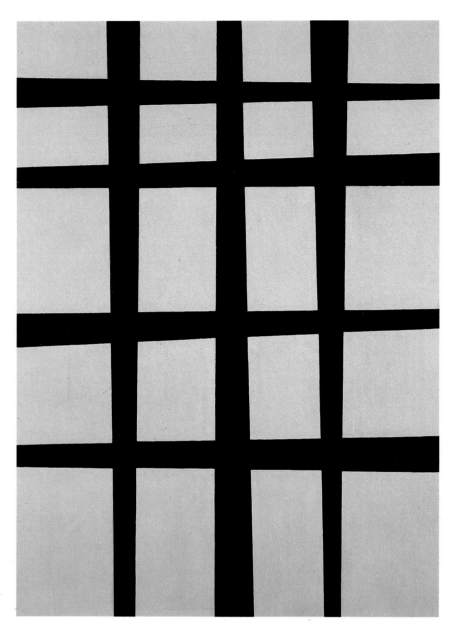

Flawed Galaxy, 1986. Oil and wax on canvas. 30 x 22". Courtesy Postmasters and Daniel Newburg galleries. *(left)*

Insomnia, 1986. Oil and wax on canvas. 62 x 42". Courtesy Daniel Newburg Gallery.

Untitled, 1986. Monochrome color photograph. 30 x 40″. Courtesy Curt Marcus Gallery. *(top)*
Untitled, 1983. Monochrome color photograph. 30 x 40″. Courtesy Curt Marcus Gallery.

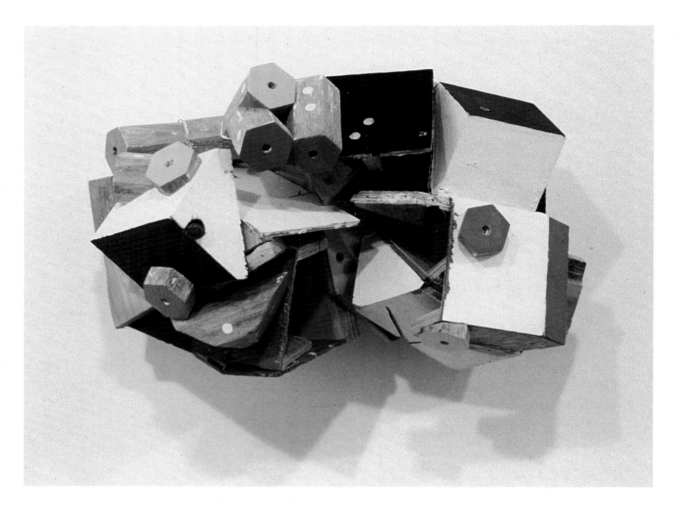

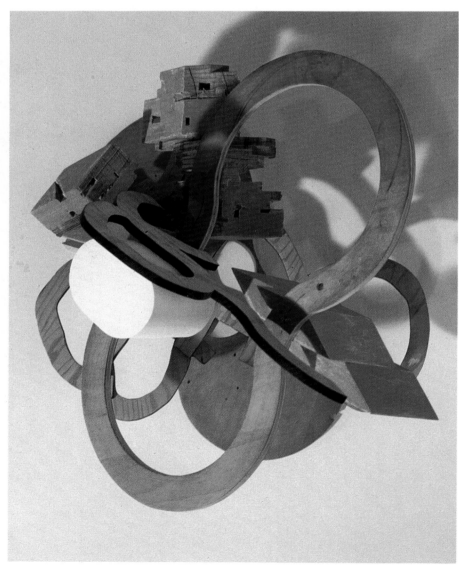

Giant's Causeway, 1984. Wood, oil, and acrylic. 12 x 20 x 13". Collection Terry Winters, New York. Courtesy Cable Gallery. *(top)*
Carnival Echoes, 1985. Wood, oil, and acrylic. 25 x 20 x 19". Collection Ilene Kurtz, New York. Courtesy Cable Gallery.

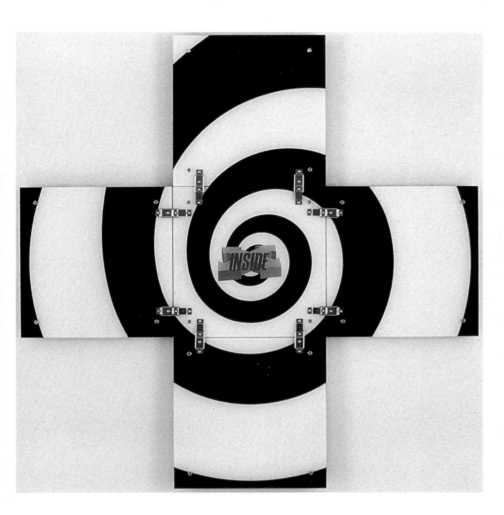

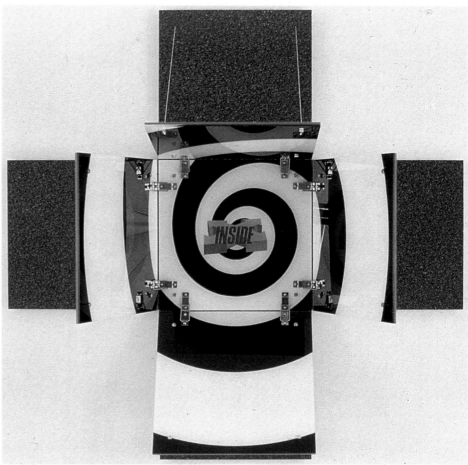

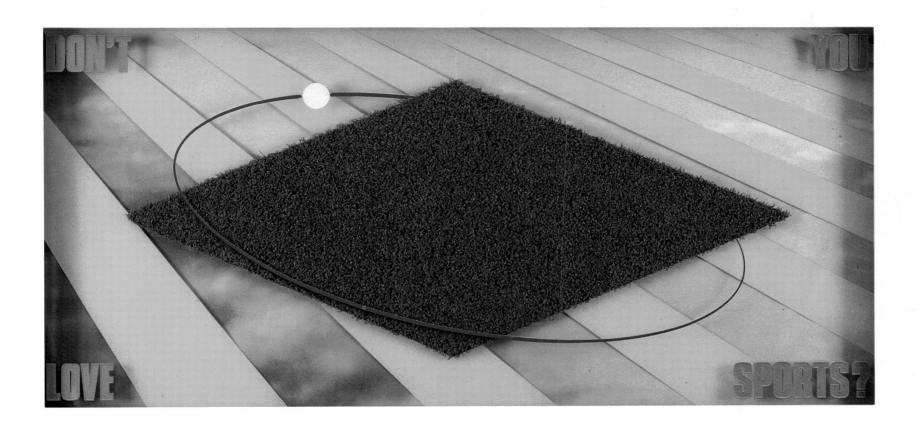

Inside (two views), 1986. Enamel on Plexiglas on wood. 60 x 60". Collection Samuel and Ronnie Heyman, New York.
Courtesy Josh Baer Gallery. *(top)*

Don't You Love Sports?, 1985. Enamel on Plexiglas with photo billboard, astroturf, and formica. 31 x 68 x 4". Courtesy Kent Fine Art.
Photo courtesy Josh Baer Gallery.

ESSENCE AND MODEL

by Peter Halley

One can refer to it as either postmodernism or neomodernism, but what is characteristic of this order is that the elements of modernism are hyperrealized. They are reduced to their pure formal state and are denuded of any last vestiges of life or meaning. They are redeployed in a system of self-referentiality that is itself a hyperrealization of modernist self-referentiality—though it is now detached from the modernist dream of revolutionary renewal. In post- or neomodernism, the syntactical elements do not change. The vocabulary of modernism is retained, but its elements, already made abstract, are finally and completely severed from any reference to any real.

In this hypermodernism, the modern is never discarded. It is simply replaced by its formal double. Typical of this process is the transformation of the modern city. Paris, Boston, and New York are not changed. (It is characteristic of modernism to precipitate change—the widening of streets, the filling of marshes, the building of monuments.) Such cities simply become their double. They are enclosed by the surrounding postindustrial universe and transformed into theme parks of the modern where one goes to see vestiges of the public, such as subway trains and parks, and of the social, at cafes, for example, or at theaters. In the same way, art is replaced by its double, by objects and images duplicating the "art effect."

The universe of the double is achieved by transforming every element into a model of itself. The modernist concept of essence with its referent in nature is further reduced to the state of the model, in which form alone, stripped of meaning, remains. In this way, the universe of the model is the final ruthless realization of the modernist impetus to idealism. In particular, the abstract is completely realized in the landscape. The abstract becomes the real, and the entire environment becomes a model of the environment. All other realities, especially those of specificity and transcendence, either are excluded or are encircled by the model and transformed into models of themselves. Thus not only is there the reality of the model, but there is also no other reality than that of the model. Consequently, developers produce cities that are models of cities, architects produce buildings that are models of buildings, and artists produce works of art that are models of the idea of art. Likewise, in this universe, by virtue of psychology and physiology, human beings can be only models of human beings, while public-opinion polls, multiple-choice tests, and answering machines determine that communication can be only a model of communication.

The operative force behind the establishment of this realm of the double and the model is the ascendancy of the principle of circulation. The vestigial remains of physical motion are inscribed within the systems of circulation of automobiles, pedestrians, and goods. Modernist knowledge is transformed into information, which circulates on TV, in weekly magazines, and through the electronic circuits of the computer. Metaphysics becomes the endless circulation of signs through the chutes of an irreal mental space.

Finally, hypermodernism is defined by closure and circularity. Modernist nature is enclosed in the nature preserve and the game park. The modern city is ringed by superhighways and embedded within the circulatory network of the subdivision. And the earth itself, initially defined as a globe by modernism, is encircled, in the hypermodern, by the orbits of artificial satellites with their electronic sensors.

In modernism, the signifier was detached from the signified—but this was done as a means of giving power and restoring life to the signifier. In hypermodernism, the signifier not only is left open to the signified, but it is left free to attach itself to an endless sequence of signifieds. But this hypermodern situation describes a hermeticism more complete than even that of modernism. No meaning is final, and signifieds are arrayed, one after another, in endless, circular procession. The circle is the metasign for the hypermodern.

BIOGRAPHIES AND TEXTS

ERICKA BECKMAN
Born 1951, Hempstead, New York

Game as a metaphor for the relationship between the personal and the social has held my fascination for a number of years, and subsequently I have developed a language of representations and strategies that invert game as a straight social critique and extend it into the realm of art. Once these ideas and their respective representations are separated from their network in a social narrative and dropped into the conditional reality of the game, they are subject to a new set of rules, the provisional government of the game. First I locate the space of the game by building an artificial, abstract realm.

ALAN BELCHER
Born 1957, Toronto, Ontario, Canada
CONSTRUCTION

A logical extension onward from using packaged product imagery and presentation as a social denominator striving for a more convenient relationship between all viewers and my art objects seems to be toward architecture (buildings being the new package). Products have an obvious illusion of personality and individual life-style. This concentration on the negativity of pseudo-choice confuses my democratic desires for the contemporary art object. There seems to be a much more successful relationship possible with any viewer by directing my endeavor toward the positive and ambitious qualities of the construction of buildings (pseudo-hope), capitalizing on everybody's involvement with their architectural environment for my urban dialogue. Photographic images of construction sites (with employed persons present) and photographically manipulating finished buildings to resemble proposed models can replace the disappointing reality of finished architecture with the energetic image of future. When these photos are mounted onto object forms influenced by architecture (i.e., tents and models), then the final illustration of hope for hope will be made obvious and immediate by my transparent construction of constuctions about construction.

GRETCHEN BENDER
Born 1951, Seaford, Delaware

Bender is not simply celebrating some idea of image chaos and overload. She seems quite aware that while any image can be absorbed into an undifferentiated flux, it can also conjoin with rigid structures of hierarchy and control.

—Jonathan Crary,
in *Art in America*, April 1984

ASHLEY BICKERTON
Born 1959, Barbados, West Indies

The paintings in the *Wall Wall* series are exactly that; if a painting is something that fills a space on a wall with color and meaning, then what is more perversely obvious than a piece of colored wall to affect meaning?

The word pieces (*U G H*, *U U E H H*, *G U H*) could be read as the symphonies of a thousand public restrooms or so many coital blurts. These preliteral grunts are expression in its most native form, and as phonemes in their auricular state, they are information at its most naked. Yet the formal elaboration of this information—the form of the content—is absurd, pompous, a saturated and elaborate system of cul-de-sac meanings. This is the old form-content dilemma acting itself out in an information age. Form and content are pitted against one another in a battle for meaning. These are not exactly paintings. These are paradigms of paintings resonant with form, content, style, and information, yet paradoxically unable to hold or fix meaning.

The interpretation of these manifestations I leave open, but by design they have much to do with a satiric literalization (epistemology as gimmick) or strategic inversion of many of the deconstructive techniques of the past decade or two. The objects can be seen as "hyperrealizations" or caricatures of the conventional art object. This is the art object as it exists in all its stations, imploded into one event.

DARA BIRNBAUM
Born 1936, New York City

My first videowork, *(A)Drift of Politics*, comprised of imagery from the popular TV show *Laverne & Shirley*, was completed in 1978. It obtained its "appropriated material" through late-night recordings by friends working in commercial studios or through sympathetic producers of local cable-TV. Currently, in 1986, all it would take to gather similar "off-air" imagery is access to a home video recorder (VCR). This onset of the newly accessible technology seems to place video basics into the hands of the viewer. Thus, I have changed my work to reflect this fundamental difference. I now "gather" footage from life rather than television. However, as with the earlier work, this gathered source material is subjected to minute examination to reveal its hidden agendas. The editing continues to be a highly refined process, giving definition to the subtlest of gestures—whether they be from the opening shot of a nearly forgotten star in TV's *Hollywood Squares* (*Kiss The Girls: Make Them Cry*, 1979) or a teenager in a New York City playground (*Damnation of Faust: Evocation*, 1983). I have chosen to concentrate on what remains endemic to both "characters"—the restraint and near-suffocation which is imposed through this technocratic society—pressures which force people to openly declare, through communicated gestures, their own identity. These resultant "looks," produced in part by mass media, require us to maintain the ability to scrutinize those projected and communicated images surrounding us. My works are meant to be seen as "altered states," which provide the viewer with means to reexamine those "looks," which on the surface seem so banal. For on television even the supernatural transformation of a secretary into a "wonder woman" is reduced to a burst of blinding light and a turn of the body—a child's play of rhythmical devices within the morose belligerence of the fodder that is our average daily TV diet.

ROSS BLECKNER
Born 1949, New York City

I was once going to spend the rest of my life on the coast of Maine. There were particular paintings I had in mind that I was going to keep making. The memory of the house, the cliffs it was on, the window I looked out of, even the moisture on it, the ocean beyond and the furnishings within, all remain vivid. Only the paintings have passed from my memory.

—From *Sketchbook with Voices*,
edited by Eric Fischl with Jerry Saltz
(Alfred van der Marck Editions, 1986)

JAMES CASEBERE
Born 1953, Lansing, Michigan

James Casebere approaches the staging of the real as a game to be played within the conventions of photographic representation. . . . Like Gide's entry into the garden, his photographs are regressions into the forgotten intensity of the imaginary realities of play. Casebere's forms suggest vistas of architectural ruins or caverns; but there is, too, an almost womblike intimacy in the shallow spaces of his images. The photograph becomes a space for reverie, a dream world, with Casebere showing a playful acceptance of its limits rather than a fascinated attachment to them. In *The Poetics of Space*, Gaston Bachelard writes of the infinite potentials embedded in miniature worlds: "Miniature is an exercise that has metaphysical freshness; it allows us to be world-conscious at slight risk. And how restful this exercise on a dominated world can be! For miniature rests us without ever putting us to sleep. Here the imagination is both vigilant and content."

—Rosetta Brooks,
in *Artforum*, February 1985

SARAH CHARLESWORTH
Born 1947, East Orange, New Jersey

Heir to anachronistic traditions of both painting and photography, we lack as a culture the terminology, the conceptual framework, with which to address the most primary questions of visual language. Originality and representation can no longer be comprehended as a simple equation, a discrimination between a primary object and its facsimile. Popular culture provides to its subjects a dense vocabulary of specific images, shapes, colors, and signs that define our visions of ourselves and our time. My work seeks in part to crystallize, to condense the rampant posing of the image, to wrench or distill from the apparent chaos of generations the basic character, the shapes that define the horizons of our experience as a culture. Between image and object, my work is an instant, a pose, an arrest that marks my position as maker and as made.

MICHAEL CLEGG & MARTIN GUTTMANN

Clegg born 1957, Israel
Guttmann born 1957, Israel

(1) If it is indeed true that every social practice is imprinted with a basic scheme which codes the global power structure, it should be possible to produce art which will demonstrate this fact and use it.

Such art will be "in the world" as well as "about the world," and this twofold relation, which can be called "metonymic," will liberate it from the necessity of using metaphorical strategies.

Being "in the world," such art will use the circumstances of its own production as a test case. It will dramatize, so to speak, its own attempt to produce meaning and thereby effect a metastatement about the current conditions for the production of meaning.

(2) In our portraits we present people who *could* be the ones who control meaning. Each of the portraits documents an encounter with the controllers of meaning, so that every choice of composition, color, props, background, gesture, etc., is subject to an interpretation that would make it the result of negotiations, an exercise in power relations.

The still-life pieces demonstrate the current state of object relations (which are not merely a part of a psychological theory but simply the way objects are related to). Power is attributed to objects, and the history of still life (which was fully internalized by the advertising industry) is the history of the manner in which objects carry their power.

GEORGE CONDO

Born 1957, New Hampshire

And in the end, mimicry grins as a clown's mask from a small gap in the green love poem. The irrealist knows that what he does is deception (Betrug). But he also knows that the deceptive images (Trug-Bilder) of art perform perhaps the last aLLUSIONs (AnSPIELungen) of our dissipated truths. Painting is the play of something only to the extent that it is the play of nothing.

—Wilfried Dickhoff, in *George Condo* (Barbara Gladstone Gallery, 1986)

CARROLL DUNHAM

Born 1949, New Haven, Connecticut

Making things which look a particular way, embedded in syntactical structures, one foot outside language.

NANCY DWYER

Born 1954, New York City

Assume the simulation of wood grain in a Formica surface is there for a reason. It's durable, but mostly it covers the unacceptable plywood underneath with a seamless final ideal.

Assume there is a purpose in loving someone who doesn't love back, in living in a state of unfulfilled anticipation. Maybe it's the perfect cover. The affinity is natural, but the nature is unreal.

BARBARA ESS

Born 1946, Brooklyn, New York

"I don't know who I am alone. I lose myself when I'm with you."

—Barbara Ess, from the song "Oblivion, Call Me to You"

I'm interested in how emotion and thought interact with the phenomenal world. My work deals with the ambiguous perceptual and psychological boundaries between people, between the self and the not-self, between in here and out there. This ambiguity creates tension—even paranoia, but also suggests mystery behind the apparently mute surface of things.

R. M. FISCHER

Born 1947, New York City

I try to have it all ways at once; the more I go on, the more I push the idea of having it all ways—making an object that has a multitude of readings. I imply an object that is sort of multifunctional. I don't like to emphasize the craftiness; a lot of the decisions are the simplest solution to a problem. I try to make the end product somewhat elegant overall, but everything is together in a nuts-and-bolts kind of way. I think of these as real objects that exist in the real world, and they're not meant to be seen at a distance in terms of experience. I'm interested in the work being able to be seen in as many different contexts as possible.

KENJI FUJITA

Born 1955, New York City

FOUR FRAGMENTS

Form: Straight lines drawn by sight, constructed volumes glued together, imperfect circles cut with a band saw.

Object: An abstract amalgam of skin, intestines, and bones where structure and surface form unpredictable bonds.

Materials: Wood, paint, rubber, metal, cast hydrostone, plastic.

Project: To make sculpture that evokes memories of what it could have been and transforms them into reasons for what it is.

ROBERT GOBER

Born 1954, Wallingford, Connecticut

I try to push it to the point where I don't know what I'm doing, because that's what I trust the most. I trust my own experience with a piece. Hopefully, the better the piece the more multiplicity of responses it will engender. But people are on the whole afraid to be bewildered in front of a work of art. But it's a prerequisite that good art demands, that you wonder 'what the hell is this?' and you're bewildered by it. People are afraid to enter that state, and so they come up really fast with reasons, equations for things.

—From the catalog for the New Sculpture show at The Renaissance Society at the University of Chicago; curator, Gary Garrels

NAN GOLDIN

Born 1953, Washington, D.C.

My work is the diary I let people read, motivated by an obsession with memory. For fifteen years I've documented my life and the lives of my friends through intimate portraits. My major concerns are the issues of intimacy, sexuality, and the struggle between autonomy and dependency. I explore the codes of gender identification, the effects of sexual repression, and the problems of couples through scenes of seduction, tenderness, sexual violence, erotic encounters, and alienation.

I present this work in the form of large-scale color prints and a constantly reedited slide show entitled "The Ballad of Sexual Dependency." In the slide show the still photographs work like frames in a film, and a narrative emerges; the sense of time and history unfolds as characters age and shift their alliances.

JACK GOLDSTEIN

Born 1945, Montreal, Quebec, Canada

The medium is the memory.

PETER HALLEY

Born 1953, New York City

FREYA HANSELL

Born 1947, Detroit, Michigan

In these paintings, the *paint* is a magnifier of itself. The paint takes the image and blows it to bits, at the same time isolating it.

The painting is a brute. It is a bully, overpowering—designed with a fast-action movie reality to take you in.

Materiality seems better to me than illusionism. What makes the picture is a formal structure, a view into space, and the physical materiality of the representation. If I want a wall, I use stone.

I am a romantic. I will always be one.

MARK INNERST

Born 1957, York, Pennsylvania

Amidst irresistible technology, artistic hybridization, and mandatory appropriation, a well-considered painting on a single support seems as clear and unfettered an expression as a person could hope for.

—From the catalog for the 1985 Exxon National Exhibition, Guggenheim Museum, New York City

SUZANNE JOELSON

Born 1952, Paterson, New Jersey

ION

PICTURE PAINTING
SEDUCTION ALIENATION
the revealed TRICK gains MAGIC
LOOKING AT LOOKING
Spirit of the theory + theory of the spirit
march in circles, spiral inward,
play musical chairs with
NATURE CULTURE
FAITH DOUBT
INTENTION INTUITION
arrested at the moment of painting.
Romanticism was a reaction against industrialization.
Industry is the new romanticism.
Nature is the new theater,
alien, seductive.
It displaces its logistic counterpart, the church,
one virgin mother for another.
Both are understood in terms of real estate,
and what is understood.
CREATION
MASS PRODUCTION
INFORMATION TRANSFORMATION
the great mythology
STILL
PRESENCE MEMORY
ANTICIPATION REVELATION DISAPPOINTMENT
STILL
Paintings don't offer or demand.
They reveal themselves to desire,
and wait
STILL

DEBORAH KASS

Born 1952, San Antonio, Texas

Witnessing the alleged exhaustion of the systems of nature and culture as we know them is interesting. I am not as interested in describing the radical shifts as much as exploring the physical, psychological, and psychic awkwardness and discomfort they produce.

JON KESSLER

Born 1957, Yonkers, New York

Mao Zedong is, like Lenin, embalmed and on view in his tomb. And so he and the tomb are a kind of public sculpture that represents a dramatic reality for millions. A sculpture that tells a story, pulls the viewer in, grabs him by his lapels and fills his mind with legends. Mao lives on, visible and palpable in his very own body, in the space of mythic time.

In the future, people will realize that Jon Kessler's vision of China is more beautiful than Chairman Mao's, and truer, too.

Reality is always elsewhere.

—From "The Daze of Our Lives:
Notes for an Essay on Jon Kessler,"
by Gary Indiana

KARLA KNIGHT

Born 1958, New York City

Paintings (and painters) need not demand belief or agreement to fulfill their function. They simply act as mirrors in which the individual can view his or her soul.

CHRISTOF KOHLHOFER & MARILYN MINTER

Kohlhofer born 1942, Bad Nauheim, Germany
Minter born 1948, Shreveport, Louisiana

My understanding of being an artist never resulted in the desire to make art. My intentions always were to make those things visible which are "missing" in real life. To create a "second" reality. Go beyond aesthetics, beyond "breaking rules." For me being an artist is foremost: being human without compromise despite the consequences; taking the risk of gambling; making the impossible possible. Mere artful commodities can be made by more or less skillful professionals. This reasoning leads me to work in collaboration with Marilyn Minter. We do not have very much in common, either artistically or otherwise. This is what I see as a possible step forward, to change radically the way art is viewed and understood today. It is a step in the direction of making the impossible possible: to achieve great painting without following the methods normally required to reach the point where it doesn't matter anymore how it's painted, where everything becomes one without losing its own identity.

—Christof Kohlhofer

My image sources are not art historical but the reproduction of media production. Culture images from magazines, movies, and TV are like ready-mades, building blocks for a language with all the inscribed signifiers. Working with Christof Kohlhofer adds another dimension. Another artist's aesthetics and intentions help to weave a texture of harmony and discord.

—Marilyn Minter

JEFF KOONS

Born 1955, York, Pennsylvania

My work sometimes gets transformed into a material where the hand must come into play, but I always try to maintain the integrity of the object. When you do transformations, these are imperfect processes you work with. There is no perfect process. If I feel I can preserve the integrity or most of it, then I say go ahead. If not, then I just have to work in another medium or find a different object. Where I do not have to have anything altered, I will not alter it, its personality, what I'm picking up the content from.

My work really has to do with the experience of life, with social experience, communication with the external world. The morality of being an artist is important, especially now. I find art is a very humanitarian act. Because of that I'm very concerned with accessibility.

—From the catalog for the
New Sculpture show
at The Renaissance Society
at the University of Chicago;
curator, Gary Garrels

BARBARA KRUGER

Born 1945, Newark, New Jersey

I want to speak and hear impertinent questions and rude comments. I want to be on the side of surprise and against the certainties of pictures and property.

I am concerned with who speaks and who is silent and with work that addresses the material conditions and social relations that comprise what we call life.

I replicate certain pictures and words and watch them stray from or coincide with your notions of fact and fiction.

It's time we became doubtful of, if not outright amused by, the notion of the artist as mediator between God and the public: a kind of star-crossed Houdini with a beret on.

—From Sketchbook with Voices,
edited by Eric Fischl with Jerry Saltz
(Alfred Van der Marck Editions, 1986)

KEVIN LARMON

Born 1955, Syracuse, New York

BLUE TABLE

In Kevin Larmon's still lifes, the objects—the translucent bowl of fruit, the hardly constructed table, and the palpable black Space itself—are succinct, virtually hypothetical in existence, and their significance, as such, is all that much more enormous, given their contrite material and psychological totality.

Insofar as they reflect the neutralization of the psyche in their incomplicit values, it can be said that these objects refer to the tentative dominion of the Neutral Subject. The bowl of fruit is a theoretical carrier signifying the suspension of Nature in an ulterior state of physical and material decomposition, and the table is an abstract carrier alluding to the signic act of Construction itself in its nascent precondition.

—Collins & Milazzo, in "Natural Genre,"
an exhibition catalog for the Fine Arts Gallery,
Florida State University, Tallahassee, 1984

JONATHAN LASKER

Born 1948, Jersey City, New Jersey

I often think of these paintings as a form of image kit or perhaps as jigsaw puzzles, which offer components of painting as clues pointing the viewer, not to a finished narrative (as when the last piece of the jigsaw completes a picture of Notre Dame), but rather to a self-awareness, an awareness of how one construes a painting.

Throughout, I try to put things in non-normal relationships with one another. Why is a biomorphic form sitting on a flat-patterned ground? Why does that neutral pattern suggest deep space? Does a certain pattern provide an interior or a landscape for a form to inhabit?

I also seek to thwart the potential narrative by making the viewer aware of paint and its physical properties. Paint has a peculiar ability to act as a locus for an experience of the actual, the physical, in opposition to the depicted, the imagined.

LOUISE LAWLER

Born 1947, Bronxville, New York

Dear Reader,

A press release is written to inform and intrigue the press, to whet their appetites and turn their heads in the right direction. It is sent to critics, newspapers, magazines, museums, and corporate advisers. For this exhibition I am using this press release as an additional location for my work. It will be sent to the entire mailing list and will be part of the presentation in the gallery.

An exhibition entitled Interesting will be at Nature Morte for the month of May. Nature Morte is a gallery in the East Village—the recently formed "third" art district. More than the "first" (uptown) and "second" (Soho), the "third" art district is seen as a homogeneous package. The neighborhood itself is used and abused as part of the art. The work, appropriately handmade souvenirs, attempts to embody the falsification that correlates "wild," "free," and "creative" with neglect and abandonment.

The gallery has been redesigned, altered to imply another kind of space, one that is redolent with the institutionalization of self-interest, where money gets money. Three pictures are included in this installation—photographs of a contemporary object. These photographs represent an expressionism that has "rolled over."

—Press release for Interesting exhibition,
Nature Morte Gallery, May 1985

ANNETTE LEMIEUX

Born 1957, Norfolk, Virginia

Samuel A. Maverick did not brand his cattle

A synthesis of periods of animate existence

collective wholes

not on my life

The confidence in an alleged fact or body of facts
as true or right

without positive knowledge or proof

SHERRIE LEVINE

Born 1947, Hazleton, Pennsylvania

FIVE COMMENTS

Since the door was only half closed, I got a jumbled view of my mother and father on the bed, one on top of the other. Mortified, hurt, horror struck, I had the hateful sensation of having placed myself blindly and completely in unworthy hands. Instinctively and without effort, I divided myself, so to speak, into two persons, of whom one, the real, the genuine one, continued on her own account, while the other, a successful imitation of the first, was delegated to have relations with the world. My first self remains at a distance, impassive, ironical, and watching.
—1980

The world is filled to suffocating. Man has placed his token on every stone. Every word, every image, is leased and mortgaged. We know that a picture is but a space in which a variety of images, none of them original, blend and clash. A picture is a tissue of quotations drawn from the innumerable centers of culture. Similar to those eternal copyists Bouvard and Pechuchet, we indicate the profound ridiculousness that is precisely the truth of painting. We can only imitate a gesture that is always anterior, never original. Succeeding the painter, the plagiarist no longer bears within him passions, humors, feelings, impressions, but rather this immense encyclopedia from which he draws. The viewer is the tablet on which all the quotations that make up a painting are inscribed without any of them being lost. A painting's meaning lies not in its origin, but in its destination. The birth of the viewer must be at the cost of the painter.
—1981

In the seventeenth century Miguel de Cervantes published *Don Quixote*. In 1962 Jorge Luis Borges published "Pierre Menard, Author of *Don Quixote*," the story of a man who rewrites the ninth and thirty-eighth chapters of *Don Quixote*. His aim was never to produce a mechanical transcription of the original; he did not want to copy it. His ambition was to propose pages which would coincide with those of Cervantes, to continue being Pierre Menard and to arrive at *Don Quixote* through the experience of Pierre Menard. Like Menard, I have allowed myself variants of a formal and psychological nature.
—1984

We like to imagine the future as a place where people loved abstraction before they encountered sentimentality.
—1984

I like to think of my paintings as membranes permeable from both sides so there is an easy flow between the past and the future, between my history and yours.
—1985

ALLAN McCOLLUM

Born 1945, Los Angeles, California

You can hold yourself back from the sufferings of the world, this is something you are free to do and is in accord with your nature, but perhaps precisely this holding back is the only suffering that you might be able to avoid.
—Franz Kafka

We hope to explain the entire universe in a single, simple formula that you can wear on your T-shirt.
—Leon Lederman, director of
Fermi National Accelerator Laboratory (Fermilab),
in Batavia, Illinois

DAVID McDERMOTT & PETER McGOUGH

McDermott born 1952, Hollywood, California
McGough born 1958, Syracuse, New York

There is for each man, perfect self-expression. There is a place which he is to fill and no one else can fill, something which he is to do, which no one else can do; it is his destiny!

This achievement is held, a perfect idea in Divine Mind, awaiting man's recognition. As the imaging faculty is the creative faculty, it is necessary for man to see the idea, before it can manifest.

So man's highest demand is for the Divine Design of his Life.

He may not have the faintest conception of what it is, for there is, possibly, some marvelous talent, hidden deep within him.

His demand should be: "Infinite Spirit, open the way for the Divine Design of my life to manifest; let the genius within me now be released; let me see clearly the perfect plan."
—From *The Game of Life and How to Play It*,
by Florence Scovel Shinn

WILL MENTOR

Born 1958, Springfield, Massachusetts

Knowledge is structured in consciousness.

STEVE MILLER

Born 1951, Buffalo, New York

Modern-day technology has reshaped and reconditioned our entire human environment. We are now in an age in which the space of the individual has been reduced to the binary electric code of input and output, question and response. If the mechanical age gave us a sense of overview, a sense of space between ourselves and the center (of power) by which we could measure our placement in the environment and over which we could survey a world which both belonged to us and which excluded us, the age of electronic media has cut out that ground beneath us. Our sense of displacement, in the 80s, reflects the inability to move into a different time-space continuum. Lewis Carroll, at the beginning of the century, looked through the looking glass and found a kind of space-time discontinuum that is the normal code of electronic culture.

PETER NADIN

Born 1954, Liverpool, England

We follow the progression of Nadin's ideas and the evolution of his vocabulary of images through periods of what appears to be stylistic dissimilarity.

Nadin's distance from the idea of impassioned and highly subjective painting lends a conceptual edge to his canvases, which seem to be, in the arbitrariness of their style and simplicity of subject, a commentary on the act of painting.

There is something generic about Nadin's pastoral landscapes and simple still-life pictures which is remote and wistful. The canvases tend to work both as idea and as pure painting; they achieve objectivity and subjectivity at the same time.

Nadin's paintings dovetail with his poetry; his investigation of painting is related to his exploration of language.
—From a press release by
Jay Gorney Modern Art, 1986

PETER NAGY

Born 1959, Bridgeport, Connecticut

Peter Nagy has been involved with the investigation of the political economy of signs. In the past his work has concentrated on familiar works of art and how they have been "logoized": short-handed and manipulated by larger systems of organization. Other works by the artist have scrutinized the collapse of distinct meanings by constructing individual signs which incorporate contradictory messages.

In Nagy's newest works, we witness the further implosion of forms and meanings. The pathology of cancer has been applied to the production of signs, resulting in logos which, although constructed out of simple representational images, are rendered abstract. These clinical black-and-white paintings depict what Jean Baudrillard has termed an "exacerbated redundancy" and enact his theory that "the meta-stasis begun with industrial objects ends in cellular organization."
—From a press release by
International with Monument Gallery,
January 1986

JOHN NEWMAN

Born 1952, New York City

My sculpture comes out of the impulse to make something that I have never seen before. I want people to look at my work and ask themselves, "What the hell is that thing, and what, for that matter, am I doing standing here asking that question?" I think sculpture is also oddly appropriate to our time. It's sort of a cross between writing a diary, building a model, and making a movie. It's very personal, yet lets you use technology. It seems like this big exciting production—machines, trucks, cranes—but at the same time you're also just out there banging on this thing. So it's sort of a cross between Vulcan's forge and Sputnik. In my work, the surface is the form: these are exoskeletons; there is no internal armature. In this regard my work bears some relation to painting, but also to fossils, to armor, to basic principles of topology. I use the color to separate out areas and order their claims on the viewer's attention; it's a way of establishing visual priorities. I get the color by mixing different metals or finishing the metal in various ways: I am not building a place to paint on. I like the feeling that the color is inherent in the material itself.

In a funny sense, viewing sculpture is a little like two dogs approaching one another ... Where does your space begin, where does mine end? How close can I get, can I get closer? Can I stick my nose in there, or not?

JOEL OTTERSON

Born 1959, Los Angeles, California

SOCIAL MUTATION

Hybridization is now the basis for existence, but to such an unhealthy extent that mutation appears rampant. Opposites have blended together to nullify their true origins. From these combinations are born such things as "heavy metal Christians," who look and sound like Hell's Angels but are really preaching fundamentalist suburban morals. Styling mousse, designer cigarettes, wine coolers, and wristwatch TVs are evidence of the abundance of mutant formations.

My job as an artist is to somehow untangle and make some sense of this mess. I insist on combining already existing objects and transcripting them into a single "phrase." Each sculpture or "phrase" is composed of individual sections that are words, commas, colons, periods, exclamation points, and question marks. Most often they are an incomplete sentence or a "ubiquitious utterance."

The sculptures deny their grounded existence by always reaching upward. They search for perfect balance in a world whose balance seems insane and illogical. Equilibrium is now achieved only through drastic contrasts. I hope that the work is a strategic intervention into the subconscious social mutation.

RICHARD PRINCE

Born 1949, Panama Canal Zone

Two guys are sitting in a bar. The first guy says, "If I have another drink I'll begin to feel it."

The second guy says, "If I have another drink I won't care who feels it."

ALEXIS ROCKMAN

Born 1962, New York City

Sublimation of instinct allows for meanings to be dressed and undressed behind a curtain of irony.

The parenthetical and presentive arrangement of abbreviations, hybrids, and tracings.

Painting is a prosthetic body, a perforated vessel.

Many species of fish, animals, and plants have evolved complex communication systems sustaining their survival. One tropical species *Chaetodon capistratus*, or four-eyed butterfly fish, carries a large eye on its tail that deceives larger fish as to its size and suitability for easy conquest.

TIM ROLLINS & K.O.S.

Born 1955, Pittsfield, Massachusetts

I am an artist who has chosen to work as a full-time teacher in a public junior high school located in the South Bronx. After school, I work with about thirty of my past and present students, ages 13 through 18, in a large studio two blocks from my classroom. The kids call themselves K.O.S. (Kids of Survival). We make art together.

We produce art for a large public audience because we want to represent ourselves, our community, and our determination on a major scale. We use art as an impetus toward understanding the historical, political, and economic forces that shape our lives and minds. The art objects we make are vital things, but they are still only trophies—culminations of a learning process and a collective, radical will. Art is most important to us as a means to knowledge.

We paint on books—on a ground of pages torn from important works of world literature. The kids and I do not make illustrations. We relate the themes of the novels to the history we are making today—to our everyday situation in the South Bronx, the United States, the world. In this way, the book is transformed from an object of cultural consumption into a vision, a tool, a foundation on which we are building new forms and contents of our own.

Beyond problems of form and content, what makes our art revolutionary is the method of its making.

PETER SCHUYFF

Born 1958, Baarn, Holland

LAURIE SIMMONS

Born 1949, Long Island, New York

What I like about Laurie's photographs is the way they fail to work. She focuses the camera on a figurine and treats it as if it were a real person—with a kind of childlike wishfulness and suspension of disbelief. Yet the ultimate product is not at all a convincing illusion, and so it seems to me that her work comes to be about illusions which are somehow too fragile to survive, or representations which fail to accomplish their purpose, to make wishes come true. And yet she seems so completely determined to do so, and this is why I think the work is effective, in that she tries so hard to create the effects of reality with such obviously crude and uncooperative materials. In this way, wishing itself becomes the subject of her work, for me. Her work establishes wishfulness as a primary principle, almost, as if there were a kind of sorrowful longing, and a kind of hurt at the root of every human conception.

—Allan McCollum, abstracted from an interview with Allan McCollum and Laurie Simmons, by Beth Biegler, *East Village Eye*, January 1986

HAIM STEINBACH

Born 1944, Israel

Hysteria in the last century was best illustrated in the operatic form. The stage of hysteria in these op-erotic times may be best illustrated by the combined networks of the computer panel and the marketplace. The cult of the individual, grounded in a passion for unique things (object, love, truth), has been replaced by a burning desire for multiplicity.

The operation of cloning is more fascinating than that of sanctification.

PENETRATING RELIEF	*ULTRA LIGHT*	*BEATRICE*
PENETRATING RELIEF	*ULTRA LIGHT*	*BEATRICE*
PENETRATING RELIEF	*ULTRA LIGHT*	*BEATRICE*

GARY STEPHAN

Born 1942, Brooklyn, New York

(The Cézannesque tradition.) Paintings as perceptual objects. A set of tropes from which the viewer constructs vision. The viewer as artist, the painting giving the viewer the building blocks of pictoral formation, changing the viewer from consumer to producer. Painting as "contentless" propertied occasion, formalism.

(The Duchampian practice.) Objects that critique themselves and the formation of meaning in culture. Examining the ways in which society orchestrates values to achieve social goals.

I would have my painting give and take back, state and doubt, such that the final score is 0.

I find myself fully believing in and doubtful of the transcendental.

Unreasoningly confident in both the verticality of values and the horizontality of information. As a consequence, the work moves to the center. A synthetic condition that does not choose between thoughts, emotions, and sensations, it seems to me they should be bound together. An ideal work would be like a good labor-management contract—somewhat disappointing to both sides. Painting as an object of mediation and absorption—not as an event to divide the mind.

Finally my intuition that after meanings is simply all being in general.

DAVID STOREY

Born 1948, Madison, Wisconsin

David Storey paints like he means it, which is not something a viewer takes for granted when confronted by Storey's stylistic buffet of modernist motifs. He makes "genuine beatnik" paintings—a cartoonish melange of Surrealism, Picassoid post-Cubism, Stuart Davis's pre-Pop graphic rhythms, with maybe some of Tamayo's totemism thrown in. Despite their knowing manipulation of genre there's nothing cynical about these paintings. Storey is truly *in* each and every canvas, controlling a vast incandescent palette and developing a signal iconography. The jazzy bounce of his line finds an imagistic corollary in his pictures of abstracted clarinets and his fat little L-shapes that could be tapping or dancing feet.

The outlines of Storey's shapes have some of Matta's rapid fluidity, while their frontality is more suggestive of Wifredo Lam. However, Storey's work has little of the Surrealist sense of threat. The clarinet may be a phallic allusion but it is hardly confrontational. A formal reading of Storey's work returns us to the surface meaning of his recognizable forms. Style appears to be less of an arena for Storey to express oedipal anxieties and erotic exhilarations than it is a means to convey, above all, a love of painting.

—Stephen Westfall, in *Art in America*, April 1986

PHILIP TAAFFE

Born 1955, New Jersey

A kind of aphoristic diagram in the form of an imaginary logbook. This is loosely based on the *HMS Bounty* incident, and it's entitled *Mutiny Within Bounty*. This is the logbook entry for Day One:

"Our condition is driving us to polite distractedness. We don't like it and we will no longer put up with it. We know how to run this ship and we are taking over. Our journey must accomplish nothing less than the establishment of paradise on earth. We've been endlessly mistreated by our culture, superabundance is bringing us nowhere, and we refuse to allow this situation to be perpetuated. We're not buying and we're not selling. We're casting our oppressors adrift on board a bronze raft, and we're getting the hell out of here. We're going to where we can celebrate our new destiny in peace and freedom, to where our only possessions are our minds, our hearts, our aspirations and whatever we find when we get there."

Day Two continues:

"Everyone seems to agree that our approaching destination looks frighteningly familiar. We may have to find someplace else."

—From *Flash Art*,
Summer 1986

MARK TANSEY

Born 1949, San Jose, California

A painted picture is a vehicle. You can sit in your driveway and take it apart or you can get in it and go somewhere.

MEYER VAISMAN

Born 1960, Caracas, Venezuela

Meyer Vaisman's work presents a hyperrealization of the relationships between biological reproduction and photomechanical reproduction.

This type of investigation is typified by the self-referencing (self-reproduction) that occurs in Vaisman's work through a numerological deployment of explicit sexual references such as rubber nipples or diagrammatic sexual organs which echo, in number and purpose, the amount of stacked canvases on each piece and the primaries (process cyan, process magenta, and process yellow) used in photomechanical reproduction.

Vaisman silk-screens a photo of fabric onto fabric and a photo of wood onto wood to establish a carefully orchestrated hierarchy between what is considered real and what is considered simulated.

This difference between the real and the simulated is further stressed by the glossy laminate applied to the surface of each piece, which freezes the various elements deployed in motion.

—From a press release by
White Columns, April 1986

WALLACE & DONOHUE

Born 1959, New York City

Can we talk about a crisis in identity?

(New Work by Wallace & Donohue)

I'm a slave to impersonation. On the worst days, I feel like the complete transmogrification of our rabid culture. All I have to do is sever a limb and I'm rife with workable material.

I think I know what you mean but your analogy is disgusting.

Well, we've dissected frontality along with everything else, building out from a painting and having a painting float off the wall, exposing a strange side view and so offering a peculiar awareness of how it is that a painting is supposed to be viewed.

(It's hard to know where the mind is.)

I thought it was interesting that B. could not understand why we would be using painting right now, but, as I pointed out to him, conventionally is not a problem anymore.

(In other words, what we posit as a belief system has to do with something like a trans-subordination of derided parts.) (Laughter)

We can talk about opacity in terms of a work's presence as that which eclipses meaning, or at least the Modernist notion of a work's *inherent* meaning. What we have are hollow conventions, and painting is just such another convention.

That's why it's exciting.

(Laughter)

What's exciting is the activity of holding meaning in check. I'm thinking of a malleable construct for opaque or hollow signifiers in which meaning can be (seemingly) offhandedly construed as something like the positive matter which accrues to a negative field.

(The Obdurate Fortitude With Which Our Slender Innuendos Become Fatuous)

(Why we're not worried about subjectivity)

So *we're* being institutionalized now.

They'll be dragging all our *dreams* into our *lives* and hammering us to these beds that aren't ours—

(Military police dropping through the ceiling)

It's a difficult area to patrol.

(Laughter)

STEPHEN WESTFALL

Born 1953, Schenectady, New York

I believe it is possible to make paintings of beauty and discipline without dogma, in the spirit of serious play.

TERRY WINTERS

Born 1949, Brooklyn, New York

Painting: Perfect pantomime.
Drawing: Tonal breath control.
The four corners. Physical evidence.
The psychological corporation. Mental space.
All images are actual size.
Pictorial mechanics. Woven, stratified, contiguous collage of materials and events.
CRYPTOGRAPHIC OBSERVATORY.
True love knot. Fiction. Fact.
"Go into seclusion with nature." (Redon)
Specific gravity. Ground zero.

CHRISTOPHER WOOL

BORN 1955, Chicago, Illinois

I knew one 4th Division Lurp who took his pills by the fistful, downs from the left pocket of his tiger suit and ups from the right, one to cut the trail for him and the other to send him down it. He told me they cooled things out just right for him, that he could see that old jungle at night like he was looking at it through a starlight scope. "They sure give you the range," he said.

. . . "I just can't hack it back in the World," he said. He told me that after he'd come back home the last time he would sit in his room all day, and sometimes he'd stick a hunting rifle out the window, leading people and cars as they passed his house until the only feeling he was aware of was all up in the tip of that one finger. "It used to put my folks real uptight," he said. But he put people uptight here too, even here.

. . . But what a story he told me, as one-pointed and resonant as any war story I ever heard, it took me a year to understand it:

"Patrol went up the mountain. One man came back. He died before he could tell us what happened."

I waited for the rest, but it seemed not to be that kind of story; when I asked him what had happened he just looked like he felt sorry for me, fucked if he'd waste time telling stories to anyone dumb as I was.

—From *Dispatches*, by Michael Herr